THE
NATURE PHOTOGRAPHER'S
COMPLETE GUIDE TO
PROFESSIONAL FIELD TECHNIQUES

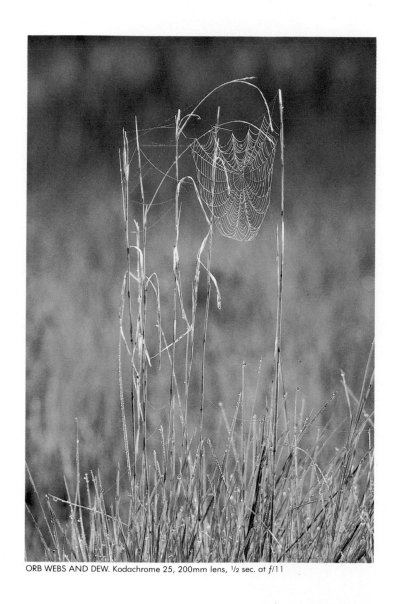

ORB WEBS AND DEW. Kodachrome 25, 200mm lens, ½ sec. at ƒ/11

THE
NATURE PHOTOGRAPHER'S
COMPLETE GUIDE TO
PROFESSIONAL FIELD TECHNIQUES

BY JOHN SHAW

AMPHOTO
AMERICAN PHOTOGRAPHIC BOOK PUBLISHING
AN IMPRINT OF WATSON-GUPTILL PUBLICATIONS/NEW YORK

First published 1984 in New York by American Photographic
Book Publishing: an imprint of Watson-Guptill Publications,
a division of Billboard Publications, Inc., 1515 Broadway,
New York, NY 10036

Library of Congress Catalog Card Number: 84-45064
ISBN 0-8174-5005-X
ISBN 0-8174-5006-8 pbk.

Distributed in the United Kingdom by Phaidon Press Ltd.,
Littlegate House, St. Ebbe's St., Oxford

Manufactured in Japan

7 8 9 / 89 88 87 86

To Andrea, who changed my life

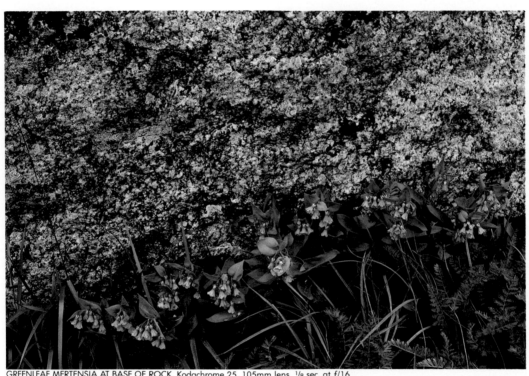

GREENLEAF MERTENSIA AT BASE OF ROCK. Kodachrome 25, 105mm lens, 1/8 sec. at f/16

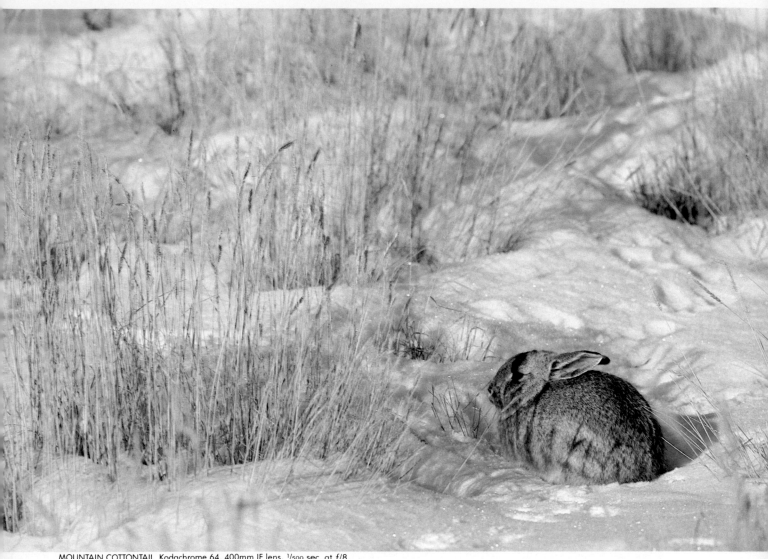

MOUNTAIN COTTONTAIL. Kodachrome 64, 400mm IF lens, $1/500$ sec. at $f/8$

CONTENTS

FOREWORD

While this book discusses many field techniques for nature photography, the most important bit of advice I can offer anyone reading this is simple: learn about your subjects. To be a better nature photographer, be a better naturalist. This means understanding the subject not just in a dry textbook sense, although I would advise you to read everything you can that pertains to your subject, but also knowing your subject through constant contact and observation in the field. The more you know about nature, the more you will see to photograph.

As you develop your knowledge, I trust you also will develop a wildlife ethic. In my opinion, no photograph is more important than the safety and welfare of the subject. Respect what you photograph. Don't expose a nest to the elements or keep the parents away from their young. Don't dig up plants to move them to another site. Don't destroy what you love.

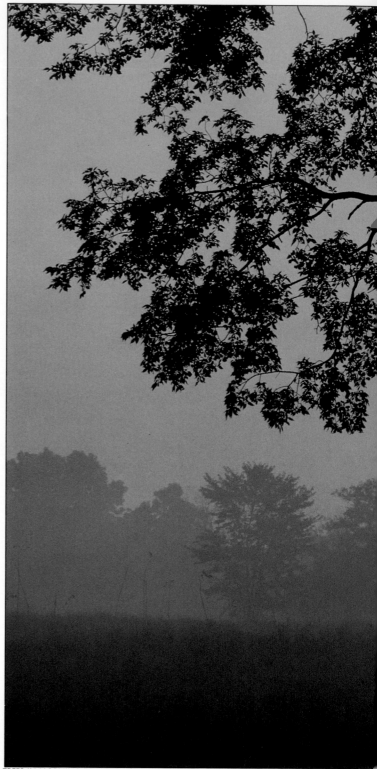

TREES IN MORNING FOG. Kodachrome 25, 105mm lens, 1/60 sec. at f/8

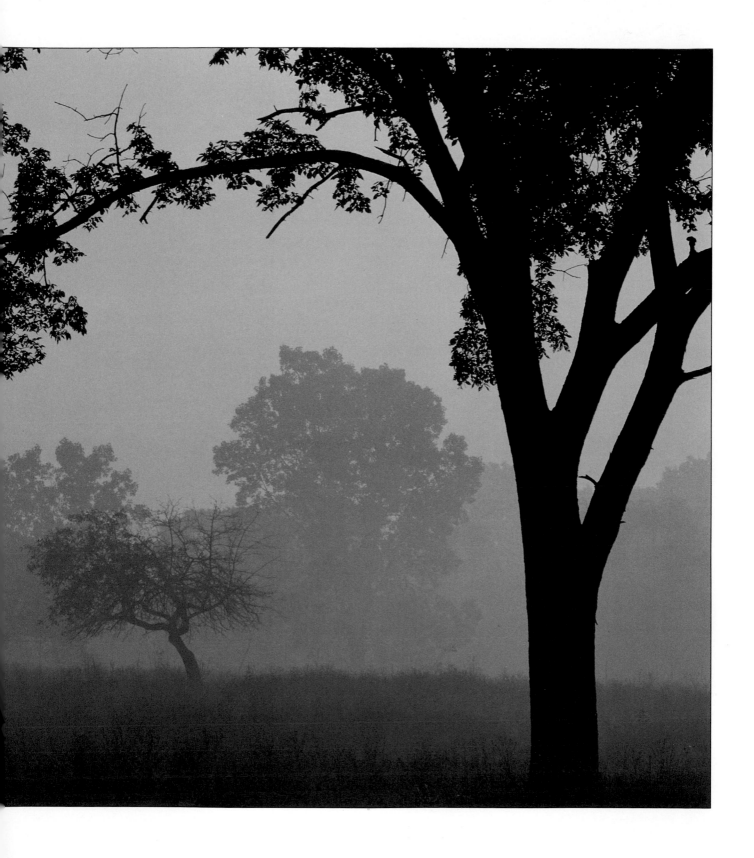

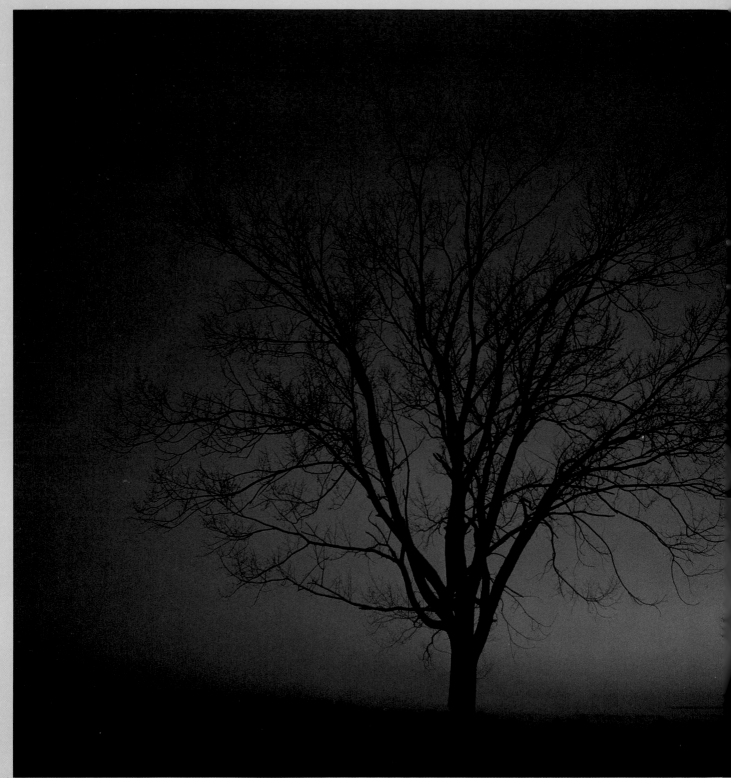

ELMS AT TWILIGHT. Kodachrome 25, 50mm lens, 1/2 sec. at *f*/11

The nature photographer often contends with fleeting phenomena. Here, the colors of twilight—changing minute by minute—were captured only because exposure determination was fast and accurate.

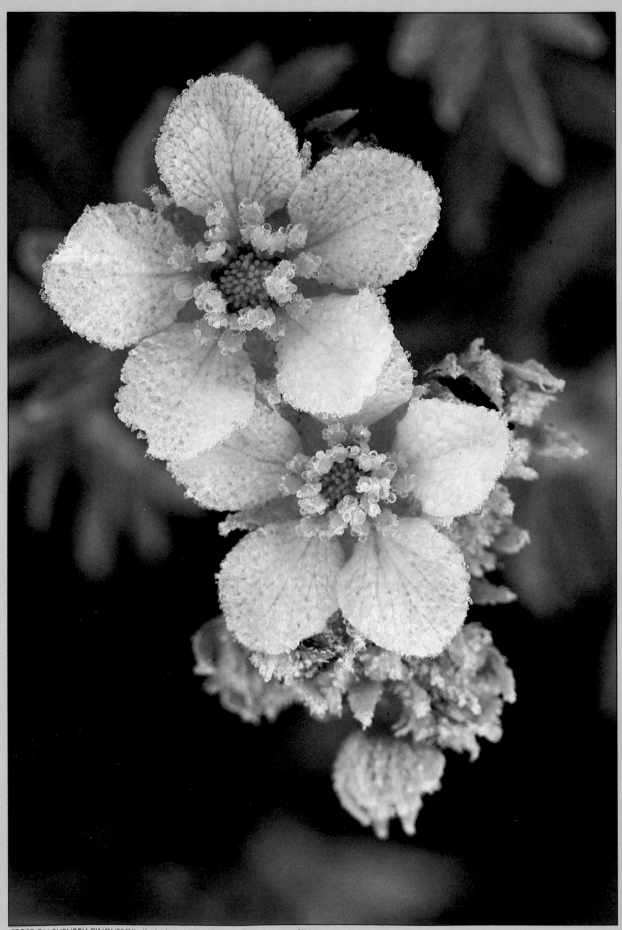

FROST ON SHRUBBY CINQUEFOIL. Kodachrome 25, 105mm lens, 1 sec. at *f*/11

UNDERSTANDING EXPOSURE

Proper exposure is the biggest problem for all photographers, whether amateur or professional. Your technique can be perfect, your lenses the best available, your film the finest, the location the most exotic; but if your exposure is off, your photographs will be throwaways. And no matter how sophisticated your camera's exposure system is, you cannot depend on it to handle every situation. If you want to become a good nature photographer, it is vital to always keep in mind the basics of exposure.

Exposure determination depends on two basic camera controls: shutter speed and aperture. *Shutter speed* is the length of time that your camera's shutter stays open when you take a picture. *Aperture,* or *f*-stop, is the size of the lens opening through which light passes to the film. Together they control the total amount of light reaching the film. Both of these values are set up to work in what are called *stops*. A stop represents the doubling or halving of the amount of light that reaches the film. Cameras are much easier to use if you learn to think in terms of stops.

The standard shutter speed sequence on most cameras is marked in seconds and fractions of a second: 1, $1/2$, $1/4$, $1/8$, $1/15$, $1/30$, $1/60$, $1/125$, $1/500$, and $1/1000$ sec. Each speed is half the preceding speed but double the following speed; for example, $1/60$ sec. is half as long as $1/30$ sec., but twice as long as $1/125$ sec. Shutter speeds control motion. A moving subject is blurred by slow speeds and frozen by fast speeds.

The *f*-stops marked on a lens also work in doubles and halves. The usual series of numbers is $f/1.4$, $f/2$, $f/2.8$, $f/4$, $f/5.6$, $f/8$, $f/11$, $f/16$, and $f/22$. Each number indicates the size of the lens opening. And the important thing to remember is that as the numbers get larger, the lens opening gets smaller. For example, $f/1.4$ represents a very large lens opening while $f/22$ is a very small one. Not all lenses have all these numbers, and some have even more, but all *f*-stop numbers work the same way. Each number represents an opening in the lens that is half the size of the preceding number and double the size of the number that follows. For exam-

ple, $f/8$ is an opening that has twice the area of $f/11$, but it has only half the area of $f/5.6$.

The *f*-stops control depth of field, which refers to the portion of a photograph, from near to far, that is in sharp focus. The smaller the lens opening, the greater the range that is in sharp focus; the larger the opening, the more limited the area that is sharp (page 53).

Stopping down is the traditional term used to describe cutting the amount of light reaching the film by going to a smaller *f*-stop. *Opening up* is just the opposite: going to a larger aperture. By extension, you should also think of shutter speeds in the same terms. Using a faster shutter speed is, in effect, stopping down since it also cuts the amount of light reaching the film. Using a slower shutter speed, which lets more light get to the film, is in effect opening up.

Since both shutter speed and *f*-stop control how much light reaches the film, and since both work in doubles and halves, we can establish a relationship between them. A stop change in shutter speed is the equivalent of an *f*-stop change. Thus the two are interchangeable. Basically, this means that to get the same amount of light to the film you can use a small lens opening and a slow shutter speed or a large opening with a fast shutter speed. It's similar to drawing a gallon of water: you can turn the tap on full for a short period of time, or have just a trickle for a long time. Either way you end up with a gallon of water. The lens opening and the amount of time it is open work together in a reciprocal relationship.

What this means is that when you need a smaller aperture for increased depth of field or a faster shutter speed to stop action, you are free to exchange shutter speeds for *f*-stops, and vice versa, and still get proper exposure. Assume, for example, that $1/125$ sec. at $f/8$ is the proper exposure. The same amount of light hits the film when you double the time to $1/60$ sec. and half the opening to $f/11$. The exact same amount of light is also produced by half the time, $1/250$ sec., at double the opening, $f/5.6$. In practice this is simple to do: Just count the number of stops you change on one scale and change the other scale this same number of stops, but in the opposite direction. Again let's start with a proper exposure of $1/125$ sec. at $f/8$. A two-stop change in shutter speed to $1/30$ sec. (more time) needs

a two-stop change in *f*-value to $f/16$ (smaller opening) to get the same amount of light to the film.

Of course, the shutter speeds and *f*-stops you choose will depend on the film you are using. Different films vary in their sensitivity to light, and this variation is expressed in their speed ratings, or ISO numbers (previously called ASA numbers). The smaller the ISO number, the less sensitive the film—that is, it needs more light for proper exposure. Hence films with small ISO numbers like Kodachrome 25 at ISO 25 are called low-speed or slow film while those larger ISO numbers, like Ektachrome 400 at ISO 400 are called high-speed or fast films. ISO numbers can also be thought of as working in stops. Although ISO ratings or various films do not always progress uniformly like shutter speeds and apertures, a doubling or halving of an ISO number represents a doubling or halving in the film's sensitivity to light. From ISO 25 to ISO 50 is a one-stop change; from ISO 50 to ISO 100 is one more stop; from ISO 100 to ISO 200 is another stop. Thus Ektachrome 400 is four stops faster (more sensitive to light) than Kodachrome 25.

Knowing the proper exposure for one film in a given lighting situation means that you know the proper exposure for all films, if you work in stops. If Kodachrome 25 is properly exposed at $1/15$ sec. at $f/8$, what is the proper exposure for Ektachrome 200 film? ISO 200 is three stops faster than ISO 25, so the exposure for Ektachrome 200 is $1/125$ sec. at $f/8$, or $1/60$ sec. at $f/11$, or $1/30$ sec. at $f/16$, or $1/15$ sec. at $f/22$, and so on. How about Kodachrome 64 at ISO 64? Technically, it is one and one-third stops faster than Kodachrome 25. ISO 25 to ISO 50 is one stop; ISO 50 to ISO 100 would be another whole stop. ISO 50 to ISO 64 is one-third stop. A third of a stop is a smidge—plenty close enough! So Kodachrome 64 would be exposed at $1/15$ sec. at $f/11+$ or the equivalent. To get an $f/11+$ aperture on your camera, you simply set your aperture ring between $f/11$ and $f/16$, about a quarter to a third of the way beyond $f/11$.

Learning to calculate proper exposure by working in stops is the starting point for all good photography. It's a simple system, and it's easy to learn. More importantly, it puts you in control of your images, rather than being dependent on your camera's meter.

IN BRIGHT SUNLIGHT, IGNORE YOUR CAMERA'S METER

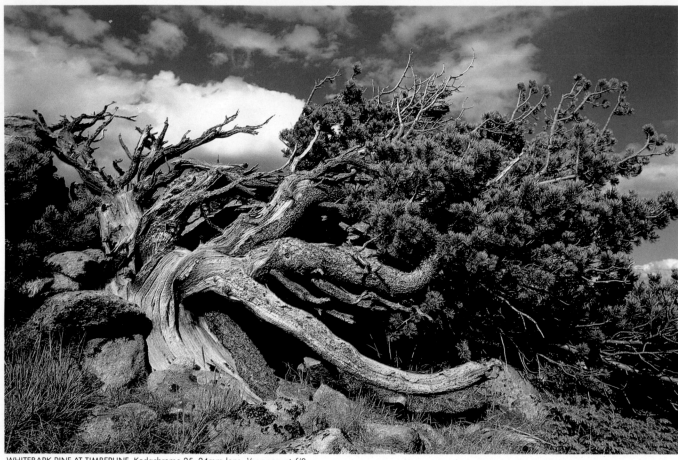

WHITEBARK PINE AT TIMBERLINE, Kodachrome 25, 24mm lens, 1/125 sec. at f/8

You can determine correct exposure two ways: you can rely on a meter, like the one in your camera, to measure the light level, or you can estimate the level of light yourself. No matter how technically advanced your camera's exposure system is, there is one situation—bright sunlight—when I strongly recommend that you go with an estimated exposure. On a bright, clear day, it is fairly easy for a meter's appraisal of the settings needed for correct exposure to be thrown off by a subject that is light colored or shiny or by a subject that is more than normally dark in tone. Yet correct exposure in bright sunlight anywhere in the world, when photographing a frontlit subject bigger than a backpack, can always be quickly calculated using what is known as the "sunny f/16 rule." When the camera is set at f/16, the correct shutter speed is the one with the number closest to the film's

ISO rating. This can be expressed as correct exposure equals one/ISO at f/16. For example, for a film that has an ISO rating of 64, the proper bright sunlight exposure at f/16 is 1/60 sec., the shutter speed closest to 64. The sunny f/16 rule works—memorize it! If your camera's meter doesn't give you the same values, ignore the meter. I have shot thousands of photographs this way.

Of course, once you know the correct shutter speed for f/16, you can use any equivalent combination of settings. You do not have to shoot Kodachrome 64 at 1/60 sec. and f/16. The same amount of light reaches the film when you use 1/125 sec. at f/11, 1/250 sec. at f/8, or 1/500 sec. at f/5.6. Pick the f-stop you need for depth of field, or the shutter speed that you need to stop subject or camera motion.

Fighting a constant wind at the timberline, I quickly composed this shot and then waited for a lull. Even so, I was forced into a compromise between shutter speed and depth of field. I chose a medium shutter speed (as slow as I dared to go with the wind) and a medium f-stop.

(Opposite page, top) Since I knew the basic exposure for bright sunlight, I did not bother to take a meter reading. In order to get both foreground and background in focus I used a small f-stop. A tripod enabled me to study the composition carefully and allowed for a slow shutter speed.

(Opposite page, bottom) A fast shutter speed was absolutely essential in order to arrest the goose in motion. To compensate for the shutter speed, I shot with the lens wide open—but this meant critical focusing. A 500mm lens allowed me to isolate the subject. When using the "sunny f/16" exposure with Kodachrome 64, I often find it best to rate the film a little faster. Try shooting at a base exposure of 1/60 sec. at between f/16 and f/22 to richen the exposure.

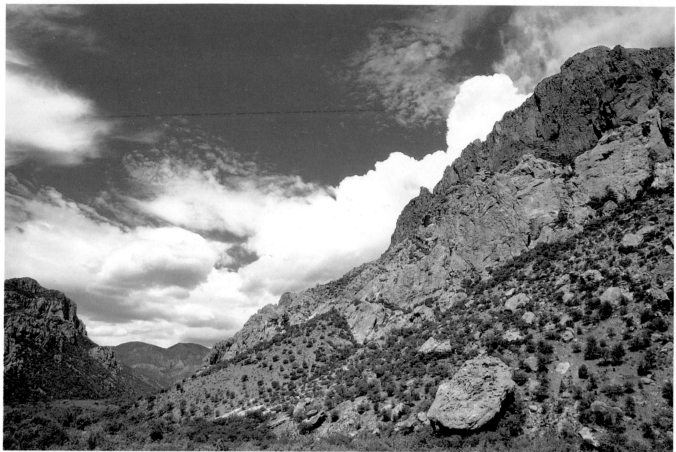

CHIRACAHUA MOUNTAINS, ARIZONA. Kodachrome 25, 50mm lens, 1/30 sec. of f/16

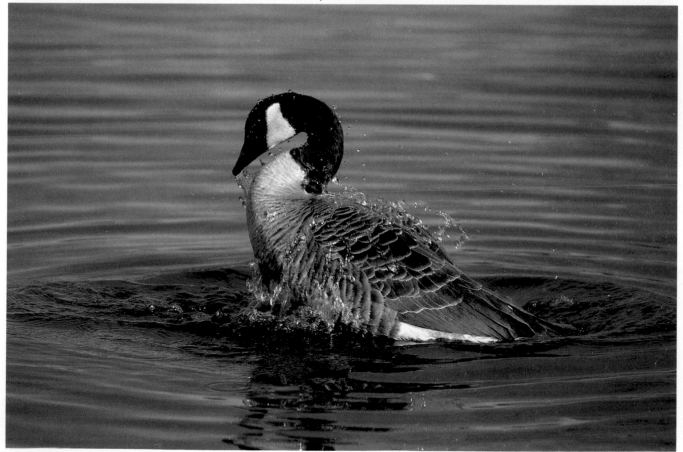

CANADA GOOSE. Kodachrome 64, 500mm lens, 1/500 sec. at f/5.6

KEEPING THE WHITE SUNLIT SUBJECT FROM WASHING OUT

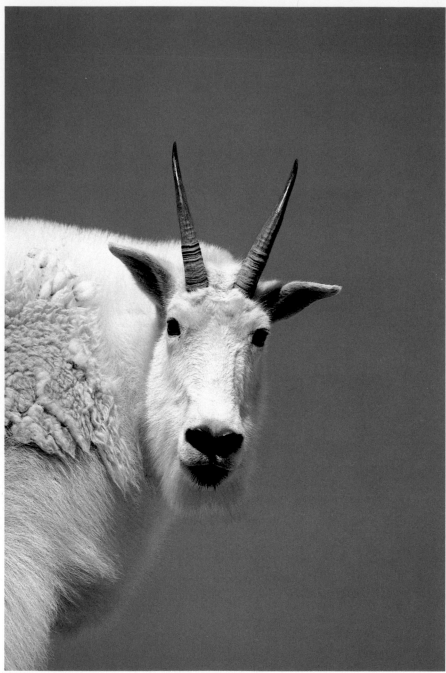

MOUNTAIN GOAT. Kodachrome 64, 300mm IF lens, 1/250 sec. at ƒ/11

*I strove for detail in the white fur of this
mountain goat and for a brilliant blue sky.
Mine was a tall order, but satisfactorily
filled: my exposure kept the goat properly
exposed, and also increased the color satu-
ration in the sky.*

When you are working in bright sun-
light, photographing white subjects that
fill a good part of the frame, the basic
sunny ƒ/16 exposure rule does not
work. Highlights and details on the
white surface become washed out, and
the resulting slide is overexposed.
Compare, for example, the two photo-
graphs of the swan on the opposite
page. In the smaller photograph, the
sunny ƒ/16 rule was used, and you can
see how all the detail in the swan's
feathers is lost. A similar problem oc-
curs when you shoot in bright sun and
include such highly reflective surfaces
as sand and snow in the frame. With
transparency film, it is especially impor-
tant to keep details in the highlights.
Once they are lost, there is no way you
can recover them.

Taking a meter reading is not the
solution to this problem, however; a
meter can also be misled by the situa-
tion. The answer is to base your expo-
sure on the sunny ƒ/16 rule, but cut
your light by one stop. This will give
you the correct exposure for keeping all
the details of your white subject intact.
Under these conditions then, the cor-
rect non-metered exposure becomes
"sunny ƒ/22." Let's assume, for exam-
ple, that you are using Kodachrome 64.
Your proper bright sunlight exposure
time is still 1/60 sec., the shutter speed
closest to ISO 64 in number. But your
proper ƒ/stop is now ƒ/22. As always,
you can pick any equivalent combination
of shutter speed and ƒ-stop that you
need for your subject. In this example
you could use 1/125 sec. at ƒ/16, 1/250
sec. at ƒ/11, 1/500 sec. at ƒ/8, or 1/1000
sec. at ƒ/5.6.

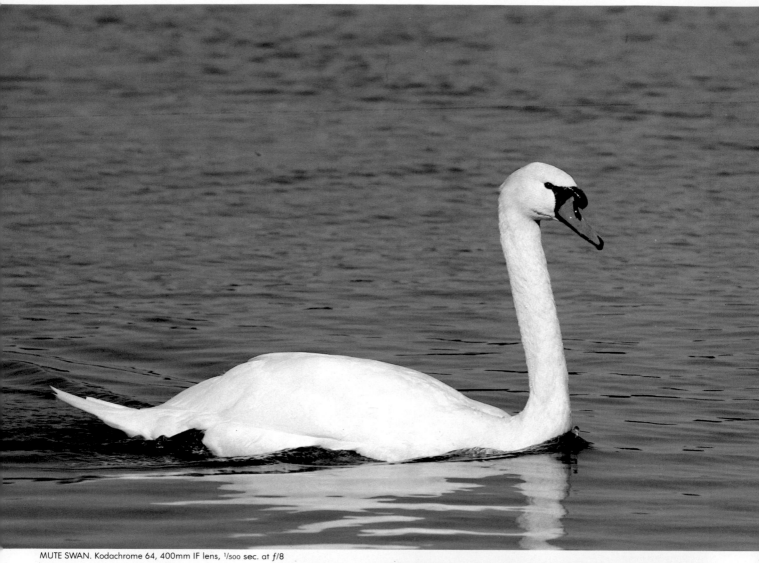

MUTE SWAN. Kodachrome 64, 400mm IF lens, ¹/₅₀₀ sec. at f/8

By stopping down one stop from a normal
''sunny-16'' exposure, I was able to main-
tain detail in the bright white swan and ex-
cellent color in the water. There is quite a
difference between the photograph above
and the one at right, which was taken with
a normal ''sunny-16'' exposure.

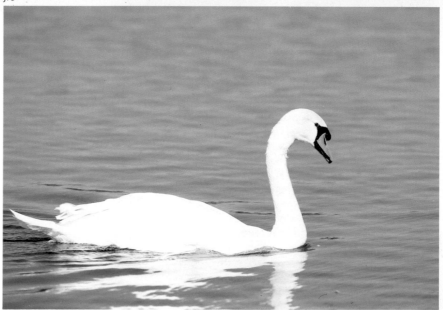

MUTE SWAN. Kodachrome 64, 400mm IF lens, ¹/₅₀₀ sec. at f/5.6

FIRST, FINE-TUNE YOUR CAMERA'S METER

When you are not shooting in bright sunlight, your camera's meter is an invaluable aid. But far too many photographers are slaves to their meters, assuming that the meter will make the *right* decision, or that their expensive, auto-exposure camera will automatically make good exposures.

The first thing to do with any meter is to make sure it is calibrated properly. Calibration is exactly what you do when you buy a car and learn what the gas gauge means. Is the tank really empty when the gauge is on the "E" mark? Probably not. You learn what it means; you calibrate the gauge by experience. You can do the same with your exposure meter.

Calibrate your meter to give a proper reading when pointed at a middle-toned subject. A middle tone is defined as average; neither light nor dark, neither white nor black, but halfway in between. It is the tonality of wheat bread lightly toasted. Technically, a middle-toned subject reflects 18 percent of the light. To meter for this, you can buy a Kodak 18-percent gray card, but luckily in nature there are lots of middle-toned, average subjects that will work just as well. Among them are green grass, most foliage, and dry tree trunks.

Calibrating a meter is easy. You know one correct non-metered exposure, the sunny *f*/16 one. Simply go outside and meter something middle-toned in bright sunlight. The easiest subject to use is the clear north sky on a sunny day. Choose an area about 45 degrees above the horizon in the middle of the day. Use a normal or longer lens, set on the infinity focusing mark.

Let's assume you want to calibrate your meter and you're using Kodachrome 25 film. Proper bright sunlight exposure is 1/30 sec. at *f*/16. Set your camera for this exposure. Then meter the sky, making sure there is no smog or haze, and simply change the ISO setting on the camera's film speed dial until the meter indicates that this setting is correct. It doesn't matter what number you end up with on the dial. After all, they are just reference marks. You know already what the meter should say is the correct exposure; you just have to get the meter to tell you this answer. Whatever number you come up with is now the setting you use whenever you're shooting that film with that meter. On the camera body that I use for Kodachrome 25 film, for exam-

CINNAMON FERNS ON SANDSTONE WALL. Kodachrome 25, 200mm lens, 1/15 sec. at *f*/11

ple, I keep the meter set at ISO 50. And on the body I use for Kodachrome 64, I set the meter at 120. In both cases, this reduces the exposure by one stop. Cameras vary, however. Be sure to test your meter.

This calibration has nothing to do with pushing film or changing development times, you are simply correcting your camera's film speed dial. Once you've set the meter at its correct mark, just go outside and photograph as usual. You can calibrate other meters by comparing them against the first one.

(Above) *Many of nature's subjects are of "average" tonality. Since I have calibrated my camera's meter to obtain a proper reading of a middle tone, I was able simply to point my camera and shoot at the reading that my meter indicated.*

(Opposite page) *By metering the entire scene as a middle tone, the flower, the grass, as well as the droplets of dew were perfectly exposed.*

WILD GERANIUM. Kodachrome 25, 105mm lens, ¼ sec. at f/16

EXPOSURE
COMPENSATING FOR VERY LIGHT AND DARK SUBJECTS

Once you have calibrated your camera's meter to read a middle-tone value, you should have no problem getting a correctly exposed photograph of a middle-toned subject. You just meter the middle-toned area, and shoot at what the meter says. But you don't always shoot middle-toned subjects. How do you meter subjects that are very light or very dark?

When you point the camera at a scene that contains a lot more light or dark tones than usual, the camera will expose it as if it were middle toned. In effect, the camera wants to make every scene it sees the equivalent in tone of a neutral gray. If you shoot as the camera's meter indicates, a predominantly dark scene will be made lighter overall and a pristine white subject like the milkweed seeds (right) will be recorded as dull and grayish. A similar problem occurs when your scene includes the sun, or any other strong light source, such as sparkling reflections on water.

The camera, in its quest for middle tones, grossly underexposes light subjects and overexposes dark ones. Thus, with a light subject you need to open the lens one, two, or even more stops to give the subject more exposure. With dark subjects, you need to stop down a similar amount to give the subject less exposure. In most cases there is an easy way to determine how much to change the exposure, and surprisingly, it is the same for both light and dark subjects. Find an area in the same light as your subject that has mostly middle tones. Take a reading of that area with your camera and then use the settings suggested by that reading to take the picture. Keep in mind those readily available middle-toned subjects you already know like green grass, most foliage, or dry bark.

For the picture of the milkweed seeds, for example, I focused on the milkweed. Then, swinging the camera to the side, I metered the green back-

ground, a middle-toned area in the same diffused light as the milkweed. I was careful not to change focus, since that would change the length of the lens, altering the amount light reaching the camera's meter. Once the meter reading was taken, I brought the milkweed back into the frame, recomposed the scene, and shot, using the settings indicated by the reading. Similarly for the sunset, I swung the camera to the side, eliminating the sun from the frame, and metered an area of the sky that I wanted to be middle toned.

There is really no one correct exposure when you're shooting a sunset because the exposure can be varied depending on the mood you wish to establish. The bright sunlight, however, misleads the camera into underexposing the scene. For the most natural looking results, take a reading of the area of the sky that you wish to be middle-toned in the photograph. Here, I selected a rich orange area (like that in the upper left of the frame) and took a reading of it, excluding the sun from the frame.

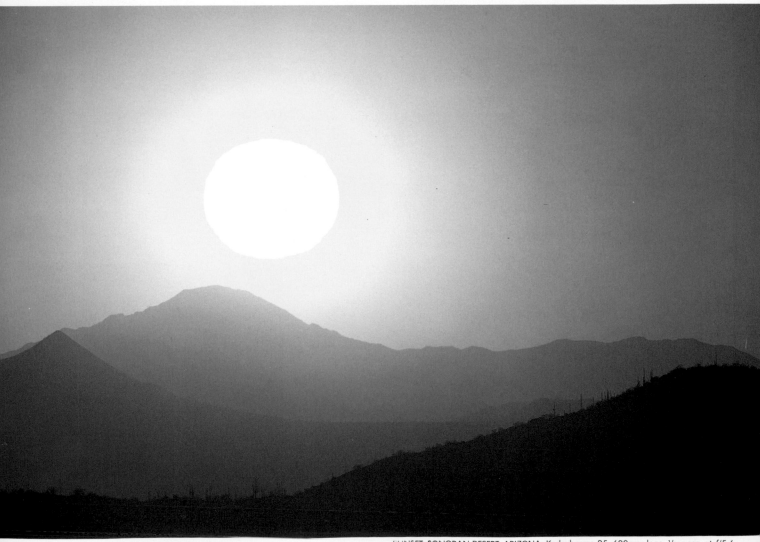

SUNSET, SONORAN DESERT, ARIZONA. Kodachrome 25, 600mm lens, 1/500 sec. at f/5.6

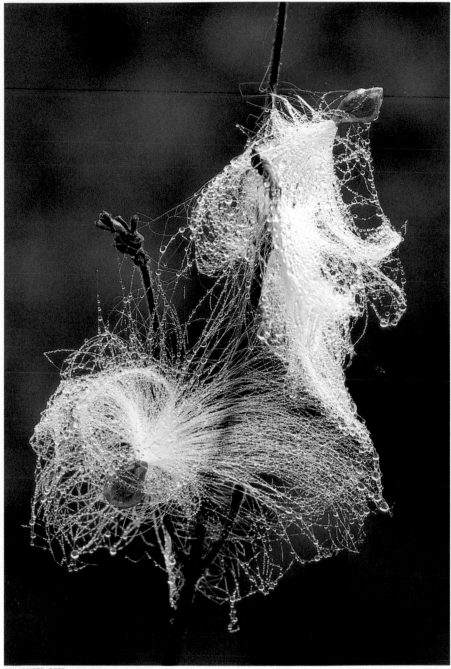

MILKWEED SEED AND DEW. Kodachrome 25, 105mm lens, ½ sec. at ƒ/11

The droplets clinging to the threads of these milkweed seeds have the translucent delicacy of spun glass. Had I metered directly, the brightness of the light they reflect would have fooled the camera's meter into under-exposing them. Instead, I based my exposure on a reading of the middle-toned background.

WHEN THERE IS NO MIDDLE TONE TO READ

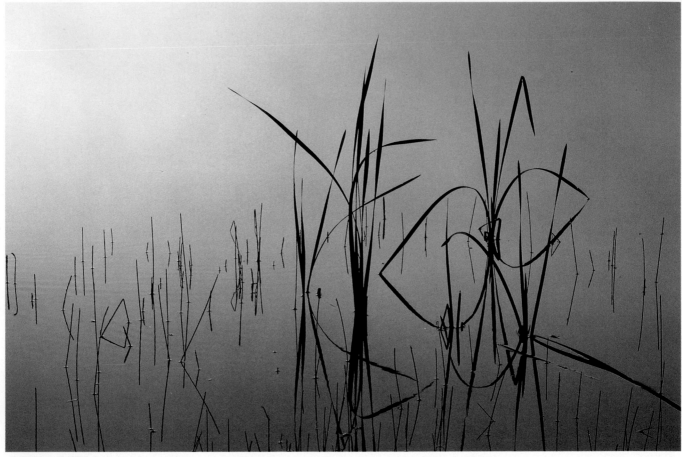

CATTAILS AND REEDS. Kodachrome 25, 105mm lens, ⅛ sec. at f/11

I photographed this scene at sunrise and wanted the water area around the reeds to appear as it actually was—lighter than middle tone. So, I metered for this area and then opened up one stop.

As long as you have a middle-toned area anywhere around you that is in the same light as your subject you will have no problem taking a meter reading. But what do you do when there is no handy middle-toned area?

One solution is to carry a middle-toned area with you in the form of an 18 percent gray card. All you have to do then is meter the card in the same light as your subject. But gray cards, in my estimation, do not work very well outdoors because they have a slight sheen to them and can be too reflective. Find something else that you always have with you. The object does not even have to be middle-toned, as long as you know how many stops off middle-toned it is. One very useful reference is the palm of your hand. With most people,

the skin of the palm is one stop brighter than a middle tone. To check the tonal value of your palm, meter it and a known middle-toned subject like green grass; and compare the two readings. Make sure that both are in the same light, and do not refocus while making the two readings since that would affect exposure values. Now, assume your palm is one stop more reflective than a middle tone. To take a picture, first focus on your subject. Then, without refocusing, meter your palm in the same light as your subject. Using the settings the meter indicates, open up one stop. Why open up? Shouldn't you stop down since your palm is brighter than neutral? If you were to shoot at what the meter says, your palm would

be middle-toned in the final slide. But it is not; it's lighter. To get it back to the correct value, you must add light.

Another way to handle a scene with no middle tones is to decide how you want the tonal values to appear in the final slide. You can meter any part of your subject, and then decide if you want that part to be middle-toned, or lighter or darker. If you want it to appear as a middle tone, shoot at what the meter says. Otherwise, compensate for the meter reading by working in stops. Color slide film has a very limited range, about six stops, from washed-out white to blocked-up black, so in general you will be metering an area and changing the reading by only a stop or two at the most.

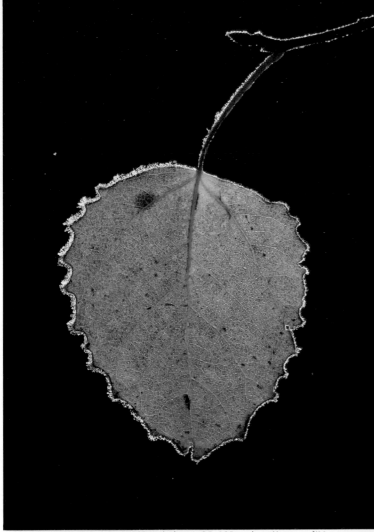

BIGTOOTH ASPEN LEAF WITH FROST. Kodachrome 25, 105mm lens, 1/8 sec. at f/11

Even though I was able to get close enough to the leaf to take my meter reading directly from it, I had to be very careful. Had I included any of the background—deep shadows along the edge of the woods—the meter would have been influenced by the dark area and the leaf would have been greatly overexposed.

Although I used a straight meter reading as the basis for my exposure of the desert cottontail, I had to allow for backlighting and opened up one stop in order to obtain detail in the shadowed side of the rabbit.

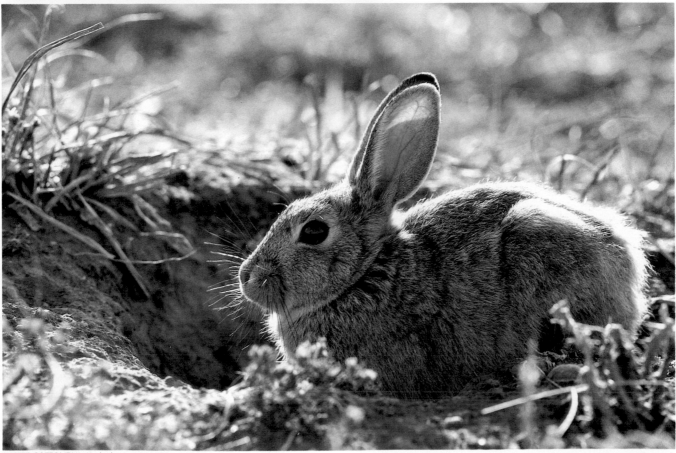

DESERT COTTONTAIL. Kodachrome 64, 400mm IF lens, 1/125 sec. at f/5.6

COPING WITH THE LOW-LIGHT SITUATION

OLD APPLE TREE IN LATE WINTER TWILIGHT. Kodachrome 25, 105mm lens, 30 sec. at $f/4$

When relying on your camera's through-the-lens meter in very dim light and using small f-stops, you will often be unable to get a meter reading. But these times of marginal light—the very edge of light—create very beautiful conditions for photography. Suppose you've found a scene you want to photograph. By studying the composition through the viewfinder you decide you need to use $f/16$ for adequate depth of field. But with the lens set at $f/16$, and the shutter speed all the way down to 1 sec., you cannot get a meter reading. Short of buying a sensitive hand-held light meter what can you do?

The answer is to work in stops. You do not have to meter at the f-stop you plan on using. Instead, meter with the lens fairly wide open and then figure out what the shutter speed would be at your shooting aperture. Let's say that you meter 1 sec. at $f/4$. What is the correct shutter speed for $f/16$? Remember that stops are doubles and halves; for every one f-stop change, shutter speed must double. The progression of changes would be 1 sec. at $f/4$, 2 sec. at $f/5.6$, 4 sec. at $f/8$, 8 sec. at $f/11$, and 16 sec. at $f/16$. In practice, you simply count the shutter speeds off as you change the f-stops on the lens.

If you shoot for 16 sec. at $f/16$, though, you will discover that the final slide will be underexposed. For very long exposures you must be concerned with reciprocity failure; the reciprocal, interchangeable relationship between f-stops and shutter speeds does not hold. In an earlier analogy, I said that exposure was like drawing a gallon of water; one possibility is turning the tap on just a trickle for a long period of time. Well, if time becomes long enough, some of the water evaporates and you must add a little more to get your gallon. Films at long exposure times act the same way. You must add a little light for correct exposure. Since this is a problem that is compounded by an increase in exposure time, it is best to add light by opening up the aperture, not by increasing the shutter speed time. Some films also shift color balance and must be filtered back to their original balance. Exposure and color corrections are given in the accompanying chart. These are the manufacturers' recommendations; be sure to test them. Most of my long exposures are on Kodachrome 25. And I don't believe it shifts color, even though Kodak says it does. I open up ½ stop at 1, 2, or 4 sec., 1 stop at 8 sec., and 1½ stops at 16 sec. Returning to my original example, I would be shooting at 16 sec. at 1½ stops open from $f/16$, halfway between $f/8$ and $f/11$. The color compensating (CC) filters given in the chart are explained in detail on page 44.

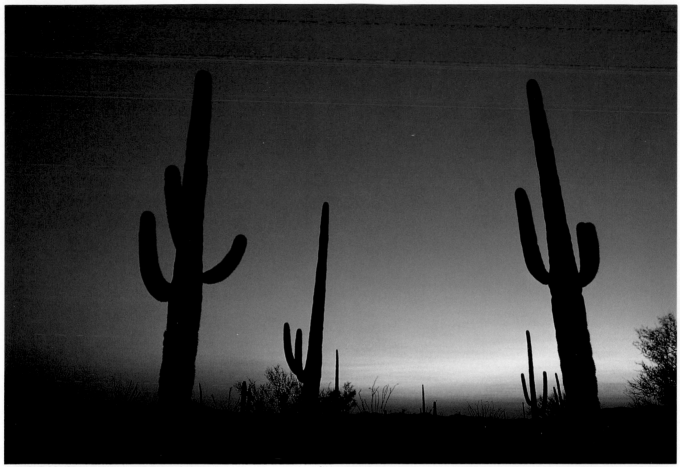

TWILIGHT, SONORAN DESERT, ARIZONA. Kodachrome 25, 24mm lens, 8 sec. at f/11

EXPOSURE AND COLOR COMPENSATION FOR RECIPROCITY FAILURE

	1 sec.	10 sec.	100 sec.
KODACHROME 25	+ 1/2 stop No filter	+ 2 stops CC10B	+ 3 stops CC20B
KODACHROME 64	+ 1/2 stop No filter	Not advised	Not advised
EKTACHROME 64	+ 1 stop CC15B	+ 1 1/2 stops CC20B	Not advised
EKTACHROME 200	+ 1/2 stop CC10R	Not advised	Not advised
EKTACHROME 400	+ 1/2 stop No filter	+ 1 1/2 stops CC10C	+ 2 1/2 stops CC10C
FUJICHROME 50	No change	+ 1/2 stop CC05R	Not advised
FUJICHROME 100	No change	+ 2/3 stop CC05C	+ 1 2/3 stops CC15C
FUJICHROME 400	No change	+ 1 stop CC10C	Not advised
AGFACHROME 64 (CT 18)	No change CC05B	+ 2/3 stop CC10B	Not advised
AGFACHROME 100 (CT 21)	No change CC05B	+ 2/3 stop CC10B	Not advised
AGFACHROME 200	No change CC05Y	+ 1 stop CC10Y	Not advised
KONICA 100 (SAKURA 100)	+ 1/4 stop No filter	+ 1/3 stop CC05G	Not advised
3M 100	+ 2/3 stop No filter	+ 1 1/3 stop No filter	Not advised
FUJICHROME 50	No change	+ 1/2 stop CC05R	Not advised

(Above) *Obtaining the proper exposure for a photograph such as this one isn't as difficult as you might think. Since I wanted the central part of the composition middle-toned, I metered this area for my basic exposure. I knew that I had to use f/11 for enough depth of field to cover the cacti, and then I calculated the corresponding shutter speed, allowing for reciprocity failure.*

(Opposite page) *This photograph was taken so late on a winter's eve that I had to shoot with the lens wide open at f/4. I calculated my exposure based on this aperture and exposed for the last red glow in the sky.*

HOW EXPOSURE CAN CONTROL MOOD

DAWN, ROCKY MOUNTAIN NATIONAL PARK, COLORADO. Kodachrome 25, 300mm IF lens, 1 sec. at f/8

At dawn and dusk, the quality of light is so delicate that it is difficult to trust your camera's meter to expose for the type of photograph that you want. In the half hour or so before the sun rises and after it sets, the light is not only changing rapidly, but it is also very diffuse. This effect is often heightened by atmospheric haze. In such light the scene perceived by the eye is subtle and usually imparts a definite emotional feeling. Sometimes it may seem light and airy, other times it may seem dark and moody. Yet, when you photograph the scene following your camera's meter, the result is often disappointing. The mood the image conveys is just the opposite of what you felt—or, even worse, the image is emotionally flat.

Your problem is matching your exposure to the feeling that you want in the final image. As the sequence of photographs shown here demonstrates, there is no correct exposure for such times of day. Depending on what mood you want to create, all three exposures

work. The center shot was based on the camera's meter, while the other two exposures vary by one stop in either direction. By bracketing in this way you can nearly always ensure that, out of the three, you will have the exposure you really want, even in the most tricky lighting situations.

Overexposing by one stop (above) lightens the tone in the final transparency, accentuating the delicate, misty atmosphere. Underexposing by one stop (opposite, bottom) darkens the scene, silhouetting parts of it and giving it a more somber feeling. Often the least satisfactory shot is the one taken at the exposure recommended by the meter, with all of the tones averaged out to a medium gray.

At twilight and dawn, color is not always the most important consideration. The hues of the landscape are faint and subtle, and the scene is frequently almost monochromatic. Varying exposure plays with the mood.

Here are three photographs that clearly indicate how effectively exposure can be used to control the mood of a scene. In the photograph reproduced above, the scene was overexposed from the metered exposure by one stop, giving the image a delicate, ethereal quality and emphasizing the misty morning atmosphere. In the second photograph (opposite, top), which was taken at the exposure indicated by the meter, the scene is slightly darker and the atmospheric moisture is not as noticeable. In fact, the effect is more neutral in feeling; the photograph could have been taken at dawn or dusk. In the third photograph, a one-stop underexposure deepened the tones of the scene considerably—even the sky is darker. Consequently, the image takes on a much more somber quality.

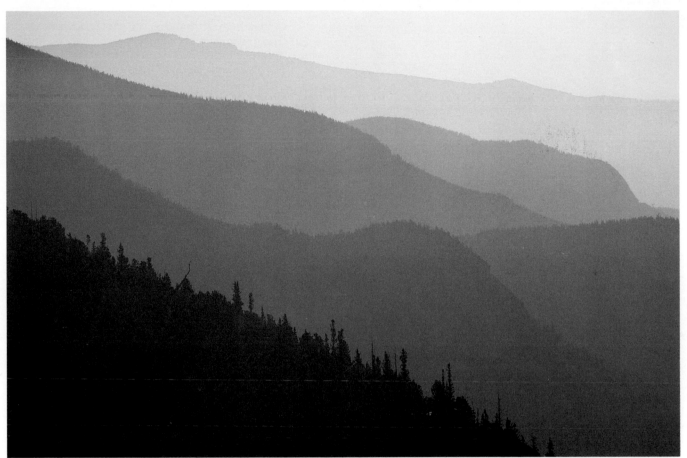

DAWN, ROCKY MOUNTAIN NATIONAL PARK, COLORADO. Kodachrome 25, 300mm IF lens, ¹/₂ sec. at *f*/8

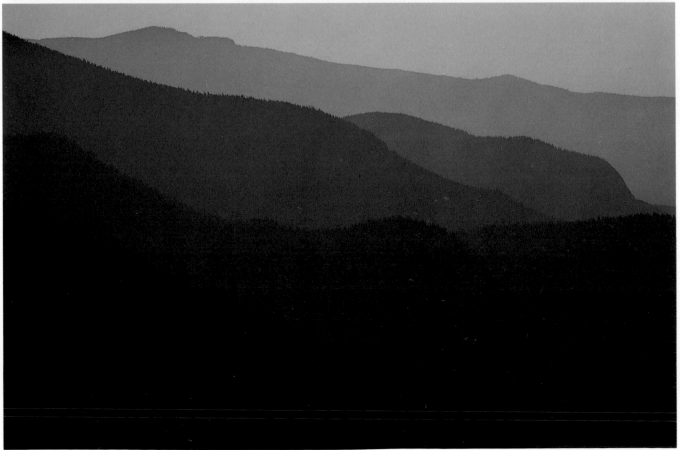

DAWN, ROCKY MOUNTAIN NATIONAL PARK, COLORADO. Kodachrome 25, 300mm IF lens, ¹/₄ sec. at *f*/8

EQUIPMENT

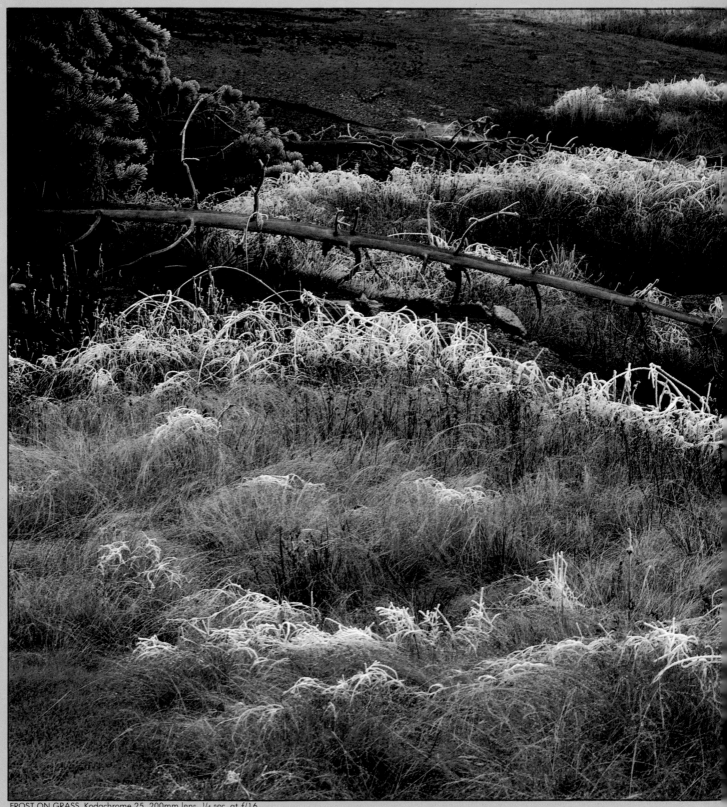

FROST ON GRASS. Kodachrome 25, 200mm lens, ¼ sec. at *f*/16

What may appear to be a relatively easy subject to photograph may not be! The grass here was growing in an area where it was very difficult for me to work because a number of small springs made the ground soft and the footing unsure. By working with a tripod and using the depth-of-field preview button, I was nonetheless able to compose the picture carefully.

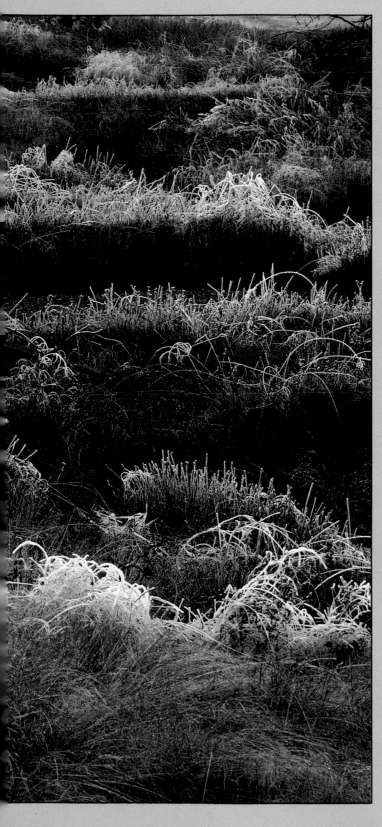

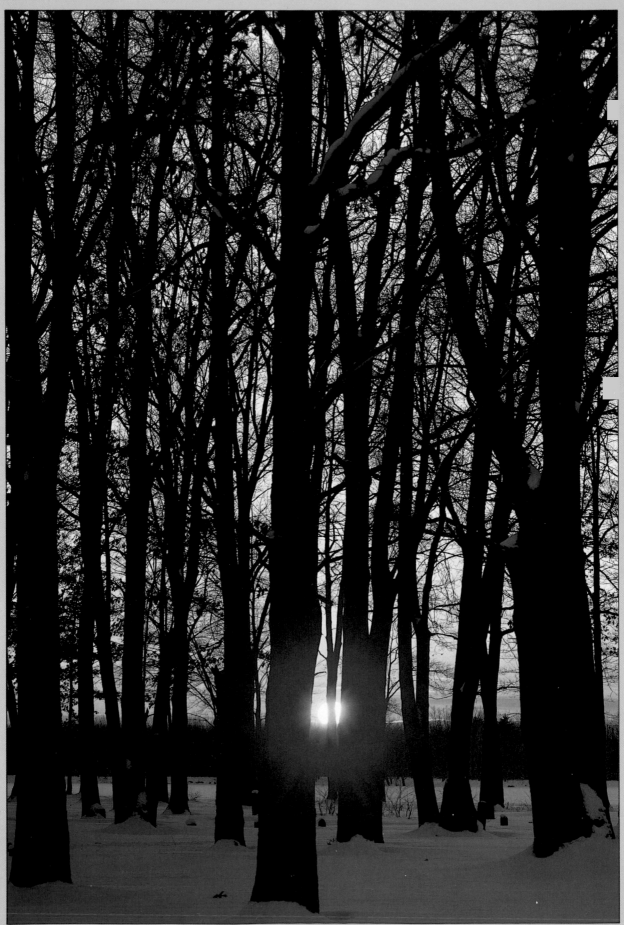

WINTER SUNSET. Kodachrome 25, 105mm lens, ¹/₈ sec. at *f*/11

BASIC FIELD OUTFITS

Beginning photographers who do not yet own much camera equipment always ask the same question: "What equipment should I purchase next?" There are two questions I must ask of you before I attempt to answer your question. First, what subjects do you want to photograph? Subject matter definitely influences equipment choice. Do you want to photograph little birds at the nest? If so, your camera equipment will be different from someone who is primarily interested in photographing flowers or scenics. Second, how much money do you want to spend? I fully understand the financial problems you may have; photography is without question an expensive hobby. However, you cannot do the job without the right tools, and cameras and lenses are only the tools of the trade. Buy the best equipment that you can afford. If your budget forces a choice between a fancier camera body or a better lens, by all means purchase the lens.

All equipment should be evaluated in terms of convenience and quality. A 100mm macro lens is more convenient for close-ups than a 100mm normal lens with extension tubes. How many close-ups are you going to take? Is this extra convenience worth the difference in price? Will you still need a set of extension tubes to use on other lenses?

You can produce top-quality nature photographs with any 35mm single-lens reflex (SLR) camera from a major manufacturer. For field work, of course, you want to be sure to buy a camera that is rugged and reliable. In addition to that basic requirement, there are some features that I consider a necessity for field work.

Manual exposure control or complete automatic exposure override. After all, you want to control how the picture looks. Samples of processed film suggest a statistical exposure accuracy of around 80 percent for automatic cameras. But why restrict yourself to this? The more control you have, the better.

Depth-of-field preview. This permits you to stop the lens down manually to preview the depth of field you will get at

If I had not been completely familiar with my equipment I could not have taken this photograph. I admired this sunset from my car late one January day. I stopped, grabbed my camera gear, and had enough time to expose three frames before the sun disappeared. I worked quickly because I didn't have to take much time to think.

shooting aperture. Remember that normally you're viewing through the lens wide open. Unless you're also shooting wide open you will end up with pictures that look very different.

Full range of lenses available. Right now you may not imagine needing a 300mm *f*/2.8 lens. But should the need arise, better to have a camera system in which such a lens is manufactured. I want a system with a longer than normal macro lens (at least a 100mm or 105mm macro) and some options in longer focal lengths. Do you have a choice in lens speed and features in a 300mm, 400mm, or longer lens?

Complete range of shutter speeds. Almost all cameras presently manufactured offer speeds at least from 1 to $1/1000$ sec. I don't think you need anything faster than $1/1000$ sec. but you will definitely use the slow speeds. At least one current camera has no speed slower than $1/8$ sec. For field work, that camera is not the one to buy. Given a choice, it would be nice to have slow speeds down to 8 seconds, but you can easily count "one-thousand-and-one,"

Interchangeable finder screens. Most cameras come with some sort of split-image rangefinder screen. When used with smaller apertures, as with long lenses or in close-up work, these screens don't work well at all. Replace the standard screen with a clear matt screen.

I would also suggest buying your manufacturer's own lenses unless you have a very specific reason—one that you can articulate—not to. Within the same brand all lenses operate in the same direction; focusing mounts all turn the same way, and *f*-stops get smaller in the same direction. This may make the difference in whether or not you get a picture when you're working fast. Lenses of the same brand also have the same color cast. Two frames done with two different lenses will both have the same color rendition. This is important if you're shooting a complete coverage of one subject. And as a side benefit most lenses within one brand will all take the same filter size.

Regardless of what you want to photograph, I would also urge you to make a top-quality tripod one of your early purchases. Eventually, if you are serious about photography and continue

with it, you will end up purchasing one. Why not start off with it? A cheap tripod will cost you about $40; double this amount and you can own the small Bogen tripod that I recommend on the next page.

You probably started out with a camera body and a 50mm lens. Now what? Decide on your primary subject matter and you can narrow down focal length choices. The list shown below gives my very opinionated choices for basic minimum outfits. These are simply suggestions, nothing more.

One piece of equipment you won't find described in this section is an electronic flash. Other than for close-ups (page 108), I rarely use flash in the field. There is, however, a section later in the book describing how to work with a flash (page 136).

Basic close-up system:
camera and 50mm lens
tripod
cable release
short telephoto lens
 100mm–135mm
extension tubes
reflectors

to be added as you grow:
clear matt focusing screen (if
 available)
200mm lens
81B warming filter
small flash unit
second camera body
rack-and-pinion focusing device

Basic bird and mammal outfit:
camera and 50mm lens
tripod
cable release
300mm lens
clear matt focusing screen (if
 available)

to be added as you grow:
monopod
motor drive
at least one extension tube
longer lens: 400mm–500mm
100mm lens
200mm lens
second camera body
hand meter

All-around outfit:
focal lengths in rough doubles:
 24mm, 50mm, 100mm, 200mm,
 etc.
at least two camera bodies
tripod
motor drive
extension tubes
small flash
81B warming filter
polarizing filter
hand meter

THE CRUCIAL ACCESSORY: A TRIPOD

If you want to improve the quality of your photographs the best single accessory you can buy is a sturdy, well-made tripod. Every working professional nature photographer shoots every exposure possible with his or her camera mounted on a tripod. Some photographers are proud of their ability to hand-hold long exposures, bragging that they can shoot at $1/8$ sec. with a 105mm lens and get sharp results. I cannot do this. I don't think they can either.

The only way to determine the sharpness of transparencies is to examine them critically on a lightbox with a top quality magnifier (see pages 138–139). This is what magazine and book editors do to every slide. You cannot tell whether slides are sharp or not from projecting them. The quality of a projected image depends on how good the projector lens is, and most are not camera quality.

It's not that unsharp photographs are bad. At times a soft focus picture may be exactly what you want. It's a question of control: Can you get a razor-sharp image whenever you want?

An old rule of thumb applies to holding a camera by hand. For acceptable pictures, never try to hand-hold at a shutter speed slower than the focal length of the lens being used. For example, the slowest speed to safely hand hold a 50mm lens at is $1/60$ sec. For a 135mm the slowest speed is $1/125$ sec., and so on. You can see that hand holding restricts you to working in bright light, using short lenses, using high-speed film, or accepting fuzzy pictures. The solution is simple—use a tripod.

Many photographers overlook the importance of the tripod head and how it can influence their work. For doing carefully studied scenics or precise close-up work, I prefer over all else a pan-tilt head where the movements along the horizontal and vertical axes are totally independent. Trying to recompose a few degrees vertically, without moving at all horizontally or flopping to the side, is impossible except with a solid pan-tilt head. Be sure to mount the head correctly. With a good head you should not ever have to loosen the camera screw to recompose. Almost all pan-tilt heads are made so that one control handle comes toward you and the other is to your right. The camera will flop to the left for a vertical, and you can still tilt it downwards. If you're loosening the camera to tilt it, something is wrong.

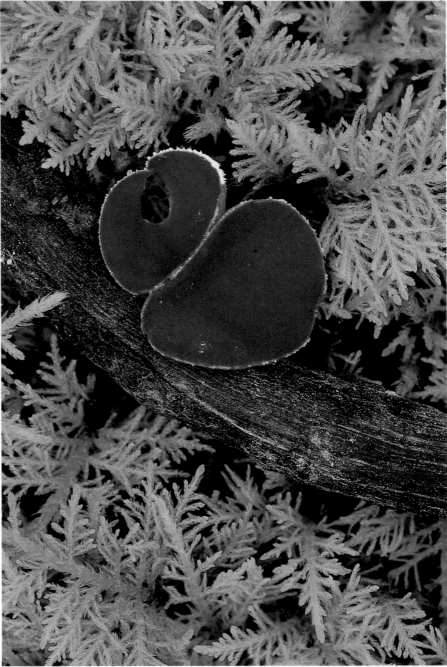

RED CUP FUNGI ON MOSS. Kodachrome 25, 105mm lens, $1/2$ sec. at $f/11$

Large ball-and-socket heads are good for action shots since there are fewer controls to adjust. Usually, if you're shooting larger animate creatures, precise framing is not as critical as the need for maneuverability. Be warned, however, most ball-and-socket heads are far too small to support a camera outfitted with long lens and autowinder.

My suggestions for good-quality, solid equipment are given below. They take into consideration the problems with low-level subject discussed on page 36.

Gitzo 320 tripod: my standard tripod.

Gitzo 224 tripod: a little lighter in weight; my backpacking tripod.

Bogen 3029 or 3047 tripod heads: pan-tilt heads; basically the same, the 3047 has a quick-release system.

Bogen 3024 tripod: good alternative, less expensive (3020 tripod complete with 3029 head).

Slik Pro-Ball tripod head: ball-and-socket head, the smallest I would suggest.

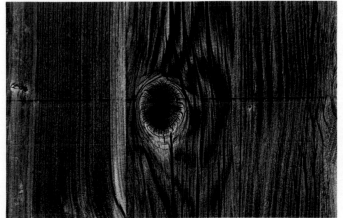

BARNWOOD *(Handheld).* Kodachrome 25, 55mm lens, $1/30$ sec. at $f/5.6$

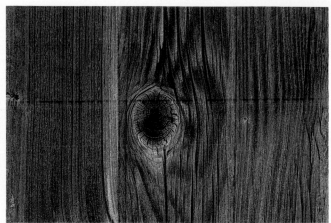

BARNWOOD *(With tripod).* Kodachrome 25, 55mm lens, $1/30$ sec. at $f/5.6$

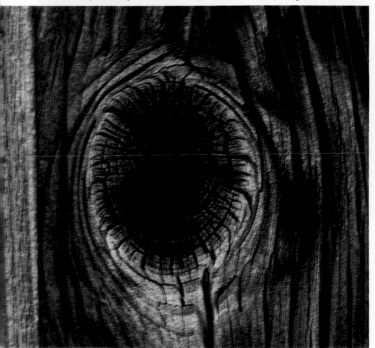

BARNWOOD *(Detail of handheld photograph)*

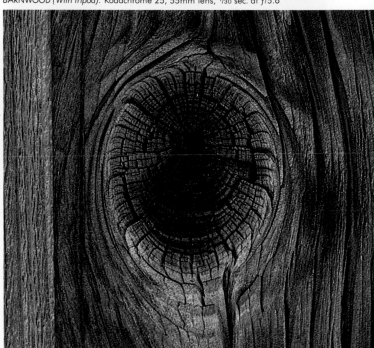

BARNWOOD *(Detail of photograph with tripod)*

(Above) To illustrate the difference that a tripod can make, the closeup of a piece of barnwood was taken first with a hand-held camera, then with a tripod. A 50mm lens was used at one shutter speed slower than its focal length, or $1/30$ sec. Even though I braced myself as much as possible, the resulting photograph is not as sharp as the tripod version.

(Opposite page) This photograph illustrates the kind of quality that can be achieved only with the use of a tripod. The light level for the scene was so low that I could not have hand-held my camera while using a fine-grained film to show all the detail in the moss.

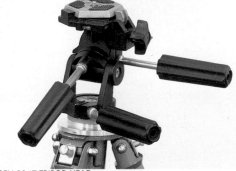

BOGEN 3047 TRIPOD HEAD

SLIK PRO-BALL TRIPOD HEAD

At left is the Slik Pro-Ball tripod head, probably about the smallest that you should use. Above is the Bogen 3047 tripod head, which features a quick-release system.

SUPPORTING THE CAMERA AT GROUND LEVEL

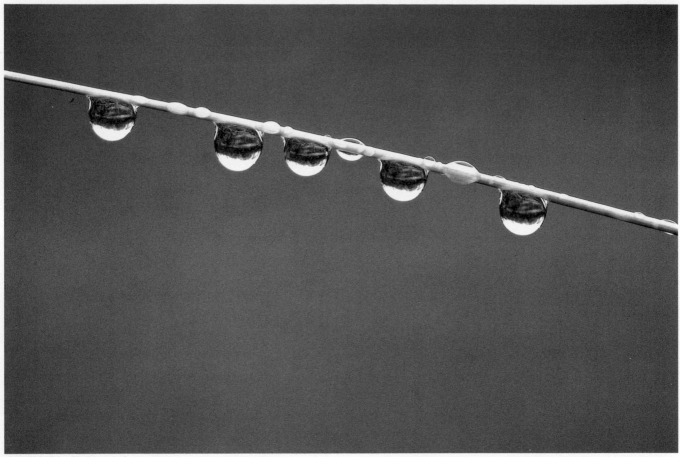

RAINDROPS ON GRASS. Kodachrome 25, 200mm lens, 1/2 sec. at f/8

A tripod is an absolute necessity for quality photography. And for normal subjects there are many tripods that work well. However, almost all tripods are designed for use at eye level, while in nature field work there are many subjects at or near ground level. Every bit of photographic advice I've read says that for low-level work the tripod centerpost should be removed, inverted, and replaced back into the tripod. This means that the camera is hanging down between the legs of the tripod and you are working with the camera upside down. How do you get your head and shoulders in between the tripod legs to look through the viewfinder? The odds are that the lens will be pointing at one of the legs, since your body is occupying one of the open sides.

Another suggestion for low-level work is to use a ground spike with a small ball-and-socket head, or a small tabletop tripod. The problem is that you must then carry these, plus a regular tripod for normal photography. And these low devices do not work that well. They will not hold much weight. And how do you put in a ground spike if you're working on rock or sand?

The real solution is to use a tripod that is designed to permit you to work with the camera upright under *all* conditions. There are several tripod lines available that have legs which will spread out flat to the ground. Gitzo tripods such as those recommended previously, are the best known and, in my opinion, the best made of these.

Most Gitzos come with a long centerpost that totally defeats the provision they make for low-level shooting. Even for normal photography you don't need a long centerpost. You want to use the least amount of centerpost you can. After all, if you extend a centerpost 20 inches, you no longer have a tripod but rather a monopod with a three-legged base, and it won't be as steady. Buy a tripod that goes to your eye level without any centerpost extension at all.

To solve the problem with Gitzo tripods, either purchase the short post they offer, or take a hacksaw or tubing cutter and shorten the long post to about 6 inches, which is all the centerpost you'll ever need. Now you have a tripod that will perform in almost any situation.

Without a tripod it would have been impossible to photograph the raindrops clinging perilously to a stem of dried grass. To maintain a safe, workable distance—so that I would not disturb the surrounding grass and cause the raindrops to fall—I used a 200mm lens on a well-extended bellows.

(Opposite page) This colorful, but poisonous mushroom is often found hidden on the forest floors of the northern Midwest. Because of the lighting conditions, I would never have been able to photograph it without the aid of a low-level tripod.

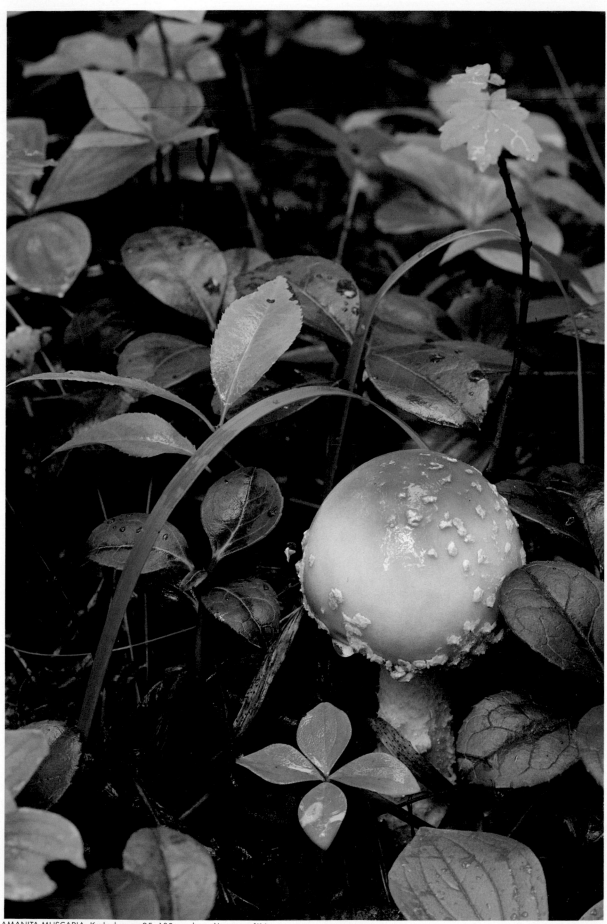

AMANITA MUSCARIA. Kodachrome 25, 105mm lens, $^1/_4$ sec. at f/11

PORTABLE CAMERA SUPPORT FOR THE MOVING SUBJECT

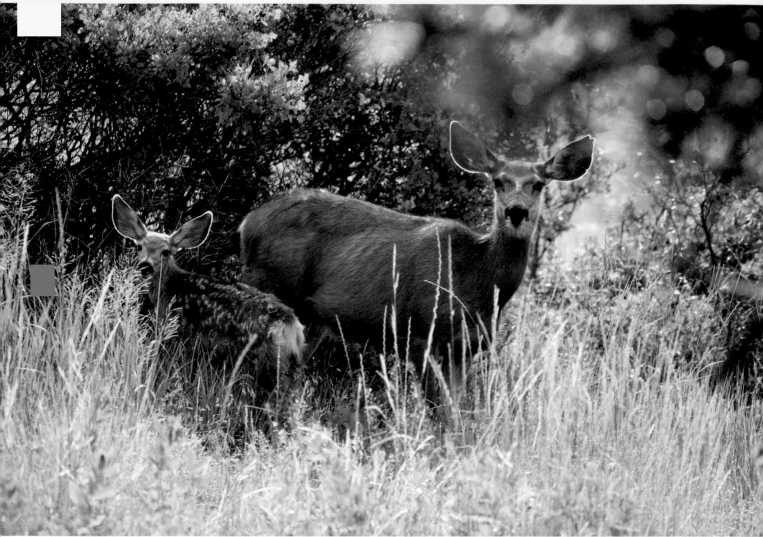

MULE DEER WITH FAWN. Kodachrome 64, 300mm IF lens, ¹/250 sec. at f/5.6

USING A SHOULDER STOCK

(Above) I made the shoulder stock shown in the photograph above, since I've never found a commercially made one that I like. You can see how it can enable you to brace your camera with just enough additional support.

(Top) I used a monopod to stalk this deer and her fawn as they moved through a hillside field. I didn't attempt to freeze their movements, but, rather, I waited until they stopped and then I took my photographs.

When you're working in rough terrain, trying to follow a moving animal, a tripod is slow to set up; and, in really uneven terrain, every time you move with an animal, you have to adjust the tripod legs again. It is also very difficult to use a tripod for flight shots of birds. Yet you don't want to hand hold the lenses that you're using, 300mm and up, since you know that would yield pictures with unacceptable sharpness.

So long as you have good light, a monopod is the ideal answer. A monopod is simply one tripod leg. While you can buy ready-made monopods, I scavenged mine from an old tripod by adding a threaded mount to the end of one leg.

Some photographers use a head on top of the monopod, but I prefer not to do so, since it's just one more thing to adjust. Instead, I use a lens with a rotating tripod collar, so that the lens itself can rotate for vertical or horizontal format, and then I just lean into position. This makes a fast-handling, light-weight system, ideal for stalking. I prefer to shoot at as fast a shutter speed as possible. With a 300mm lens I try to always use ¹/250 sec. or ¹/500 sec., although I've gone as slow as ¹/60 sec. with acceptable results.

For photographing birds in flight, especially when they're moving across your field of view, a shoulder stock is

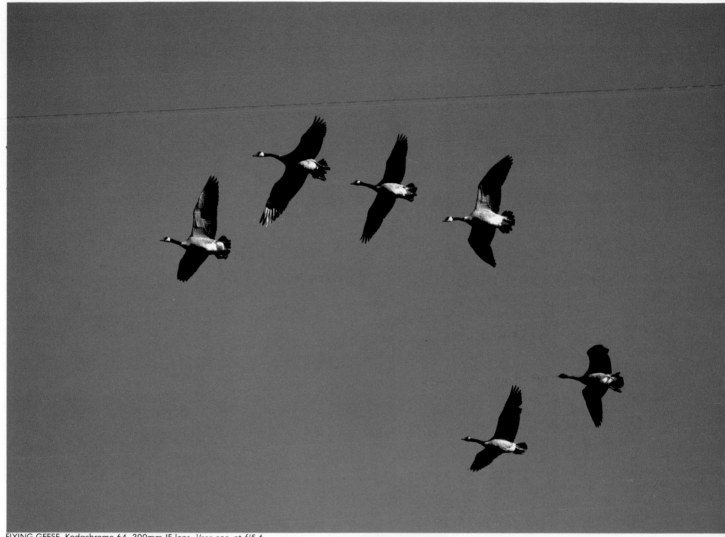

FLYING GEESE. Kodachrome 64, 300mm IF lens, 1/500 sec. at *f*/5.6

very helpful. It's quick, and gives just that much added support over hand holding a camera and lens. Personally I have never seen a commercially made shoulder stock that I like. Most are either too flimsy or too bulky. I made mine from a ¼ × 1-inch aluminum strap, bent and bolted into shape. Even more than with a monopod, you need good light to shoot with the less firmly planted shoulder stock. My favorite lens to use with a stock is a 300mm *f*/4.5 internal-focusing (page 70) lens, which is lightweight, compact, and fast handling. To stop birds in flight you need a shutter speed of at least 1/250 sec., and if they are close to you, 1/500 sec.

A shoulder stock is very helpful in tracking the flight of birds. I used a 300mm lens, which enabled me to zero in on the geese. I knew that my basic exposure for bright sunlight was 1/60 sec. at f/16, but I needed a faster shutter speed to stop the motion of both the geese and the photographer!

CHOOSING FILM FOR SHARP, GRAIN-FREE IMAGES

If you have taken the trouble to buy good equipment and to use good techniques when photographing, then you should also use good film. Shoot the slowest speed slide film that you can use given the existing lighting conditions. The slower the speed, the sharper, more grain-free the film. I recommend using slide film for many reasons. Slide film is capable of producing sharper images with more saturated colors than print film. Slides can be made into prints if you want them far easier and better than print film can be made into slides. The results you get with slides are readily apparent. You can instantly see your mistakes and your successes. I cannot tell much of anything by looking at a color negative, but I need only a glance at a slide to check exposure, color balance, and other factors. With a bad print, you don't know if it is the result of something you did or something the printer did. Slide film is much less expensive to use. Film wastage is to be expected, especially when shooting animate subjects. Edit your slides by looking at them through a 7× or 8× loupe on a light box, and edit ruthlessly. If you plan on ever submitting photographs for publication, magazine and book publishers work almost exclusively from transparencies. And slides on slow-speed film are the only thing that will be accepted by stock photo houses.

I conducted an informal survey of 20 of the top wildlife photographers in the United States and Canada. In total, they said that over 95 percent of their work was done on ISO 64 slide film. The second most used film among them was ISO 25 slide film. Kodachrome was the most widely used brand.

Pick one film and stick with it. Learn its characteristics, so that you have even more control over the image-making process. Choose a film that is widely available. What happens if you're in an out-of-the-way spot and run out of film? Can you buy more locally? Choose a film that is available fresh and is not likely to have been sitting on a dealer's shelves for months on end.

In the field, I also suggest you code your film. I mark the plastic canisters with a round stick-on label, red for Kodachrome 64, white for Kodachrome 25. I place the label on the side of the canister and when the roll is shot I pull it off and stick it back on the top. At a glance I can tell the type of film and if it's been exposed or not.

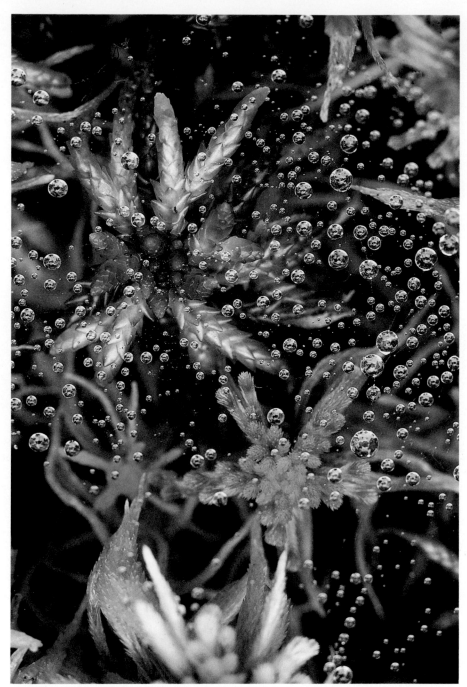

SHEET WEB OVER SPHAGNUM MOSS. Kodachrome 25, 105mm lens, 1 sec. at ƒ/11

The extremely fine grain of Kodachrome 25 is shown to its best advantage in the photograph above. The detail of the delicate sheet web and the drops of dew would have been lost had I used a faster film.

RED MUSHROOMS.
Kodachrome 25, 105mm lens, ½ sec. at f/16

Even when a small detail of a 35mm transparency is blown up, you can still see the quality that Kodachrome will give you. Notice how the detail of the dimly lit mushroom stems is still present and the colors are still true in the large detail shown at right.

RED MUSHROOMS *(Detail of Kodachrome)*

RED MUSHROOMS.
Ektachrome 200, 105mm lens, ¹/₁₅ sec. at f/16

If you compare the same subject taken on Ektachrome film, the difference in grain is very apparent. The subtle highlights and intricate detail that is present in the Kodachrome frame does not appear on Ektachrome.

RED MUSHROOMS *(Detail of Ektachrome)*

THE TWO FILTERS TO ALWAYS CARRY

You're using a good film that you are familiar with and you know it gives you good color rendition, yet some of your photographs seem a little dull. The colors are just not as vibrant as you remember in the actual situation. Some of the photos you made on overcast days seem too muted, or shots taken in bright sun just don't exhibit the deep, saturated color you saw.

At times, you may wish to use filters to enhance your photography. Some photographers seem to always use filters; I do not, far preferring to let the natural atmospherics be my filters. But there are certain conditions where I would recommend adding a filter to make a scene look more true to the eye. I find two filters especially useful; they are the only two that I consistently carry.

The light on overcast days tend to be bluish and cool. You can overcome this coolness by adding warmth to the scene with an amber-tinted filter in the 81 series—either an 81B, which I use, or the slightly stronger 81C. Given a choice most people prefer a warm photograph over a cool one. This is especially true if the subject has warm colors: reds, oranges, and yellows. Shooting autumn foliage, for example, I would use a warming filter to make the colors really stand out. But don't overdo it; some scenes should be cool: frost, snow, and twilight blues are good examples.

The other filter I would urge you to buy is a polarizer. Polarizers saturate colors by removing the reflected highlights on surfaces. And by removing the reflections on haze and other particles, polarizers can darken the blue sky. They often help when you are shooting foliage or grasses since there is a surprising amount of glare from these surfaces. A polarizer's effect varies with your angle to the sun; the strongest effect occurs when you point your camera at a right angle to the sun. You also can control the degree of polarization: just mount the filter, look through the lens, and rotate the filter until you get the desired effect.

Polarizers cut the light reaching the film between one stop (no apparent visual effect) and two stops (full polarization). If you're basing your exposures on the sunny f/16 rule or using a hand meter, remember to allow for this.

When you buy a polarizer, make sure it will work on your widest lens. Some off-brand polarizers are so physically thick they will vignette the corners of the frame. Check this by mounting the filter on the lens and looking at a light source with the lens manually stopped down all the way.

A polarizing filter is an essential piece of equipment, and here's the proof: compare the photograph at left, which was taken without a polarizer, to the photograph at right, which was taken with a polarizer. The difference? In the second photo, the color rendition of the sky is much improved, the clouds take on more prominence, and the reflections in the lake are better defined.

LAKE (Without polarizer).
Kodachrome 25, 55mm lens, 1/30 sec. at f/16

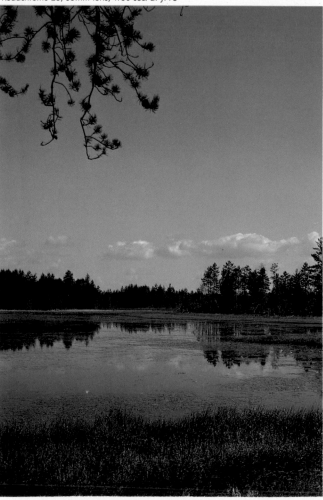

LAKE (With polarizer).
Kodachrome 25, 55mm lens, 1/15 sec. at f/11

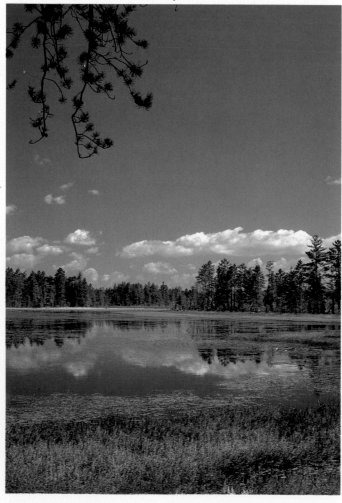

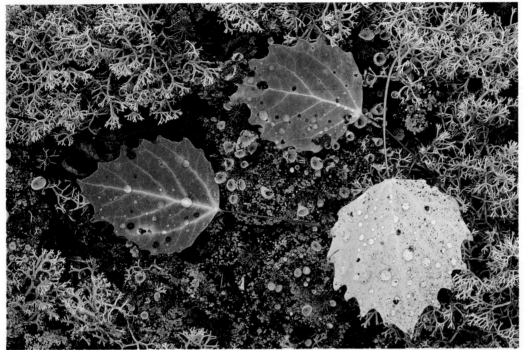

AUTUMN LEAVES (With warming filter). Kodachrome 25, 105mm lens, 1/60 sec. at *f*/8

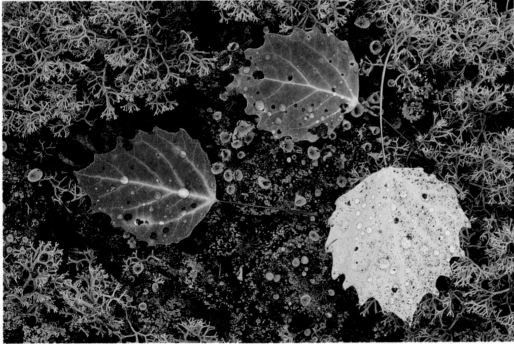

AUTUMN LEAVES (Without warming filter). Kodachrome 25, 105mm lens, 1/60 sec. at *f*/8

A warming filter can make a subtle difference in your photographs. The top photograph was taken with an 81B warming filter; the bottom photograph, without a filter. Not only are the autumn colors of the leaves more exciting, without looking artificial, but the first photograph is simply much more pleasing to the eye.

CC FILTERS FOR SUBTLE COLOR ADJUSTMENTS

I never use the so-called special effects filters. Nature is special enough all by itself without adding tinsel. On extremely rare occasions, however, I do use filters other than an 81 series warming filter and the polarizer recommended on the preceding page. In these situations, I turn to the color compensating (CC) gelatin filters.

CC filters are available from Kodak and other suppliers in a variety of strengths in the six primary and complementary colors: magenta, yellow, cyan, red, green, and blue. I use the very weak 10CC strength, which adds just a hint of color. I use these filters basically for two subjects: flowers and jungles. Some pale pastels, especially the faint pinks and yellows of many flowers, photograph too pale, becoming washed-out, almost whites. With a weak 10CC filter I can add the slightest hint of color to punch up the subject just a little and get a result that looks more natural to the eye. In the tropics the impression of a rain forest is warm, lush green vegetation. But photographs with no filter often appear to be cool and bluish because of all the moisture in the air. The solution is to stack two filters (and stacking gels is optically superior to any other way of using two filters). Use an 81B gel for warmth, and a 10CC green to emphasize the lushness, and your rainforest pictures will look like your experience of the tropics.

Gelatins are fragile 3-inch squares, so to mount them on a lens a gel filter holder is needed. The best holders are hinged frames that thread directly into the lens. The Nikon gel holder is a good metal one that will fit any lens with a 52mm accessory thread. The front side of the Nikon holder has a 60mm diameter thread for a lens hood but there's only one 60mm hood on the market, made by Nikon, and it's rather expensive. Kalt makes a plastic version of the Nikon holder that you can obtain in well-stocked photo stores. It comes in a variety of screw-in sizes (49mm, 52mm, 55mm, and 58mm) and has a front thread of 62mm, a standard size, allowing you to use an inexpensive rubber lens hood. When used with short lenses the shade can be collapsed or removed, while with long lenses it can be extended.

Carrying gelatins in the field is tricky. I find you can carry them in the little manila envelopes they come in, but it's better to make a filter book. Pick up a small, easy-to-carry snapshot album for 126 Instamatic-sized prints, 3½ × 3½-inches. Leave each filter in its tissue and just slide each under the acetate as you would a print. These little snapshot books hold about 20 or 24 filters, if you want to go that far, without doubling up any. You can label filters and add information by using self-adhesive labels.

Here, I used what I refer to as my "jungle filtration," an 81B gel plus a 10cc green gel to counterbalance the moisture in the jungle air and thereby got the colors as I truly saw them.

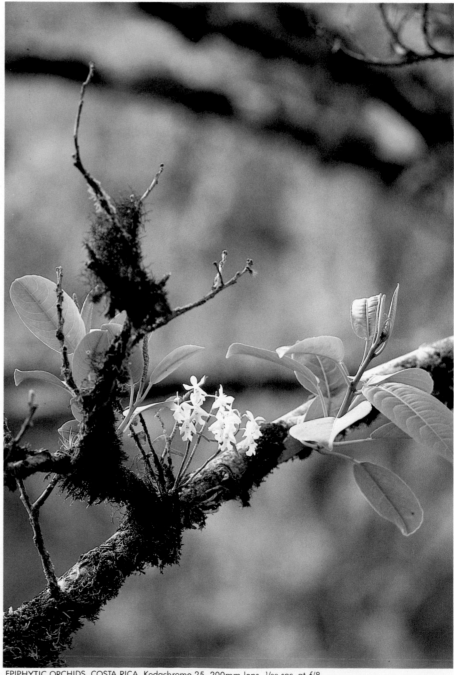

EPIPHYTIC ORCHIDS, COSTA RICA. Kodachrome 25, 200mm lens, 1/30 sec. at f/8

CYPRESS KNEES DURING RAIN. Kodachrome 25, 105mm lens, 1/8 sec. at f/8

Often the moisture in the air will cause lush vegetation to photograph a cool, bluish tone, rather than a warm green. The combination of an 81B gel and a 10CC green gel helps the foliage retain its natural green color.

NIKON GEL FILTER HOLDER.

The gel filter holder above is shown open, ready for insertion of one or more filters.

Again, to capture the natural quality of this rain forest, I used the 81B and 10CC green gel combination. The 81B adds warmth to the scene, and the 10CC green gel emphasizes the lushness of the vegetation.

RAIN FOREST, COSTA RICA.
Kodachrome 25, 55mm lens, 1/30 sec. at f/8

WORKING WITH A HAND-HELD LIGHT METER

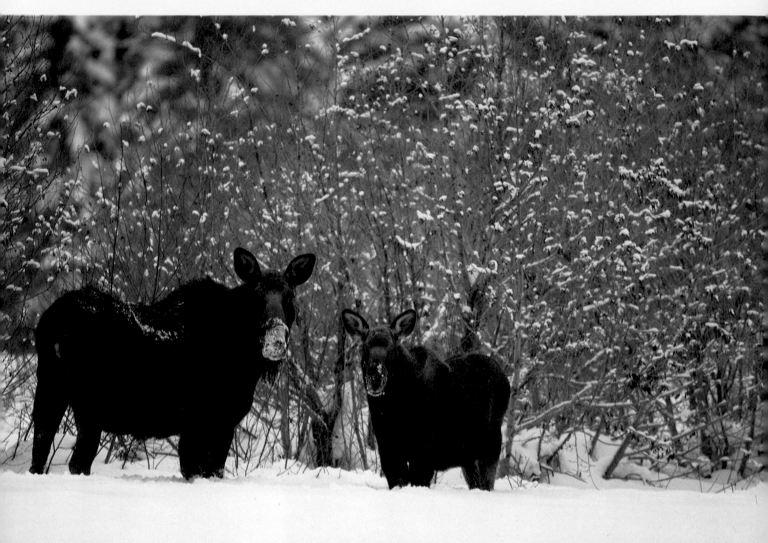

MOOSE AND CALF IN SNOWSTORM. Kodachrome 64, 400mm IF lens, 1/15 sec. at f/3.5

Since this photograph was taken during a snow storm very late in the day, the light was very low and there was no middle-toned subject from which I could take a reading. I wanted detail in the dark images of the moose, yet I could not overexpose the white snow too much. An incident reading gave me the starting point for my exposure.

In some situations, I prefer to use a hand-held meter instead of my camera's built-in through-the-lens meter. Hand meters are of two kinds: reflected light meters and incident light meters. Reflected light meters read the light reflected from the subject when you point the meter at the subject. This is just like your camera's meter, which is also a reflected light meter. An incident light meter measures the light falling on the subject. You put the meter in the same light as the subject. Many meters combine both types into one meter. I don't feel the need to carry a hand meter for reflected light readings because the TTL meters on today's cameras are very sensitive. Some camera models will read down to 8 sec. at f/32 with ISO 25 film.

Spot meters are narrow-angle reflected light meters, usually reading an angle of view of just a few degrees. As with all reflected light meters, you must either meter something middle-toned or interpret the values the meter indicates as explained in the sections on metering. I am not particularly interested in having a narrow angle for my work. If I need a spot reading, I can achieve about the same results by putting a long lens on my camera. Most of the newer cameras are very heavily center-weighted in their metering patterns, some models having 80 percent of their reading in the center of the frame. By adding a 200mm or longer lens, I have an extremely narrow angle meter. Some cameras can take spot readings without switching lenses.

My preference for a hand meter is an incident light reading one. Since this type of meter measures the light falling on the subject, you generally do not have to worry about the reflectance of the subject. You simply point the meter

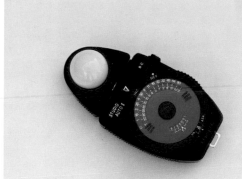

SEKONIC L-448 HAND METER

The Sekonic hand meter shown above is the one that I normally use. It gives an extremely sensitive incident light reading, and I can operate it with one hand, which makes this a very convenient meter for use in the field.

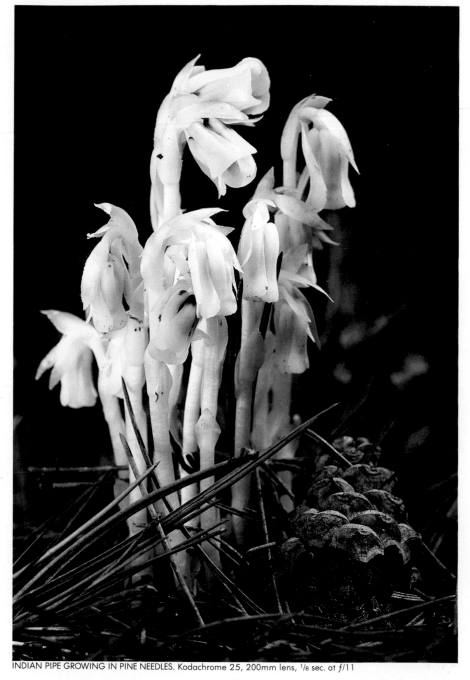

INDIAN PIPE GROWING IN PINE NEEDLES. Kodachrome 25, 200mm lens, 1/8 sec. at f/11

There I was with very contrasty lighting and a white subject, and no middle-toned area to read in the same light as the subject. So, I used a hand-meter incident reading of the shaft of light illuminating the Indian Pipe, and then compensated for the extension.

toward the camera position, making sure the meter is in the same light as your subject. I mostly take incident readings when I'm working in a high contrast situation, or when there is no medium-toned object nearby to meter. I can quickly take an incident reading, then adjust my shooting exposure if necessary. Remember that you must allow for light loss to extension if you're doing close-ups (page 102).

Carrying a hand meter can be a problem. Most of them come with a neck cord, but letting a meter dangle on the end of the cord is inviting disaster. The meter swings around, bashing into tripod and camera. Use the neck cord, but place the meter in a shirt pocket. For colder weather I make sure my field coats have chest pockets on them. Trying to dig out a meter from under several layers of clothing when you're trying to work fast just adds to your aggravation. In very warm weather I don't use a neck cord, but rather a belt holster sewn by a local leather store.

My choice in hand meters is the Sekonic L-448. This meter, besides being an extremely sensitive incident light meter, has two advantages often overlooked. You can operate it with one hand. Most meters demand that you align a dial with either a number or a null mark. The Sekonic has a servo motor that aligns the dial, so in the field you can keep one hand on your gear and still take a meter reading. And the meter uses one standard AA battery, the same type of battery as in your motor drive or small flash. That is a real plus since you don't have to carry more than one type of spare battery.

MOTOR DRIVE: A FAST THUMB FOR ADVANCING FILM

When photographing stationary subjects, you usually have lots of time to wind the film and to take another shot. But when action occurs, you may not be prepared. A lot can happen during the few seconds it takes to advance the film manually.

Action photography is the forte of a motor drive or winder. The differences between the two are minor. Both advance the film and cock the shutter when you trigger them. Motor drives generally have a faster top speed in frames per second, up to five fps, and often also have a motorized film rewind. Many winders and most motors offer both a single frame mode (you must lift your finger and push the trigger button again for each shot), and a continuous speed (the camera keeps firing and winding as long as the button is depressed).

Today's advertising suggests that you cannot be a serious photographer without one of these devices. I don't agree at all, believing as I do that subject matter dictates their use. If you want to photograph elk in Yellowstone in autumn—the males bugling and sparring with each other—by all means purchase a motor drive. But if you're primarily interested in shooting flowers or scenics, why burden yourself with the extra weight?

Some people think that a motor drive ensures that you will capture the peak action if you just hold the button down. This is not true at all; you still have to be very selective. Think about it like this: let's say you're shooting at $1/500$ sec. to stop action, and your motor drive can advance the film at 5 frames per second. If you shoot in the continuous mode for one second, you've captured $5/500$ of the action, but missed $495/500$ of it. At 5 frames per second you could shoot a 36 exposure roll in about 7 seconds. You would spend far more time rewinding and reloading than shooting. You must be selective!

Generally I use a motor drive as a fast thumb. That is, I use it just to wind the film so that I'm always ready for the next shot. My motor drive has a continuous speed that I always leave it set at, but I hardly ever just hold the button down. Instead I shoot a single frame at a time by just quickly lifting my finger after triggering the motor. But I'm ready to fire a burst if the opportunity presents itself.

Some photographers are concerned about the noise of a motor drive scaring the subject. I've rarely encountered this. If it happens, turn the motor off, let the animal or bird settle down, and use the standard manual shutter release for awhile.

With a motor drive, I know that my camera is ready to perform at a moment's notice—so I won't miss any spontaneous shots of particularly fascinating and nimble-footed subjects.

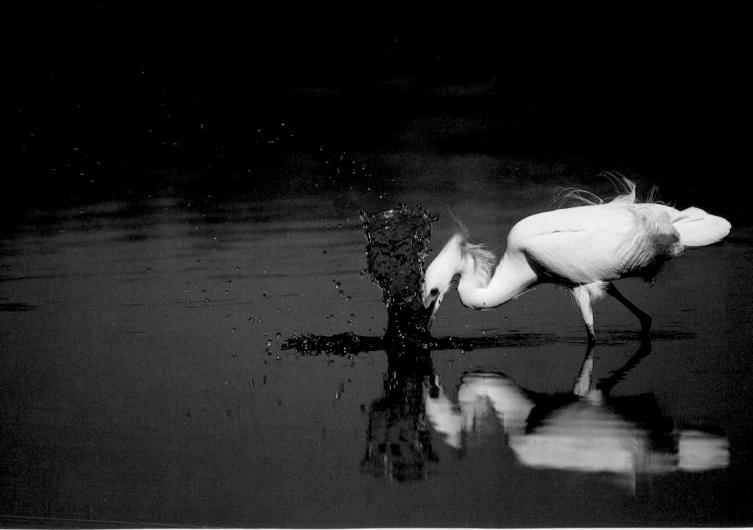

SNOWY EGRET FISHING. Kodachrome 25, 300mm IF lens, $1/500$ sec. at $f/5.6$

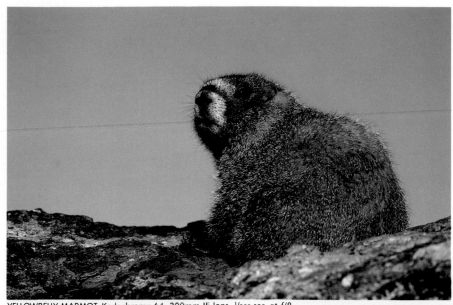

YELLOWBELLY MARMOT. Kodachrome 64, 300mm IF lens, 1/250 sec. at f/8

Be prepared for the unexpected just as I was and am. One second after I had photographed the marmot tight-lipped, it yawned. Under normal circumstances, the camera would have been away from my eye and I would have missed the more expressive photograph.

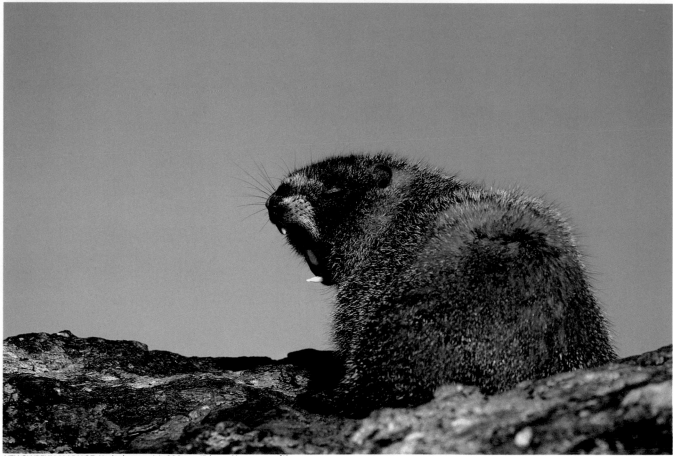

YELLOWBELLY MARMOT. Kodachrome 64, 300mm IF lens, 1/250 sec. at f/8

LENSES

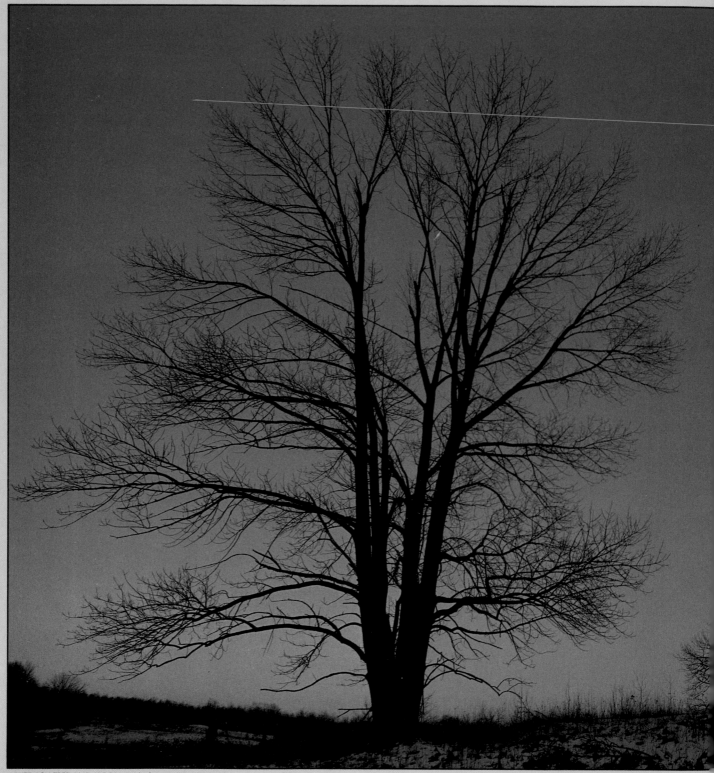

WHITE ASH TREE AND MOON. Kodachrome 25, 200mm lens, 1 sec. at f/22

Finding the subject for your photograph may sometimes present you with more difficulty than any technical problem you may encounter. I searched a fair amount of time to find a tree on a slight rise to silhouette against the twilight sky. Once I found it, I used a 200mm lens to make the moon appear the size we see it.

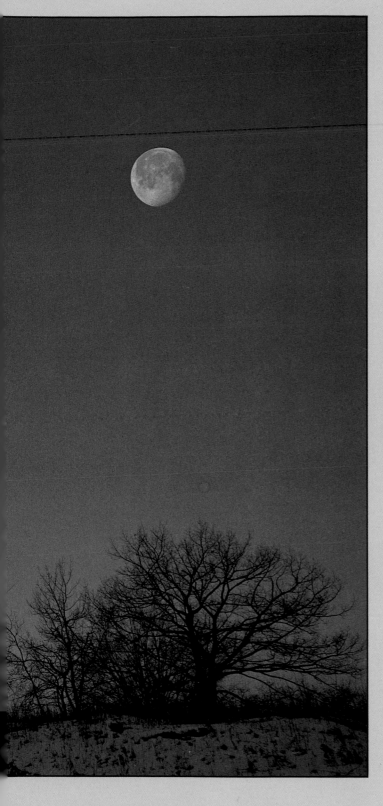

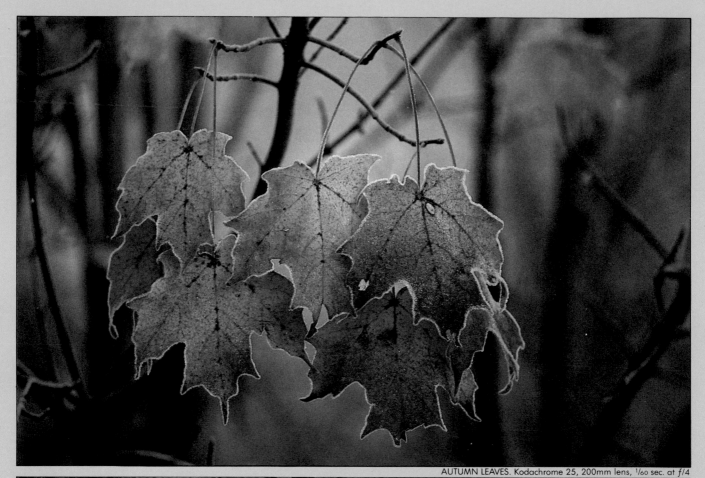

AUTUMN LEAVES. Kodachrome 25, 200mm lens, 1/60 sec. at f/4

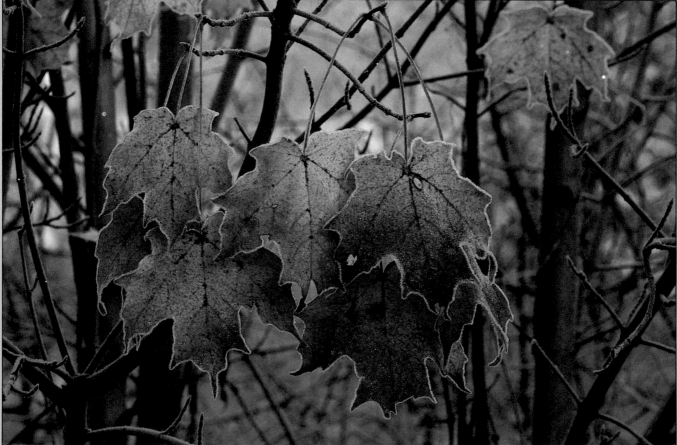

AUTUMN LEAVES. Kodachrome 25, 200mm lens, 1 sec. at f/32

WHAT LENSES DO

The two most basic considerations of any lens are the focal length and the maximum aperture of lens speed. Let me review these in simplified terms and discuss how they affect depth of field.

Focal length is, in very basic terms, the distance between the optical center of the lens and the film when the lens is focused at infinity. This focal length distance is normally measured in millimeters. In practical terms it is easiest to think of focal length as whether it magnifies or reduces the size of an image as compared to some norm, the usual starting point for 35mm cameras being that produced by a 50mm lens.

The 50mm lens is the focal length most often supplied with the camera body. Lenses around this focal length are commonly called "normal" lenses although "standard" might be a better term. The 50mm lens became the norm more through the result of historical accident than any well thought out concept on the part of early camera manufacturers. Any lens of a focal length longer than 50mm is generally referred to as a "telephoto" while any focal length shorter than 50mm is a "wide angle."

There is a direct relationship between the focal length of a lens and both the angle of view and the image size. The angle of view is how much a lens sees, the angle of its vision. As focal length increases, angle of view decreases. From any one location, the longer the focal length the less of an angle the lens can see. Telephotos take in a very limited coverage, while wide-angle lenses, as their name implies, cover a very broad field of view.

As angle of view changes, so does the size of the image, how large things look through the viewfinder. When photographing from any given location, there is a direct relationship between the focal length of a lens and the image recorded on the film. The longer the focal length, the bigger the image. The linear magnification of an image varies directly in proportion to the focal length. If you double the focal length (from 50mm to 100mm, from 100mm to 200mm, and so on) you double the image magnification. For example, a subject that measures ½-inch high on a slide taken with a

This pair of photos illustrates well the choices you have with depth of field. The top photo was taken with the lens wide open at f/4; in the bottom photo, the lens is stopped all the way down to f/32.

50mm lens would measure 1-inch high on a slide taken with a 100mm lens from the same camera position.

The maximum aperture of a lens is the size of the largest hole formed by the lens's iris diaphragm, the variable opening that lets light through the lens to the film. The size of the aperture is indicated in terms of an *f*-stop number. These numbers are determined simply by dividing the focal length of the lens by the diameter of the aperture. For example, if the focal length of the lens is 200mm and the optical diameter of the largest hole is 50mm, the *f*-stop number is $200 \div 50$ or *f*/4. Lenses with the larger maximum openings are called "fast" lenses since they let in more light than a smaller opening. However, you can see that a fast lens must also be a physically large lens. A standard 200mm lens usually has a maximum aperture of *f*/4, or a 50mm diameter opening. A 200m *f*/2 lens, though, must have an aperture 100mm in diameter, and this means larger lens elements, more weight, more care and cost in construction, and a higher price tag.

The aperture *f*/4 on a short focal length lens and *f*/4 on a long focal length both represent the same amount of light coming through the lenses to the film. If they did not, it would be extremely difficult to take a properly exposed photograph.

Consider two lenses being used from the same location and focused on the same subject. Both lenses have apertures 25mm in diameter, but one lens has a focal length of 50mm while the other has a focal length of 100mm. Since image size is proportional to focal length, the 100mm lens produces an image on film that is twice the dimension of the 50mm lens's image. Both lenses transmit the same amount of light, but the light is spread out over an area four times as large (twice as high an image, twice as wide an image, for four times the area) with the 100mm lens. This means that the actual image on film of the 100mm lens is four times less bright. Compare *f*-stop numbers though. The 50mm lens has an *f*-stop of $50 \div 25$ or *f*/2, while the 100mm lens is $100 \div 25$ or *f*/4. If we give the 100mm lens an aperture opening of *f*/2, a 50mm diameter hole, which is the same ratio as the 50mm lens has, then both lenses will produce images of the same intensity. We're concerned about the relative apertures, not the actual physical apertures, which will be of different sizes for

different focal lengths.

The actual *f*-stop used to take a picture controls the *depth of field*, which refers to how much of a picture, from near to far, appears to be in sharp focus. I say "appears" since theoretically the image is at its sharpest focus only in a single plane, the given distance at which the camera lens is focused. As a practical matter, what is seen is a zone of sharp focus that extends in front of and behind the plane of sharpest focus. On either side of this zone, both near and far, the image is noticeably not sharp. This zone of relative sharpness is called depth of field.

From a practical point of view, depth of field varies with the *f*-stop used, with the distance from the lens to the subject, and with the focal length of the lens. Practical considerations of depth of field can be summed up with the following:

With any one lens, the smaller the lens aperture, the greater the depth of field; the larger the aperture, the shallower the depth of field. Thus you will get great depth of field when a lens is set at *f*/22 and very limited depth of field when the lens is set at *f*/2.

With any given lens set at any given f-stop, the shorter the distance from lens to subject, the shallower the depth of field. With any lens you loose depth of field as you move the camera closer to the subject and gain magnification. The reverse is also true: the greater the distance from the subject, the greater the depth of field. Thus, if you focus on a subject that is 3 feet from the camera, you will have a much shallower depth of field than if you focus on a subject that is 30 feet away.

When photographing from any one spot, the longer the focal length, the narrower the depth of field at any given distance. For example, if you focus on a subject that is 20 feet away with first a 50mm lens and then a 200mm lens without moving the camera, the 200mm lens will give much less depth of field.

Regardless of the focal length used, photographs taken at the same image size and at the same f-stop *will have the same depth of field.* For example, if you first shoot a subject from a distance with a 200mm lens set at *f*/4 and then move close to shoot the subject at the exact same image size with a 50mm at *f*/4, both of the resulting shots will have the same depth of field.

MAINTAINING TOP OPTICAL QUALITY

You've bought good lenses, always use a tripod, and switched to slow-speed film for quality. Still, at times your slides seem soft, as if you had been shooting in the mist. You notice this seems to occur with backlit subjects, when you're using your zoom lens, or lenses with filters.

If you're using a filter and not using a lens hood, you're most likely experiencing flare problems, light is reflecting off the glass surfaces of the lens's elements. Zoom lenses, with their many elements, are especially prone to flare. I would suggest *always* using a lens hood, regardless of the type of lens or filter or direction you're shooting.

Some photographers leave UV (ultra-violet) or haze filters permanently mounted on their lenses, saying that doing so offers protection for the lenses. I've often wondered what they are protecting against. If it is dirt and fingerprints, then the filter should be taken off before every shot, otherwise, they're shooting through all that dirt. Of course, they could keep the filter clean, but why not then just keep the lens clean? If it is protection against breakage, then a rubber lens shade makes even more sense, as it can act as a shock absorbing bumper.

Lenses are designed to give the sharpest image without a filter being added to the front, otherwise the lens designer would have incorporated a built-in filter (which some lenses have). Any filter placed in the light path will degrade the image to an extent, depending on the quality of the filter, so buy the best filters you can. Why purchase a $300 optic and then place a $5 piece of glass in front of it?

Don't get me wrong—there are times to use filters, even as protection, such as when you are working in spray. But use filters only when you have a valid reason for doing so. Regardless, always use a lens hood.

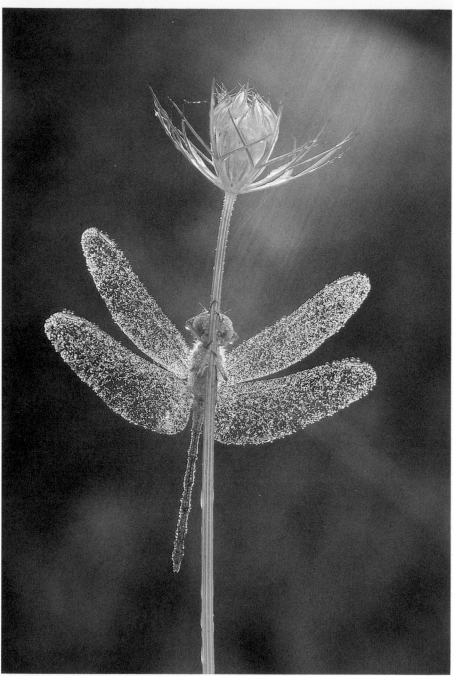

DEW-COVERED DRAGONFLY. Kodachrome 25, 105mm lens, 1/8 sec. at f/8

I added an uncoated warming filter to the lens, but no lens hood. The result: the morning sunlight struck the filter, causing flare streaks and thus lowering contrast. In this case, however, the results are not particularly bad!

(Opposite page) Here's an excellent example of terrible flare. I used a skylight filter for both photos and exposed them identically. The two shots were taken about ten seconds apart, just long enough for me to add the lens hood and provide you with a comparison. Again, the direct sun on the filter caused the extreme flare.

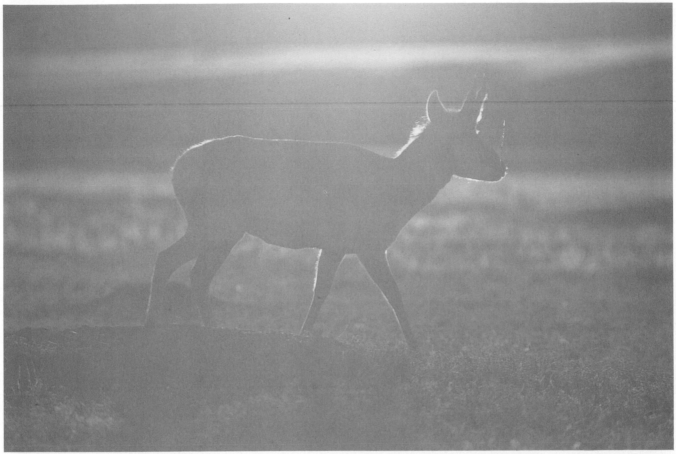

PRONGHORN ANTELOPE. Kodachrome 64, 500mm lens, ¹/₁₂₅ sec. at f/5.6

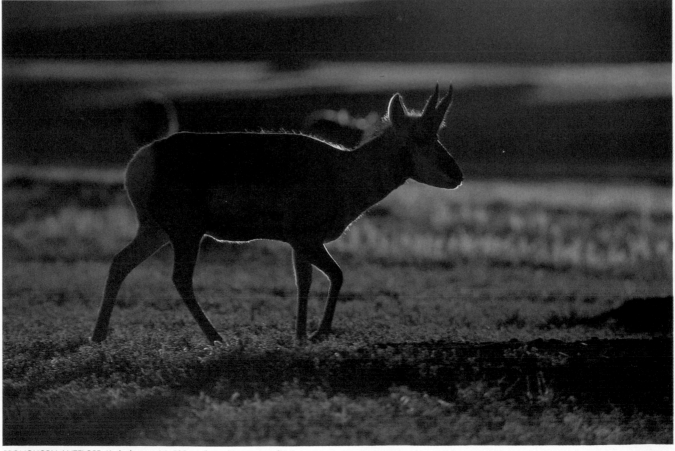

PRONGHORN ANTELOPE. Kodachrome 64, 500mm lens, ¹/₁₂₅ sec. at f/5.6

A WIDE ANGLE FOR TIGHT SPOTS AND SWEEPING SCENICS

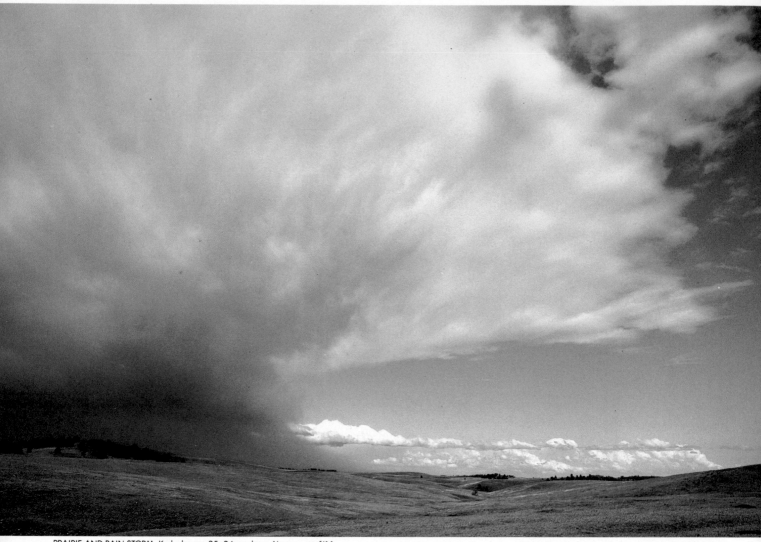

PRAIRIE AND RAIN STORM. Kodachrome 25, 24mm lens, 1/60 sec. at f/11

A wide-angle lens lets you work close to the subject and still include it all in the picture. I personally think the nature photographer needs only one wide-angle focal length in his bag. I would suggest either a 24mm or a 28mm lens. In terms of field work, the difference between these two lenses is about two or three giant steps closer or further from the subject. If you are hooked on wide angles you could include a 20mm lens in your gear, but that is as wide as I would suggest for the field.

You will discover that your use of wide angles is related to geographic location. When working in broad, open areas, with big sweeping subjects and blue skies, you will reach for your 24mm. However, in more contained areas, such as forests and other densely wooded spaces, you will not photograph with wide-angle lenses nearly as much. Areas that contain large bodies of water or that are dotted with many small lakes will have air that contains a lot of water vapor and hence there are many gray sky days; this is not the time to include the sky in your pictures. Overcast skies record as blank, washed-out, dirty whites.

You've probably heard it said that wide-angle lenses give you great depth of field or conversely that telephotos have very shallow depth of field. Neither statement is quite true. Only when comparing pictures shot from the same point do wide-angle lenses give more depth of field than telephotos. But wide angles take in more of an image, they yield a sweep, while telephotos reach out and pluck a section of the scene. If image size remains the same—if you walk up with your wide angle so as to include just what the telephoto is getting, or if you back way off with the telephoto to include all the wide angle sees—depth of field will be the same if you shoot at the same aperture. Wide-angle lenses do not give you more depth of field, nor do telephotos give you less depth of field; it's the image size obtained with the lenses that affects depth of field. To fill the frame with a subject, you will be right on top of it with your 24mm, or backed off a distance with your 200mm. But if you shoot at the same f-stop, the depth of field will be the same.

SPINULOSE WOOD FERN AND HORSETAIL. Kodachrome 25, 24mm lens, ½ sec. at f/16

Having put myself in a rather tight situation, I needed an out—and a 24mm lens was it. I wanted to illustrate the woodfern surrounded by horsetail growing along the edge of this wet wood. Since I could not back up to use a longer focal length, the 24mm enabled me to work in close to the subject.

Similar to my woodfern situation, a 24mm gave me the freedom I needed to move in close, about three feet away from the nearest stalks of goldenrod.

GOLDENROD IN LATE SUMMER.
Kodachrome 25, 24mm lens, 1/15 sec. at f/16

57

DO YOU NEED A NORMAL LENS?

The odds are that a 50mm or 55mm was the first lens you owned, since it came with the camera. By definition, if you own it, it's good. Actually, lenses in this focal-length range are optically some of the most highly corrected lenses.

I tend to treat 50mm lenses as long wide angles, using them to shoot scenes and sections where my 24mm is just too wide. And of course they are easily hand held, if you want to do so.

Many photographers, myself included, do not own a normal 50mm or 55mm lens. Instead I have a 55mm macro. I do not often use it for close-ups (as explained later in the close-up section) although that is an added feature that is available if I should need it. What I do like about macros in the 50mm range is they have small f-stops providing great depth of field for shooting scenics. Most standard lenses only go down to $f/16$, while almost all 50mm macros go to $f/32$. This doesn't mean that I shoot all my 50mm shots stopped down to $f/22$ or $f/32$, but the stops are there if I want them.

If you already own a 50mm lens I would not suggest you run out and buy a 50mm macro just to get small f-stops. Use what you own first. If you discover that you're using your 50mm lens at $f/16$ and wishing it would stop down more, then perhaps a macro is the answer. Personally I would not recommend owning both a 50mm and a 50mm macro, since I see no reason to double up on focal lengths. One or the other will do the job.

Some people say that macro lenses are only good for close-ups and that they do not deliver quality images at normal distances. That is simply not true. Modern lenses are so good that the images are indistinguishable. I would not be concerned either that owning a macro lens leaves you without a fast 50mm lens. How often do you shoot your 50mm lens wide open? If you own an $f/1.2$ or $f/1.4$ lens, have you ever used those stops? Generally you will be shooting stopped down for some depth of field. Usually you won't even be using a macro lens wide open.

ALPINE SUNFLOWER. Kodachrome 25, 55mm lens, ½ sec. at $f/22$

These flowers were photographed on a steep slope above timberline in the Rocky Mountains. If I had used a lens longer than 55mm, I would have had to move downhill and shoot at too sharp an angle. A 55mm lens offered a reasonable working distance, and I could stop down for the needed depth of field.

I photographed this tree situated on top of a small hill with a 55mm lens because it is short enough to permit me to work fairly close to my subject, yet long enough to cover only the wintry red portion of the sky. If I had backed away and used a longer lens, the image of the bottom branches and trunk of the tree would have merged with the ground.

CHERRY TREE AND WINTER SUNSET. Kodachrome 25, 55mm lens, 1/8 sec. at f/11

AUTUMN COLOR AND APPROACHING STORM. Kodachrome 25, 55mm lens, 1/30 sec. at f/16

This photograph represents my most typical use of a 55mm lens—as a long wide-angle for scenic views. Sometimes a 24mm is just too wide, and a 55mm can provide you with the proper amount of coverage.

THE 105MM: BEST ALL-AROUND FIELD OPTIC

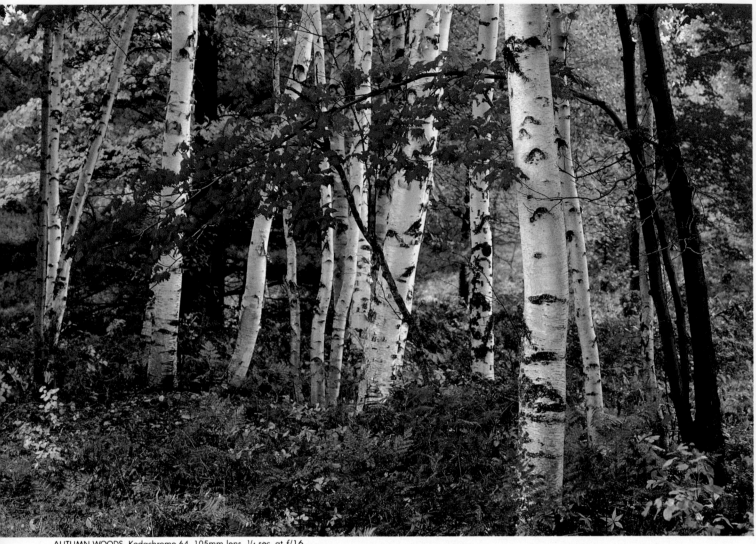

AUTUMN WOODS. Kodachrome 64, 105mm lens, ¼ sec. at *f*/16

The overcast day on which I photographed this small maple growing in the midst of a white birch grove was ideal. Thanks to the clouds, contrast was lowered and the whites were not burned out. Had I included the sky, it would have registered as nothing but a drab gray.

If I could own only one lens for all my nature photography, I would pick a short telephoto. Specifically I would choose a 105mm lens, or even more specifically a 105mm macro lens. As a professional photographer, I sell more photos made with this lens than with any other lens.

Lenses in the 100mm range are great for close-up work (see the close-up section). They're also very useful for doing scenics, allowing you to close in on a section. Since this focal length has a narrower-than-normal angle of view, they permit you to limit how much sky is included if you're shooting scenes on overcast days. You can also photograph animals by showing them in their habitats. It's hard to do this with a 50mm

lens since you have to be twice as close to the animal in order to keep the same image size.

If you're interested in zoom lenses, some of the best ones cover the short telephoto range. I would consider 80–200mm or 70–210mm lenses.

Lenses in the 100mm range are often called "portrait lenses" since this focal length is often used for photographing people. I consider a lot of my work also to be protraiture: protraits of a flower, of a hillside, of a tree. If you are interested only in photographing mammals, or if all you want to shoot are sweeping scenics, then this focal length is not the one of choice. But for general work, covering the broadest range of subjects, the short telephotos have no peer.

RED PAINTBRUSH AND ROCK.
Kodachrome 25, 105mm, 1/2 sec. at f/32

A 105mm lens isolated this portion of a meadow high in the Rocky Mountains. This focal length enabled me to crop out nearby elements in order to feature the paintbrush and the rock.

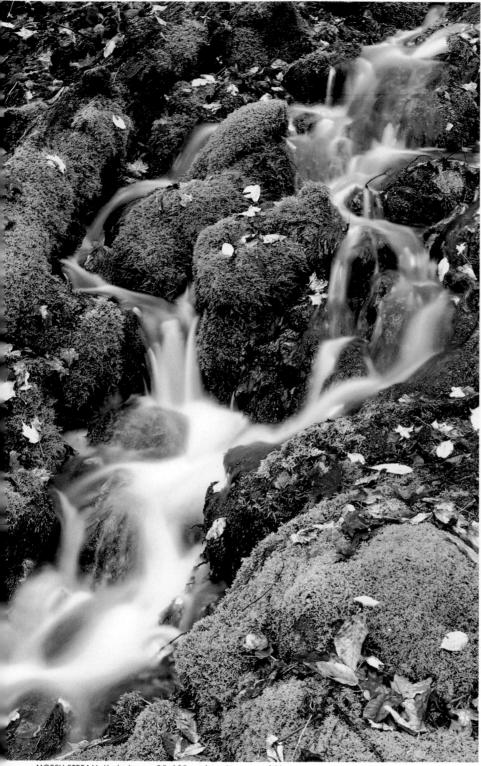

MOSSY STREAM. Kodachrome 25, 105mm lens, 1/2 sec. at f/22

The blurred water in this autumnal ''portrait'' of a small stream is courtesy of a slow shutter speed, about 1/2 sec. Although I strove to get this blurry effect, I did not really have any say in the matter. My slow film, coupled with the depth of field I needed, forced me to shoot a fairly long exposure at a small f-stop.

THE 200MM: VERSATILE LONGER LENS

You want a long lens, something longer than a 105mm or a 135mm, but still you don't think you're ready for the size, weight, and cost of a good 400mm. You want a lens that is easily carried yet relatively fast.

If that is your situation, you should consider a 200mm lens. In my mind, 200mm lenses occupy a unique position. They are the shortest of the long lenses, or the longest of the short lenses. With a 200mm you can finally photograph wildlife, albeit the tamer ones in the national parks. Yet 200mm lenses are physically small enough that you can handle them more like normal lenses, far more so than you can the really long lenses.

Extremely high quality 200mm lenses are readily available at very affordable prices. Most are quite compact, lightweight, and easily maneuvered. The most common wide-open aperture is $f/4$, and most of these will take the same size filters as standard 50mm lenses. Any longer focal length and the filter size is sure to be larger.

The 200mm lenses are the longest lenses that can be consistently used hand-held with no other support. The old rule of thumb suggests not hand holding a lens at a speed slower than the focal length, so a 200mm could be used at $1/250$ sec. Shooting wide open would give you an exposure a full two stops off bright sun with Kodachrome 64.

One situation where many photographers overlook the advantages of a 200mm is in close-up work. For flowers the size of roses or black-eyed-Susans, a 200mm with extension to make it focus closer is ideal. If the subject is quite low, a 200mm has the added advantage of letting you shoot the subject from a distance at a less acute camera angle. Even with a low-level tripod you always have at least the height of the tripod head. Compared to a 50mm, a 200mm lets you back away for the same image size and photograph more parallel to the ground.

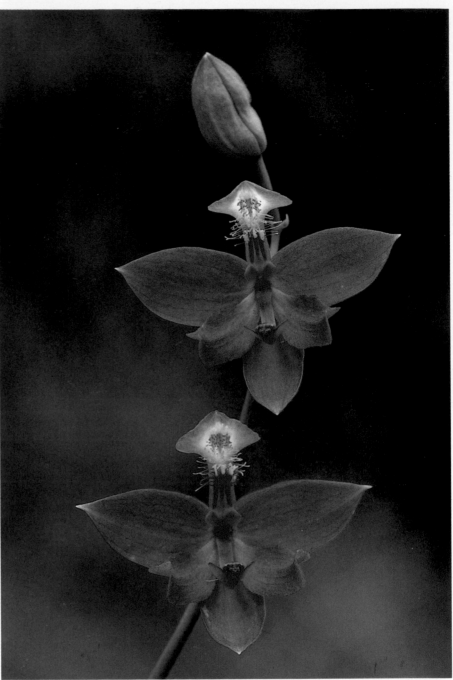

CALOPOGON ORCHID. Kodachrome 25, 200mm lens, $1/15$ sec. at $f/8$

I spotted this orchid in the middle of a Michigan bog, the blossoms about a foot above the unstable ground. My 200mm lens performed perfectly: it isolated the flower against a background of out-of-focus vegetation, and allowed me to position myself far enough away so that my movements in the soft, spongy peat would not disturb the flower.

(Opposite page) Here, I used a 200mm lens to highlight the orb webs against a background of dark trees. Had I been any closer with a shorter focal length, the top webs would have been lost against the early morning sky. Exposure was determined very carefully.

ORB WEBS.
Kodachrome 25, 200mm lens, $1/4$ sec. at $f/11$

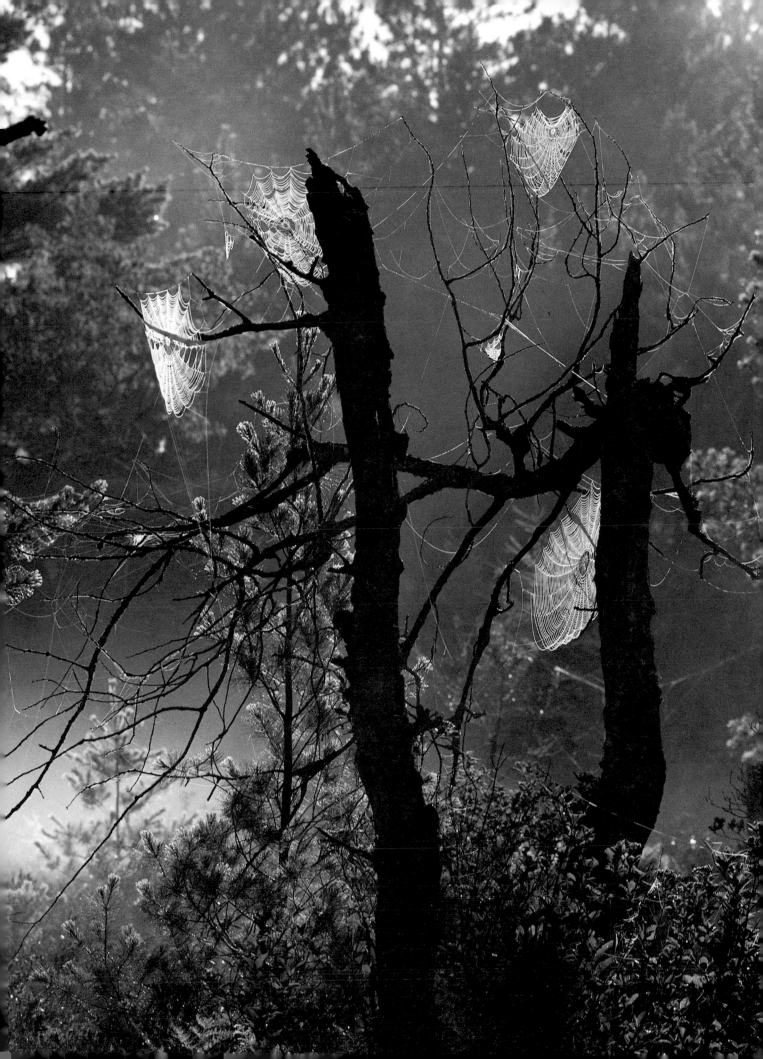

A LONG LENS FOR WILDLIFE (AND SOME SCENICS)

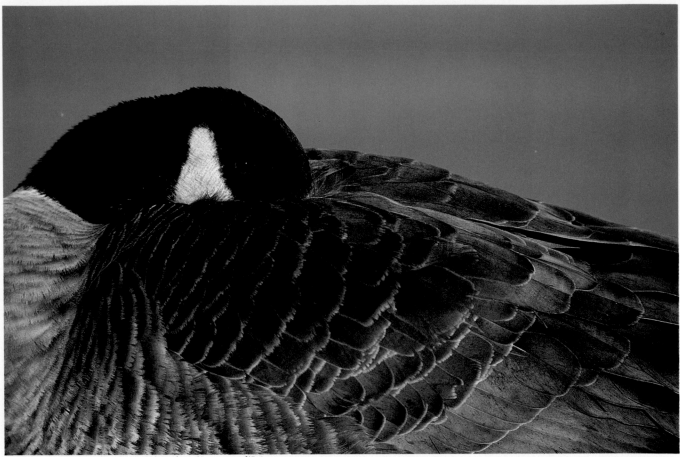

CANADA GOOSE. Kodachrome 25, 500mm lens, ¹/₂₅₀ sec. at ƒ/5.6

The non-photographer's idea of a wildlife photographer is a person using a huge lens about a half mile from a deer yet getting good results. You know it doesn't work that way. But how long a focal length do you need to shoot wildlife?

The answer to focal length in long lenses lies in your answers to two questions: how big of a subject do you want to photograph, and how close to it can you get? The larger the subject, the shorter the focal length needed from any given spot. And getting closer is always a solution to focal length. A 50mm lens focused at 5 feet gives the same image size as a 500mm at 50 feet. But can you get 5 feet away from the subject? Many wildlife subjects are smaller than you think. Even with a 500mm you must be within 20 feet to get a frame-filling shot of a cottontail.

Whatever focal length you decide on, buy the best lens you can possibly afford. Most of the time you will be shooting with the lens fairly wide open, using a fast shutter speed to stop the movement of your subject. You will definitely have to pay a high price for a

lens that retains image quality at wide open apertures. A long lens that is not razor sharp until ƒ/8 or ƒ/11 is useless for field photography—it's too slow.

What focal lengths to consider? I would suggest starting with a 300mm ƒ/4. Most 300mm lenses are compact, lightweight, easy-to-handle lenses, and excellent ones are available at affordable prices. A 300mm lens is long enough for working with large mammals in national parks and is ideal for photographing nests from a blind. This is also a focal length that can be used with a shoulder stock or monopod; any longer and it gets tricky.

If you plan on shooting much from a car, or working birds without a blind, then 300mm is often too short. I would pick one longer lens, buying the best affordable. A 500mm or 600mm is useful for car work; a 400mm is a good all-around compromise. You also might consider a fast long lens to allow you to work in dimmer light and still keep your shutter speed up. If you do that, I would suggest something like a 400mm ƒ/3.5. A fast 600mm lens is just too big, too heavy, and too costly.

Here, a 500mm lens was used from a distance of twenty feet to crop in on just a part of this goose—the part I was most interested in putting on film, of course.

(Opposite page) The 300mm lens is an excellent scenic lens. Shooting from the top of a hill, I was able to isolate a part of the hillside opposite me.

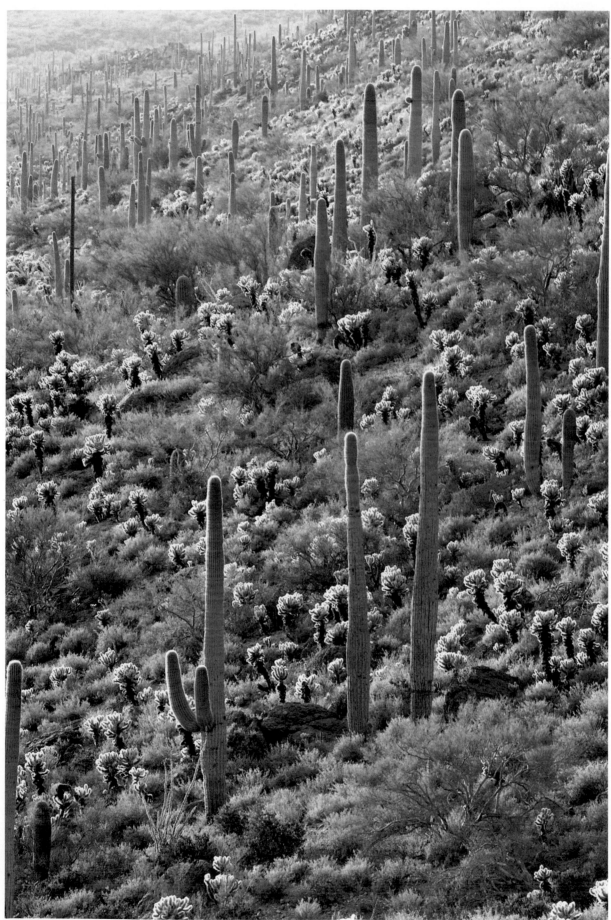

SAGUARO AND CHOLLA. Kodachrome 25, 300mm IF lens, 1/8 sec. at f/11

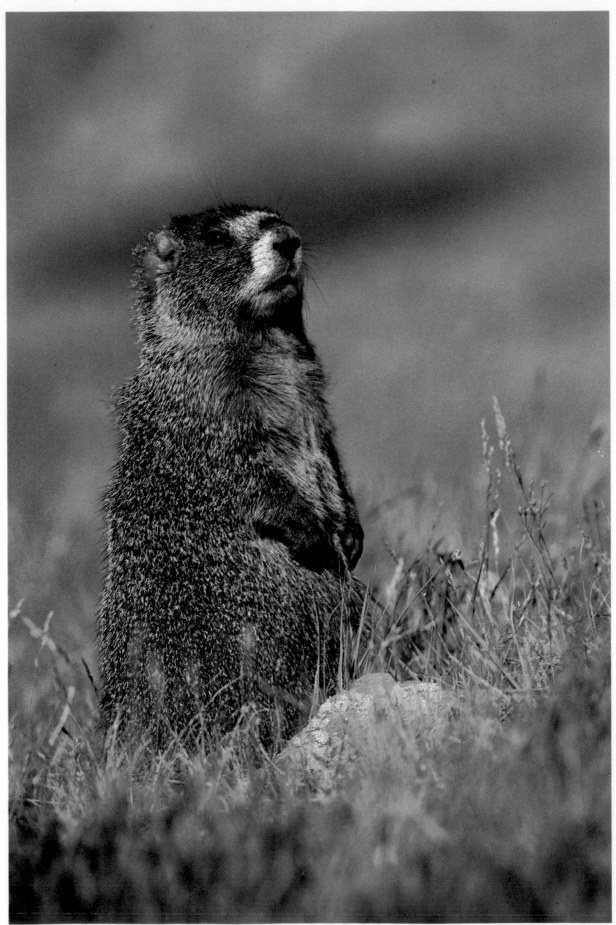

YELLOWBELLY MARMOT. Kodachrome 64, 400mm IF lens, $^1/_{500}$ sec. at f/5.6

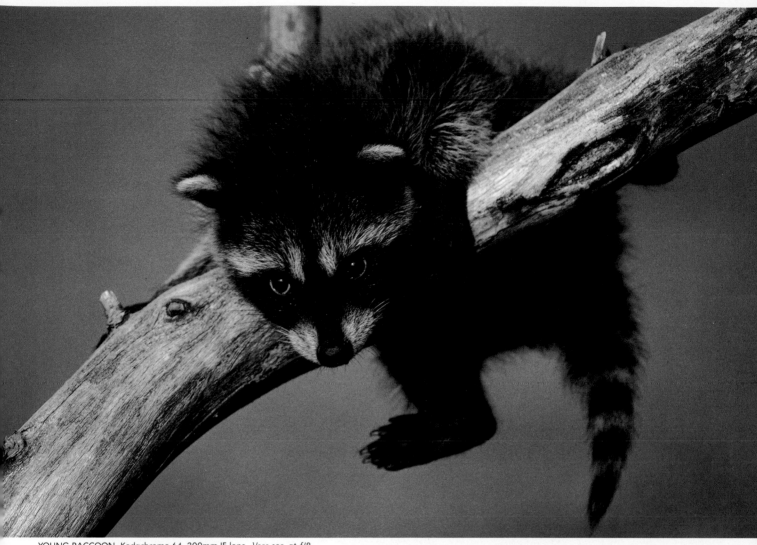

YOUNG RACCOON. Kodachrome 64, 300mm IF lens, ¹/₂₅₀ sec. at f/8

I would not buy anything over 600mm. Even if you could afford such a lens and could carry it, with any lens over 600mm you end up shooting through too much air, and atmospheric problems degrade the images you get. Within reason, always use the shortest focal length you can. If you can shoot with your 300mm, don't use your 500mm.

Lack of sharpness is the major problem with a long lens. All long lenses magnify vibrations, and the longer the focal length, the more the problem. The solution is to use the fastest shutter speed possible. The depth of field that is gained by going one stop down is meaningless when compared to the sharpness that is gained by going one faster shutter speed.

Mirror, or catadioptric, lenses are another alternative. However, for me they have two major drawbacks. First, because of their physical construction they render out-of-focus highlights as doughnut-shaped rings. Generally one is either indifferent about this fact or cannot stand it, and I am in the latter group. Second, they are too slow. Most mirrors are 500mm $f/8$, and most are actually slower in actual transmitted light than that. If $f/8$ is your fastest stop, you can shoot Kodachrome 64 at a top speed of ¹/₂₅₀ sec. under the best of conditions. $f/8$ is also too slow for critical focusing. In bright sun it's all right, but not in the marginal lights of dawn or dusk. I would buy a mirror lens only if the size and weight were my primary concerns.

A fast handling 300mm is an ideal lens for close work with active subjects, such as this spright young raccoon. You can easily imagine the activity he generated just seconds prior to and immediately following my photograph!

(Opposite page) If I had to choose only one all-purpose lens for bird and mammal work, it would be a fast 400mm lens. It helped me greatly with this marmot by providing me with lots of working room.

HOW FAST A LENS DO YOU NEED?

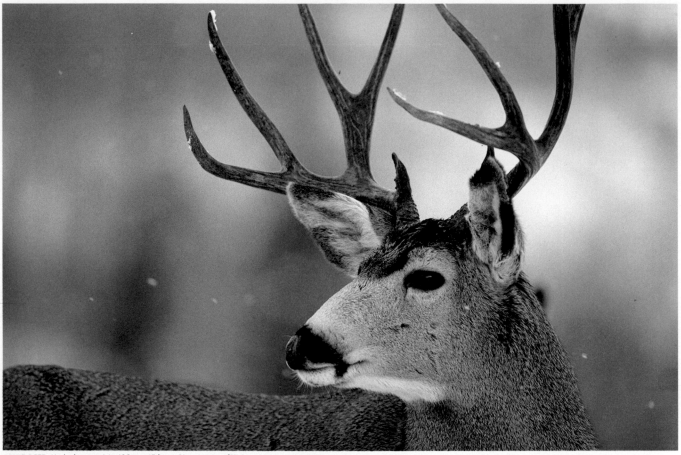

MULE DEER. Kodachrome 64, 400mm IF lens, ¹/₁₂₅ sec. at ƒ/3.5

The "speed" of a lens refers to its maximum aperture. An ƒ/2 lens is "faster" than an ƒ/2.8 lens, and an ƒ/2.8 one is "faster" than an ƒ/4 one, as the wider ƒ-stops let in more light. The chart shown below gives you the full ƒ-stops and the numbers in between. In this way you can compare speeds to see just how much faster one lens is than another.

Modern lenses are so good that you cannot tell the difference on film between the image shot with a fast lens and the one made with a normal speed lens. There are two advantages to fast lenses: a faster stop is easier to focus since there is less depth of field and more light by which to focus, and if you need to use the faster stop, it's there. This is exactly where I must ask a question of all the photographers who brag about the high-speed optics they own. Are you going to use the lens wide open? If not, why do you have such a lens? In focal lengths shorter than 200mm I personally see few reasons to

own high-speed lenses for nature work. Most of the time you will be stopping short lenses down to obtain some depth of field. You can decide if you need a high speed lens by considering how many shots you now make with your lenses wide open. How many times have you actually used your 50mm ƒ/1.4 lens at ƒ/1.4?

There are three drawbacks to fast lenses: size, weight, and cost. All three are the direct results of the fact that there is more glass (larger elements) in a fast lens. Nikon's 50mm ƒ/1.8 lens weighs 7.4 ounces, while their 50mm ƒ/1.2 totals 13.4 ounces, and that's just over one stop difference in speed. Choose the 50mm ƒ/1.8 Series E Nikon lens and the weight is only 4.8 ounces. This weight discrepancy is far greater with the longer focal lengths. Canon's 300mm ƒ/4L is 2 pounds, 7 ounces, while the one stop faster 300mm ƒ/2.8L is 5 pounds, 1 ounce. If you're planning on carrying the lens 10 miles up a mountain that is an enormous difference

The wide open aperture of the 400mm lens, ƒ/3.5, was useful both for shooting and for focusing when I photographed this deer in dim light during a snowstorm.

in weight.

Price is also directly related to speed. It is far more difficult to manufacture fast lenses. Consider the two Canon lenses I just mentioned. The 300mm ƒ/2.8L is roughly three times the price of the ƒ/4 version.

However, focal lengths longer than 300mm are exactly where I would recommend considering a fast lens if you can justify the cost and weight differences. Most long lenses are slow. Typical 300mm lenses have a maximum aperture of around ƒ/4, 400mm lenses, about ƒ/5.6, and anything longer, roughly ƒ/8 or slower. Generally with long lenses you want all the light you can get, both to focus with and to shoot by. You definitely want to have at least the option of fast shutter speeds.

F NO. 1/2 STOP INTERVALS		1.2	1.7	2.4	3.4	4.8	6.7	9.5	13.5	19	27	38	54	
F NO.	1	1.4	2	2.8	4	5.6	8	11	16	22	32	45	64	
F NO. 1/3 STOP INTERVALS	1.1 1.3	1.6 1.8	2.2 2.5	3.2 3.6	4.5 5	6.4 7.1	9 10	13 14	18 20	25 29	36 40	51 57		

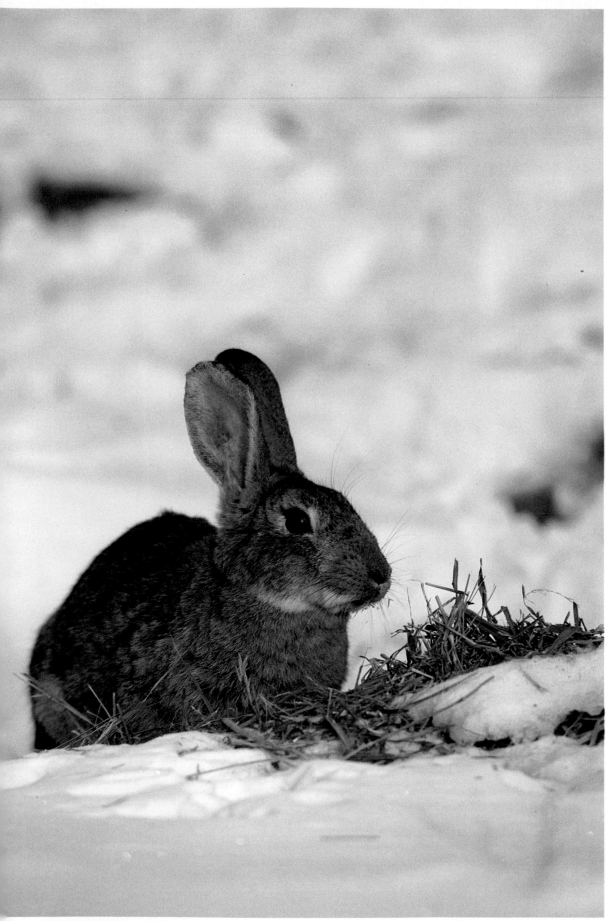

Fast lenses have a limited depth of field, and therefore they are easier to focus than regular lenses. But even on subjects like this, fast lenses perform. So don't think for a moment that they are useful only for dimly lit situations.

RABBIT IN WINTER. Kodachrome 64, 400mm IF lens, 1/500 sec. at f/4

THE IF LENS FOR LESS HASSLES

If you have a choice in the long focal lengths you are considering buying, I would definitely recommend the internal focusing (IF) feature. These lenses focus by changing the relationship of the optical elements within the lens itself rather than by getting physically longer or shorter as standard lenses do. This allows IF lenses to have very rapid and smooth focusing, a plus when working on moving subjects.

One real advantage of IF lenses is their close focusing limit. Since they do not have a helical thread focusing mount the space saved is used to make the lens focus much closer than regular lenses. For example, the standard Nikon 300mm $f/4.5$ lens focuses down to 13 feet from the film plane while the Nikon 300mm $f/4.5$ IF gets down to 8 feet from the film plane. In field work, that's a big difference.

Since they do not change their physical size as they focus, there is no light lost to extension within their own focusing range (see page 102). The exposure remains constant as the subject moves nearer or farther away. To focus at 8 feet with the standard 300mm requires enough extension to cost you at least a stop of light. That's the difference between shooting at $1/60$ sec. or shooting at $1/125$ sec. Not with the IF. You use the same exposure at 100 feet from the subject as you do at 8 feet. With a standard lens you must constantly change exposure to compensate for the extension change when photographing small moving animals, such as feeding birds. With an IF lens, you're free to concentrate on photography.

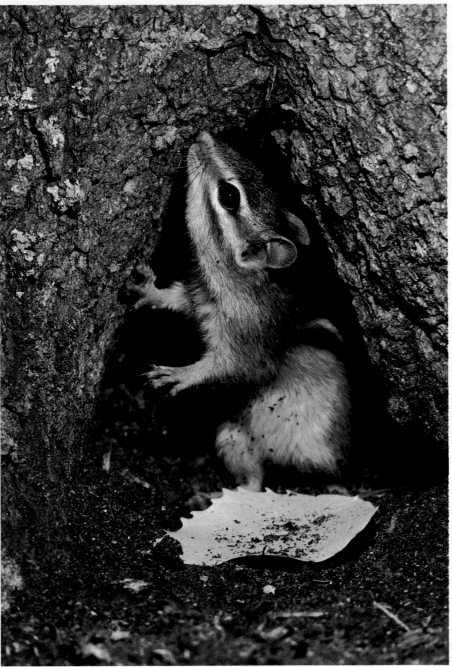

EASTERN CHIPMUNK, Kodachrome 64, 300mm IF lens, $1/250$ sec. at $f/8$

The chipmunk was photographed from a distance of seven feet, the closest focusing distance of the 300mm IF lens. Had a regular 300mm been used at this distance, a stop of light or more would have been lost to extension. In order to arrest the motion of the chipmunk, I needed as much shutter speed as possible.

(Opposite page) I photographed the ptarmigan with a 300mm IF lens at a working distance of about seven feet, just as I did the chipmunk. Even at that distance I was still able to shoot at the standard "sunny f/16" bright sunlight exposure.

WHITE-TAILED PTARMIGAN. Kodachrome 64, 300mm IF lens, $^1/_{250}$ sec. at $f/8$

USING A TELECONVERTER FOR EXTRA LENGTH

A teleconverter is an optical device that, when added to a lens, magnifies the image obtained by that lens. A teleconvertor is often touted as being a convenient and less expensive method for obtaining additional focal length. While this is effectively true, no teleconverter added to a lens can match the original quality of that lens used alone. You should not expect to obtain the same image quality with a teleconverter as you would by simply purchasing and using a longer lens. A teleconverter changes the effective focal length by the power of the converter and slows the lens down by the same factor. For example, a $2\times$ converter (the most common variety) changes the focal length of a standard 200mm $f/4$ lens to 400mm, while it slows the lens by two stops to $f/8$.

There are some definite drawbacks to converters. First of all there is the loss in speed. Any lens that is $f/8$ or slower is too slow for field work, both in terms of shooting light and focusing light. Generally there is also a loss of sharpness with the lens used wide open. This means the lens must be stopped down to an even smaller shooting aperture to get any quality results, and that makes the lens effectively even slower.

If you find that you need additional focal length, I would not recommend using zooms and fairly short lenses with teleconverters. Don't put a $2\times$ converter on a 135mm lens to obtain 270mm and expect to get results that match a regular 300mm. A normal 300mm is not *that* expensive. If you want quality in that focal length, buy a prime lens.

Teleconverters will work, though, if you follow these suggestions:

Try the new $1.4\times$ converters. You're giving up a little in power, but they only cost you one stop of light. In the field, that can mean a great deal of difference.

Buy the best converter you can. Basically this means the major camera manufacturers' own converters. These are expensive; Nikon's $1.4\times$ retails for considerably over $200.

Use the best prime lens you own. Converters magnify whatever is put in front of them, and this includes any lens defects. By starting out with a good lens, you are leaving less to chance.

Only use converters when you have to. Use converters to make a long lens, 300mm or up, into a really long lens when you need it in a pinch. If you discover you always need a 400mm lens, you'll get better results by purchasing a 400mm lens.

Use the best technique you can. Remember that with a converter you are now using a much longer lens, so you have to be even more careful and concerned about vibration problems, critical focusing, atmospheric distortions, and other factors.

SHORTTAIL WEASEL. Kodachrome 64, 300mm IF lens with 1.4x teleconverter, 1/250 sec. at $f/8$

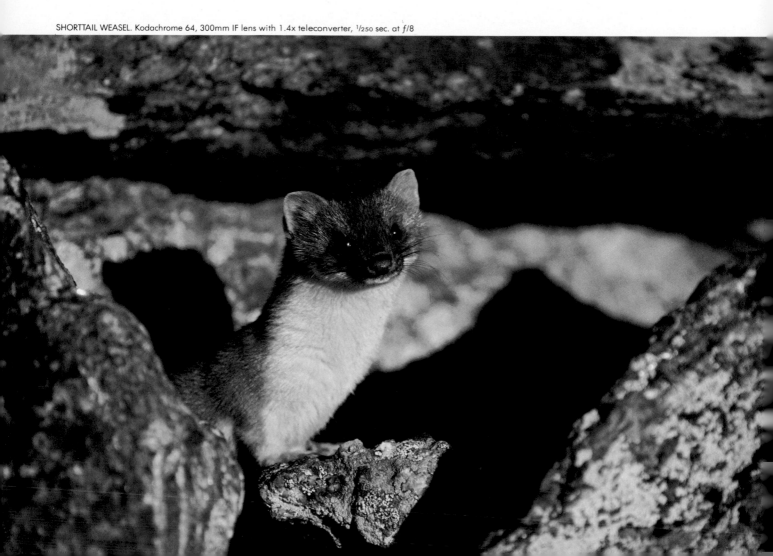

BONAPARTE'S GULL. Kodachrome 64, 400mm IF lens with 1.4x teleconverter, ¹/₅₀₀ sec. at ƒ/8

Driving by a marina one day, I spotted some gulls and attempted to drive my car as close to them as possible. My 400mm was not long enough, alas, but with the addition of a 1.4X teleconverter, I wound up with a 560mm lens and the photographs I wanted. The type of quality that you can expect from a teleconverter is apparent here.

While photographing pika in a rockpile, I spotted this weasel hunting the area. With no time to spare or to stalk any closer, I quickly snapped a 1.4X converter onto the 300mm ƒ/4.5 IF lens that I was using in order to get a longer focal length. I ended up with a 420mm ƒ/6.4 (which is ¹/₃ stop past ƒ/5.6). In effect, the converter is a longer lens in a compact, transportable package.

BERGAMOT AND OLD STUMP. Kodachrome 25, 105mm lens, ⅛ sec. at ƒ/32

Thoughtful attention to careful composition separates an outstanding photograph from one that is merely acceptable. In this photograph, the placement of the old tree stump within the frame, surrounded by the colorful Bergamot flowers, creates an image that is not only pleasing to the eye, but visually interesting as well.

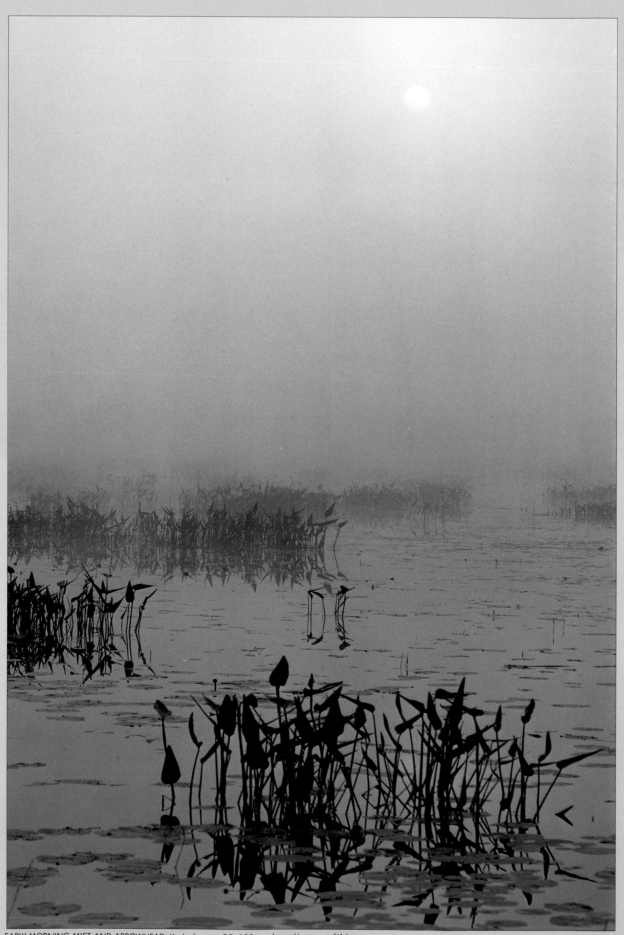

EARLY MORNING MIST AND ARROWHEAD. Kodachrome 25, 105mm lens, ½ sec. at f/16

LEARNING TO SEE

Composition is how you choose to coordinate all the parts of a picture into a whole. I emphasize that it is your choice because you play an active role in photography, indeed you *must* have this involvement. Picking one lens over another, deciding to photograph from this spot rather than that, including only so much in the picture—these should be conscious decisions and not just left to chance. The world is not ordered by itself; we place temporary importance on some parts of it by including such parts in the photographic frame. We impose order on chaos by using what we call composition.

An awareness of the light itself is the place to start. In field photography you can encounter light striking a scene from a variety of directions. We can basically break this down into three forms of light, named for the direction from which the light illuminates the subject in relation to your camera position: front lighting, side lighting, and back lighting. The direction of light, the angle of illumination, affects not only the exposure for a scene, but also determines the whole visual and emotional impact of the image.

Front lighting is what most people would call the "normal" lighting condition. The sun is behind you in the traditional "keep the sun over your shoulder" position, and is illuminating only those parts of the subject that face the camera. There is an absence of shadows, so this lighting is not very good for portraying depth or three-dimensional shape. This flat, even light makes exposure determination rather easy; all parts of the scene are receiving the same illumination.

Back lighting is the direct opposite to front lighting. The light source is behind the subject. Depending on the exposure you give the frame, the mood of a backlit scene can vary greatly, from dark silhouettes to light, ethereal

shapes. We seldom experience the actuality of a backlit scene as a photograph portrays it. Our eyes can accomodate the range of contrast better than can any film, and our minds expect the image to appear more evenly.

Side lighting is light coming from a right angle to the direction you are photographing. Now you have shadows, which define texture and form. Within the two dimensions of the photographic image, objects can take on the strongest feeling of three dimensionality. The highlights and shadows themselves often are the major parts of the composition.

Besides having a direction, light also has a character; it can be the extremes of hard or soft, or anywhere in between. Hard light is that which is emitted by a point source of light: the harsh sun on a cloudless day, direct electronic flash, or a light bulb with no shade. Shadows are sharply defined, crisply edged. If you expose for the highlights (which you should do with slide films), the shadow areas will block up into dense blacks, while exposing for the shadows results in washed-out highlights. The latitude of a film is how it handles such a contrast range.

The other extreme of character is soft light. This even illumination is the light of open shade, average indoor non-directional lighting, or the light just before dawn or just after sunset. Shadows are diffused or nonexistent, as there is little contrast across the scene. The light will vary from "bright overcast" days, the joy of close-up photographers when the light is directional yet open, to the total flatness of a foggy morning.

Finally, light has color. Early and late in the day the light is warm, tinged with yellow and orange. At midday the light is far cooler, more blue when compared to the morning.

Once there is light, we can see forms and the colors of forms. Form, or

shape, is the basic building block in nature photography. We are most interested in the specificness, the "suchness," of objects, whether they be birds or buffalo. Remember, though, that a photograph includes both the specific form of your subject and the less distinct form of the background; you must pay attention to both.

Often your eye is directed by the texture of forms, or the patterns into which the shapes are organized. Adding texture to form increases the layers of involvement of the viewer as it appeals to another of the senses. Through our own day-to-day experience we have developed an awareness of texture to the point that merely seeing such a surface evokes a response almost as real as the texture itself. Pattern is the repetition into which line, form, color, or shape can be organized. It can be geometric or abstract, regular or asymmetric.

Then there is color. Strong, pure, and undiluted colors attract our attention and quickly express emotion. So powerful is the effect of strong color that the color itself can come to dominate a photo, subjugating all the other picture elements. Soft, muted, and moody colors are far more subservient to the emotion of the subject itself. Muted colors lend themselves to color harmonies far easier than do the strong colors. But strong, warm colors advancing against cool, receding colors hold the attention of the viewer and direct his eye.

Because of the complexity and variety of compositional elements, it is easy to overwhelm the viewer. In general it is a good idea to strive for a visually simple picture, which is usually far more effective than a complex one. Simplification—having only one visual center of interest rather than many—is the strongest compositional technique you can master.

Very diffused, soft lighting created the muted colors in this photograph. All of the elements of color and light are perfectly combined to impart the proper mood for this scene.

COMPOSITION
FINDING THE BEST SUBJECT

The first step in composition is to pick your subject. While that sounds like a simplistic statement it is not so easy in practice. We are constantly bombarded by images. Thousands of subjects are in front of us at any one time. The problem is to concentrate on one subject and not all the others.

I think it helps to articulate as clearly as you possibly can exactly what it is you want to photograph. This helps you narrow down your vision, to find the one subject that's better than all the others, and to focus in on that subject.

Let's say you set out one autumn day and are awed by what you see. You want to take a picture. Define as precisely as you can what it is that strikes you. Hold a conversation with yourself. "I like this scene." What specifically about the scene? "I like the fallen leaves." What specifically about the fallen leaves? "I like the reds." What about the reds? "I like the way the newly fallen red leaves contrast with the faded browns of earlier leaves."

Now find the one subject that is the essence of your definition. It may take quite a bit of searching to find it. Frame that one subject and keep everything else out of this picture. Choosing a subject is as much what you do not include, as what you do include. How you organize the picture is the rest of composition.

Choosing a subject often involves looking around until you find it in the right setting. In the top photograph, the cinnamon fern is just a jumble of leaves, with little to indicate just why I found it so attractive. In the second photo, the golden color of the ferns is much more evident, contrasting with the red of the fallen leaves and the rich green moss.

(Opposite page) Many insects spend the night clinging to vegetation. If you search carefully, you will find them there in the morning, covered with dew and unable to fly until the sun and wind have dried them. The first dragonfly I photographed (top) is not dewy enough to fully convey the wetness of morning. The second held more dew and was better situated to allow for more background control.

CINNAMON FERNS IN AUTUMN. Kodachrome 25, 55mm lens, ½ sec. at f/16

CINNAMON FERNS IN AUTUMN.
Kodachrome 25, 55mm lens, ½ sec. at f/16

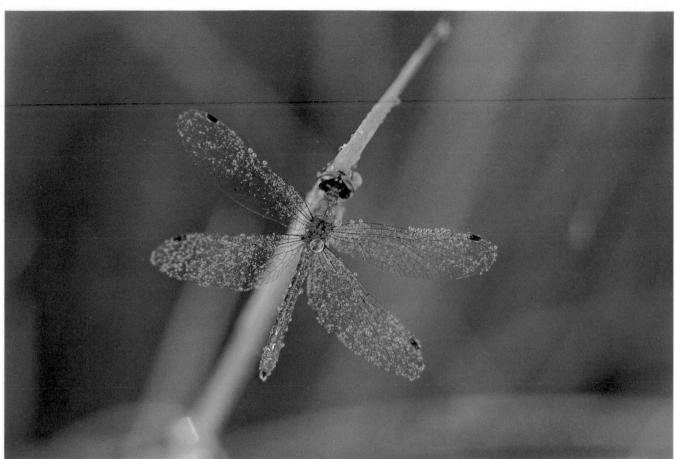

DRAGONFLY AND DEW. Kodachrome 25, 105mm lens, ¹/₄ sec. at f/16

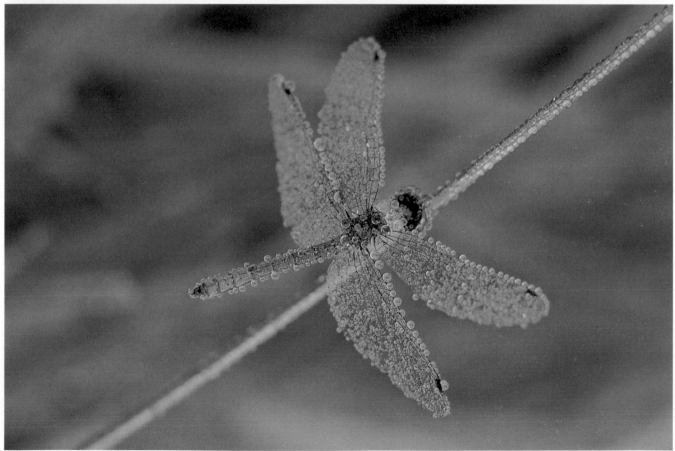

DRAGONFLY AND DEW. Kodachrome 25, 105mm lens, ¹/₄ sec. at f/16

HOW FORMAT AFFECTS AN IMAGE'S IMPACT

One sure sign of a begininng photographer is to look at the format of his or her pictures: they are all horizontal. Changing the format of a photo, though, can change the entire emotional impact of a picture. I grant you that the controls on a 35mm SLR are set up to be used with the camera in a horizontal position. Not all subjects, however, work well in a horizontal composition. Let the lines within the subject dictate the orientation, not the camera body used to make the photograph.

If you intend to try marketing any of your photos to the publishing world, I would also suggest shooting every subject, as much as is possible, in both vertical and horizontal compositions. Different markets demand different formats. Many magazine editors like to see both versions of an image, which gives them some flexibility as to how the picture may be used in a layout. Some markets are very specific. For example, filmstrips are a horizontals-only market, while most magazine covers are vertical only. Wall calendars are generally all one or the other, rarely mixing the two formats within one calendar. Some places have a distinct requirement that is their's alone. *Audubon* magazine, for example, uses a wrap-around cover, which must be a horizontal image that can be divided down the center of the frame.

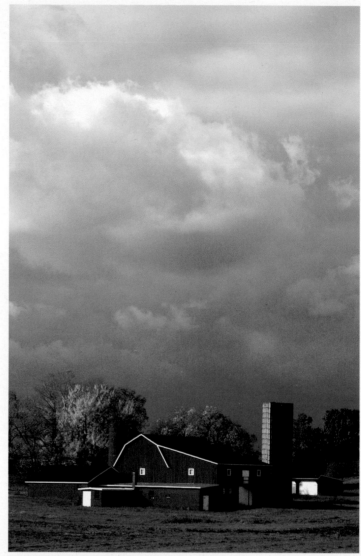

RED BARN AND AUTUMN STORM, Kodachrome 25, 55mm lens, 1/30 sec. at f/11

Photographed from the same spot but framed differently, this scene becomes two distinctly different photographs. There is no right way and no wrong. It's all a matter of taste (or assignment, of course), and the sort of mood that you'd like your photographs to express. However, the vertical framing heightens the impact of the approaching storm.

RED BARN AND AUTUMN STORM, Kodachrome 25, 55mm lens, 1/30 sec. at f/11

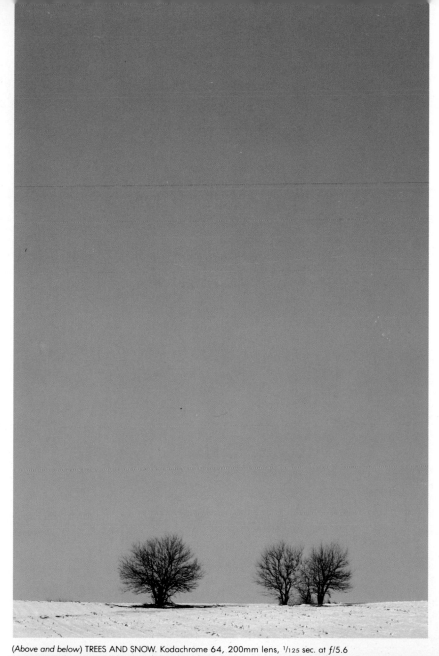

(*Above and below*) TREES AND SNOW. Kodachrome 64, 200mm lens, $^{1}/_{125}$ sec. at f/5.6

Again, the same subject has been photographed from the same point, but the change of format has altered the image dramatically. The horizontal format is by far the more interesting composition.

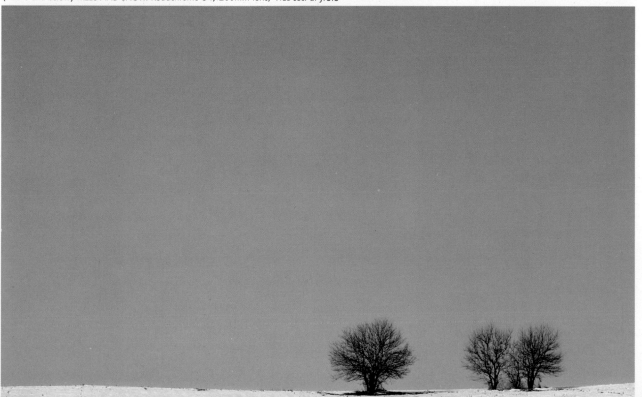

COMPOSITION
POSITIONING YOUR SUBJECT IN THE FRAME

Once you have chosen a subject to photograph and have decided if you're going to shoot a vertical or horizontal, you still have two more decisions to make: How much of the subject should you include and where should you put the subject within the frame?

Framing can be controlled several ways. One method is to change lenses. From any one spot this changes the cropping of the scene without altering the perspective (page 80). Another way is to move closer to or farther from the subject. Or you can move around the subject with one lens, changing the point of view. Less experienced photographers often do not frame tight enough, but rather try to include everything. When you decide what your subject is, frame it so that you are only photographing your subject. Don't get so tight, though, that your subject is touching the very edges of the frame. Natural creatures, whether plants or animals, need a little room to live in.

Placement deals with arranging specific objects in the most effective positions within the frame. The biggest mistake most photographers make is to place the main subject dead center in the frame; a bull's-eye composition. Often you're so excited just to see an animal through the viewfinder that deciding where to place it in the frame is the last thing on your mind. In general, you want action or the implied path of action to be leading into the frame. This gives validity to the space surrounding the subject.

Even with relatively still subjects, trying to concentrate on framing and placement while hand-holding the camera is almost impossible, especially with longer than normal lenses. Your own unsteadiness causes the image in the viewfinder to wave around too much. One of the joys of working with a tripod or other camera support is that you can study the composition before you shoot, rather than getting your pictures back and realizing you should have done it differently.

When you're shooting scenics make sure you keep the image square with the world. One of my pet peeves is seeing slides where the horizon line is cockeyed. If you're having trouble keeping the horizon horizontal, set up your equipment, and then step away and look at the camera back. Sometimes it's easier to judge the camera's position, to see if it is level, rather than looking at the image in the finder.

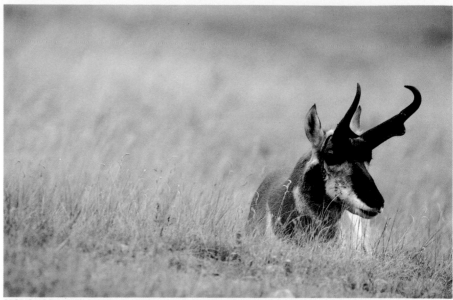

PRONGHORN ANTELOPE ON PRAIRIE, Kodachrome 64, 400mm IF lens, 1/250 sec. at f/5.6

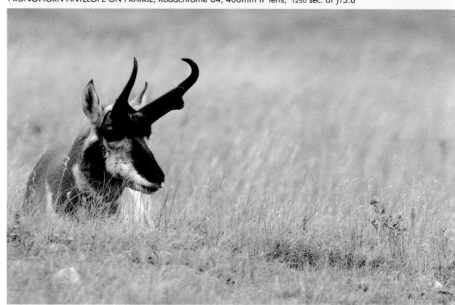

PRONGHORN ANTELOPE ON PRAIRIE, Kodachrome 64, 400mm IF lens, 1/250 sec. at f/5.6

Which photograph of the antelope is the more successful? The one with the animal looking into the frame, since the implied action is included. In the top photograph, the space at left is visually weak and not at all involved with the subject.

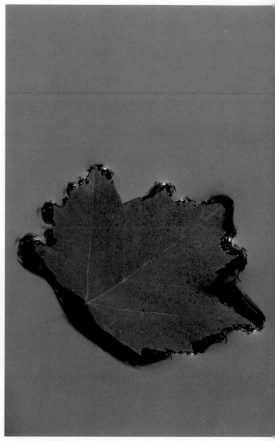

FLOATING LEAF,
Kodachrome 25, 200mm lens, ¹/₁₅ sec. at f/11

I used a 200mm lens for both photographs of this leaf, but I shot from opposite sides of the small pool on which it was floating. In the photo at left the reflections of the autumn trees ringing the pool surround the leaf with color. In the second, above, the viewpoint was carefully chosen to include only the reflection of the blue sky.

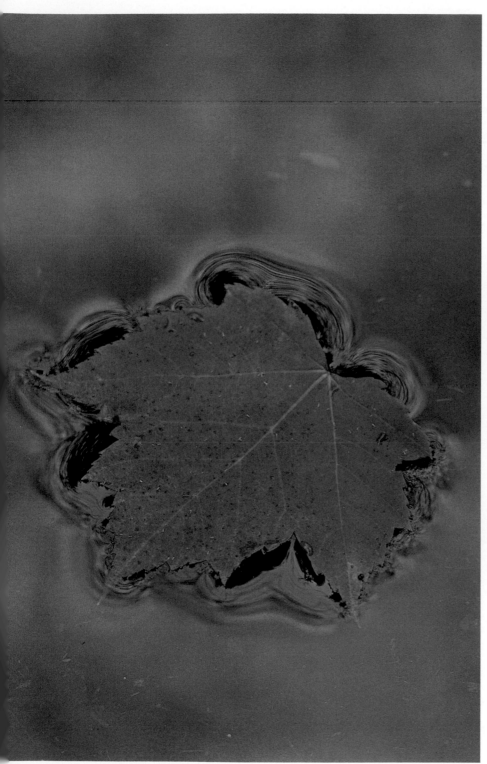

FLOATING LEAF, Kodachrome 25, 200mm lens, ¹/₁₅ sec. at f/11

AN IMAGE'S SPECIAL POINTS OF POWER

PRAIRIE SUNRISE, Kodachrome 64, 500mm lens, ¹/₁₂₅ sec. at f/5.6

No matter the scale of the subject, from scenics to close-ups, the rule of thirds always helps me compositionally, as it did in positioning this lonely tree in the lefthand side of the frame.

(Opposite page) Here is another example of the rule of thirds, this time using a vertical format. The placement of the reeds within the frame adds visual impact to the image, much more so than if the subject had been placed dead center.

Thinking of the elements within the frame in terms of points of power and lines of force will help the composition. Any strong line, whether it be strong by mass, brightness, or color contrast, will stand out boldly. And some positions within the frame are more powerful than others as locations for important subjects.

If you don't know where to start with the placement of the subject within the frame, try the old standby "rule of thirds." Divide the frame into thirds both horizontally and vertically like a tic-tac-toe grid shown at right.

The grid itself is a strong network for lines; horizons, for example, are far stronger when they fall on a thirds line than when they cut through the middle of the frame. And as the pictures here

show, no matter what the subject size, the intersections are powerful points for placing the subject or the subject's most important element. Remember that you have four intersections for a horizontal, and four more possibilities when you flip the camera for a vertical.

Sometimes the process of setting up a tripod, selecting a lens, and adjusting

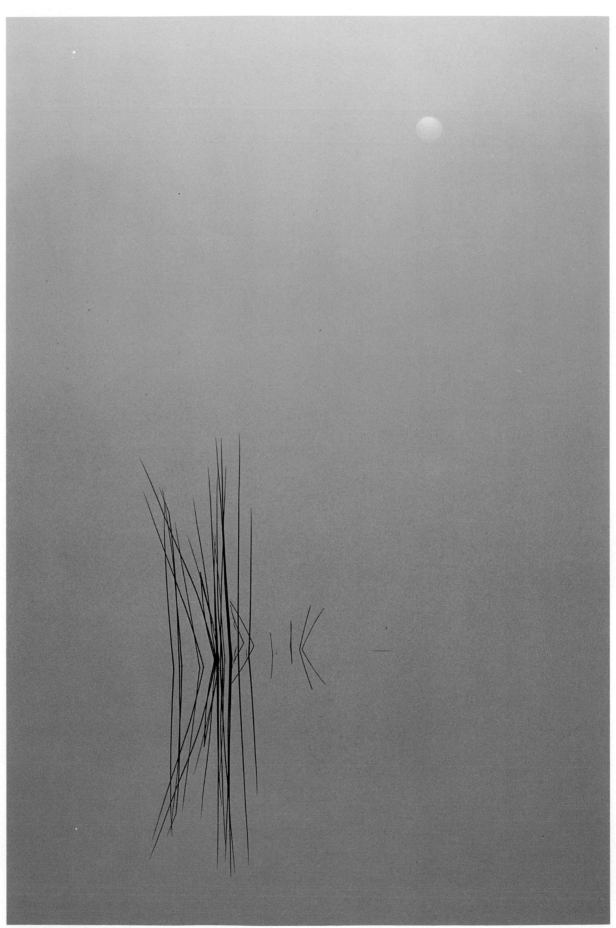

SUNRISE AND REEDS, Kodachrome 25, 105mm lens, $^1/_{15}$ sec. at $f/8$

the camera controls imparts an importance to what you see through the viewfinder that is not valid. You're afraid to change the composition because of all the effort you've already gone through.

Try drawing a sketch first. This is the best compositional aid I know. Take a rectangular note pad roughly the proportions of a 35mm slide and sketch very roughly the major lines and forms of your subject. A sketch of a flower that shows a small circle dead center in the horizontal rectangle of the note pad will quickly reveal your problem. Work with your sketch by changing placement and framing until you have a pleasing composition. Then translate what you have on paper into what you see through the viewfinder by using all the controls available to you.

I'm not trying to suggest that there are any hard-and-fast rules for composition. I've offered these suggestions merely as starting points. You can use them any way you want. Composition is by nature very subjective. Everyone has his or her own unique vision and everyone's pictures should be just as unique.

Both of these photographs are close-ups, yet they are very different compositionally. The butterfly photo is complete in that the subjects are fully included in the frame; the web photograph gives you the impression that the web is grandiose, going on forever and ever. You will notice, however, that both images adhere to the rule of thirds.

CABBAGE BUTTERFLY ON WILD RYE. Kodachrome 25, 200mm lens, 1/8 sec. at f/5.6

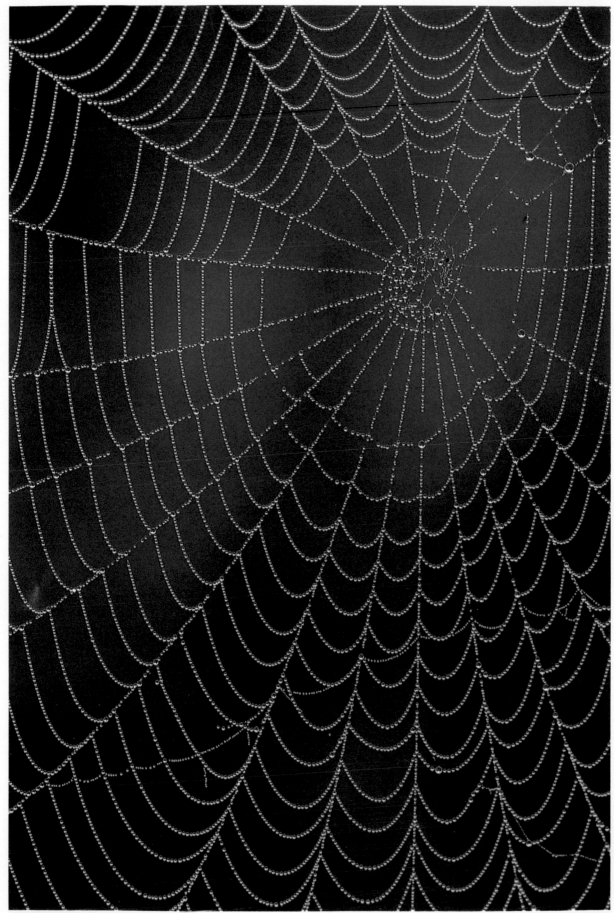

ORB WEB AND DEW, Koduchrome 25, 105mm lens, 1/8 sec. at f/16

CLOSE-UPS

DOWNY NORTHERN VIOLET WITH HAIRCAP MOSS. Kodachrome 25, 200mm lens, 1/4 sec. at f/16

When I found this violet, my inclination was to isolate the blossoms within the haircap moss, thereby eliminating all of the surrounding vegetation. Once I positioned the tripod so that I was shooting flat into the violet faces, I found I needed a narrow angle of view in order to include only the moss. The answer: my 200mm lens.

EASTERN TAILED BLUE BUTTERFLY WITH DEW. Kodachrome 25, 105 mm lens, ¹/₂ sec. at f/11

MAKING LENSES FOCUS CLOSER

Any lens will focus closer if you move it physically away from the film plane, if you "extend" it. Indeed, this "extension" is how a normal 50mm lens focuses to its closest point; it physically gets longer as you rotate the focusing ring. Extension is in my opinion the easiest and best way to shoot close-ups in the field. (If you've tried them, you know that the filter-like screw-in supplementary close-up lenses are of limited power and quality.)

The term macro, as applied to fixed focal length lenses, basically means that the lens has a lot of built-in extension and so can focus very close all by itself. For fieldwork, macro lenses are by no means a necessity. Other lenses work just as well when you extend them by fitting either extension tubes or bellows between the camera body and the lens.

Extension tubes are fixed-length, rigid tubes that can be bought individually or in sets. A bellows unit is also just extension, but it is variable in length. Extension is extension is extension, however you get it. It is simply space between the lens and the camera body. Many macro lenses are sold with a "life-size adapter," which is just a fancy name for an extension tube. If it has no glass in it, it's an extension tube.

The big difference between tubes and bellows, besides the fact that bellows are far bulkier for field work, is the automatic diaphragm coupling. Normally you are viewing through a lens with the aperture wide open. When you push the shutter release, the lens stops down to your selected ƒ-stop, and then opens up again. For the lens's diaphragm to close down when you press the shutter, there must be a mechanical link between the camera body and the lens. Most extension tubes provide linkage while few bellows do. For field photography, especially of animate creatures, this ability to focus quickly and easily with the lens wide open is essential. When you are working in dim

Once I found this lovely, dew-covered butterfly—by no means an easy find—I went on to the next difficult step, which was to position my tripod correctly. Focusing was made much easier by using a rack-and-pinion between the camera body and tripod head. These devices help greatly when you're working at 1X (as I was here) or higher.

light, the added extension makes the viewfinder image even darker, and depth of field is minimal. If you then have to focus at small ƒ-stops, which let in even less light, you will have a lot of problems. You can retain the auto-diaphragm feature on some bellows with a double cable release. One end of the Y-shaped cable goes to the camera body to trigger the shutter; the other goes to the lens to stop down the diaphragm. But this cable is just one more item to carry (and to lose). If you do use a double cable, don't walk around with it attached to the camera and lens. I've seen the top shutter assembly pulled out of a camera when a double cable release caught on a branch. My advice: unless you plan on shooting lots of stationary, inanimate subjects, buy auto-diaphragm tubes.

How many tubes do you need, and how much extension is enough? Here I must introduce some terms and a quick formula. When we talk of close-up photography we generally speak in terms of the magnification of the image on the film. Everything centers around the concept of *life size*, usually expressed as 1×. To shoot life size means you are photographing an area the same size as the film format. With 35mm film, this means you are shooting an area 24mm × 36mm, or about 1 × 1½ inches. The real object and the image on the film are the same size. This is like taking a 35mm slide mount and holding it flush on the subject. Whatever lies within the frame of the slide mount is what you would get at 1×.

The extension you need to get to this magnification depends on the lens you use. A simple formula should give you some answers:

$$\text{Magnification} = \frac{\text{Extension added}}{\text{Focal length used}}$$

Let's say you want to shoot at life size with a 50mm lens. You can see this means you have to add 50mm of extension. Remember that there is some extension built into the lens tube itself so that it can move in and out for focusing. Most 50mm macro lenses, for example, focus to half life size. This means that they have 25mm of extension built in; they can get 25mm longer all by themselves. To reach life size with a 50mm macro, you must add an additional 25mm of extension.

If you know the size of the subject you want to photograph, you can figure out the extension you need by working in terms of magnification. Life size (1×) means photographing an area roughly 1 × 1½ inches; ½× is an area twice as big, 2 × 3 inches; ⅓× is an area three times as large, 3 × 4½ inches; ¼× is 4 × 6 inches; and so on.

Any given amount of extension yields less magnification as the focal length increases. With all lenses focused at infinity, 25mm of extension gives ½× on a 50mm lens; ¼× on a 100mm; ⅛× on a 200mm; and so on. Which lenses you should consider for fieldwork are described on the following page.

After you shoot close-ups for a while you will probably discover that you prefer to consistently use only one or two lenses. Soon you will automatically know roughly how much extension you need for any given situation; you won't need to figure out any formulas. It's easiest to put the extension on, and look at the subject through the lens.

What extension do I actually carry? While I own a bellows that has full auto-diaphragm coupling, I rarely carry it any more. I prefer to use tubes for their more compact size and ruggedness. My field outfit is one 50mm tube, one 25mm tube, and one 12mm tube. If you have a teleconverter, it can help you get more magnification when you have used all of your extension. If you place the converter directly behind the lens you are multiplying the focal length and will need even more extension to reach any given image size. However, if you insert the converter behind the extension, next to the camera body, you will have increased the magnification by the power of the converter. Your working distance will also be the same as it was with no converter at all. When you shoot at magnifications much over 1½× (half again larger than life size) it's best to use the special technique described on page 118.

When shooting natural light close-ups use the mirror lockup device if your camera has one. This eliminates one source of vibration that can cause unsharp pictures. If your camera does not have a mirror lock, check the self-timer. With some of these the mirror goes up at the start of the timer's run. Of course, you can only "lock" the mirror up this way if you're shooting objects that aren't going to move.

YELLOW STONECROP. Kodachrome 25, 105mm lens, ¹/₁₅ sec. at ƒ/11

This very small alpine flower growing from the base of a rock could have been photographed with one of several lenses, from 50mm to 200mm. I chose a 105mm because of its convenient working distance, about 18 inches from the subject.

(Opposite page) Sheet webs lie flat on the ground. A 105mm gave me the working distance that allowed me to spend lots of time checking my composition. I didn't have to worry about accidentally touching the web with my hands or my equipment. With a 50mm I would have been too close; a 200mm used at this image magnification would have required about 50mm of extension. My 105mm macro has enough built-in extension to cover this area properly.

In choosing a lens for close-up work, your main concern should not be whether a lens is macro or not but what the focal length is. It is a lens's focal length, and focal length alone, that determines how a picture looks. Macro lenses are more corrected for close-up work than regular lenses, especially for copying flat subjects like stamps or artwork. But when shooting three-dimensional subjects with a macro and a non-macro lens you would be hard-pressed to tell the difference in the final slides in a side-by-side comparison. Good technique is more important. A less-than-perfect lens, used with good technique (top quality film, sturdy tripod, and cable release) will always yield technically better photographs than the most expensive lens used sloppily.

When picking a focal length for nature close-ups one of the most important considerations is the amount of working distance the lens provides. Working distance is the free space between the front end of the lens and the subject. Having sufficient working distance is vital in the field, because you often cannot get close to your subject without encountering a barrier or disturbing the subject. This is especially a problem since your camera will often be mounted on a tripod. If you try to get tight, frame-filling images with a lens of normal focal length, you are likely to feel very frustrated. This is one reason why I do not recommend buying a conventional 50mm macro lens for field work. To get enough working distance, you need a lens with a longer focal

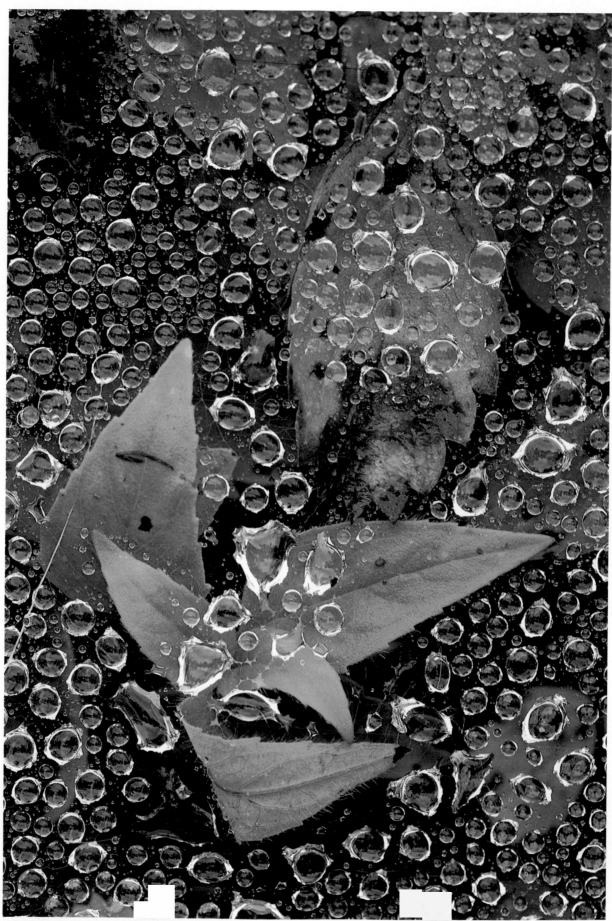

SHEFT WEB AND RAINDROPS. Kodachrome 25, 105mm lens, ¼ sec. at f/16

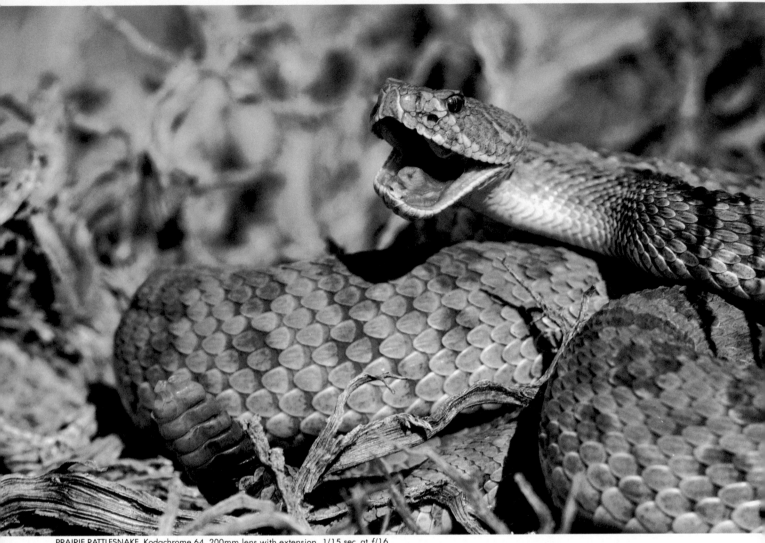

PRAIRIE RATTLESNAKE. Kodachrome 64, 200mm lens with extension, 1/15 sec. at f/16

length—either a long focal length macro or a regular telephoto on extension.

My most often used focal lengths for close-up photography are 105mm and 200mm. If you don't own a lens in this range and are considering these focal lengths, take a serious look at long macros. Because of the built-in extension, they are more convenient to use for close-up work than a regular telephoto mounted on an extension tube. However, if you already own a 105mm, I would suggest not rushing out to buy a 105mm macro. Take the difference in cost and put it into extension tubes or a better tripod.

My own safety was my primary concern when it came to photographing this beauty of a rattlesnake. A 200mm lens allowed me to narrow in on him from a safe distance, about three feet. Even so, I was extremely careful.

(Opposite page) Again, working distance was my main concern. Had I attempted to get any closer to the snake, which I found in the middle of a blackberry tangle, it no doubt would have left. A 200mm gave me enough room to ease my tripod carefully into position about three feet away.

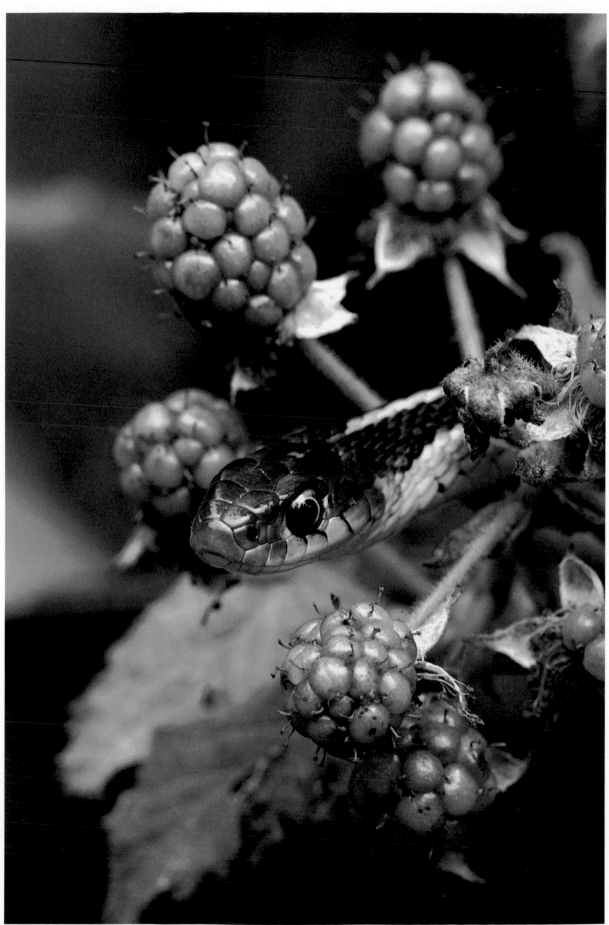

EASTERN GARTER SNAKE. Kodachrome 25, 200mm lens, ⅛ sec. at ƒ/11

HOW LENS LENGTH CONTROLS THE BACKGROUND

Another major consideration in selecting a lens for close-up work is its angle of view. Angle of view determines how much of a scene a lens takes in. A long telephoto lens, for example, has a very narrow angle of view, and it takes in a much smaller area than a normal or a wide-angle lens. Angle of view is important in close-ups because it allows you to control what the background looks like. Since the longer focal lengths take in a narrower angle (diagram), they show less of the background behind the subject. Thus to get rid of a distracting background, you will often find it helpful to use a longer-than-usual focal length since it will allow you to show a smaller and less cluttered area of the background.

A long focal length may also let you, with a slight shift in camera position, select a portion of the background that makes the subject stand out more clearly and distinctly. In the case of the comparison shots of the butterflies shown here, switching from a 105mm to a 200mm allowed me to eliminate a distracting strip of sky.

As the accompanying diagram shows, working distance is porportional to focal length. Therefore, 50mm is twice as far from the subject as 24mm; 105mm is twice that of 50mm; 200mm is twice that of 105mm. The actual angles of view that the lenses have is: 24mm, 84 degrees; 50mm, 46 degrees; 105mm, 23 degrees, 30 minutes; 200mm, 12 degrees, 20 minutes. Notice how going to a longer focal length decreases background coverage.

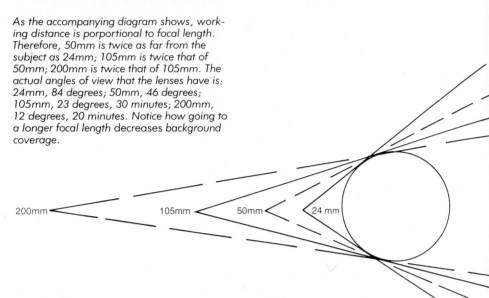

200mm 105mm 50mm 24 mm

VICEROY BUTTERFLY. Kodachrome 25, 200mm lens, ⅛ sec. at ƒ/8

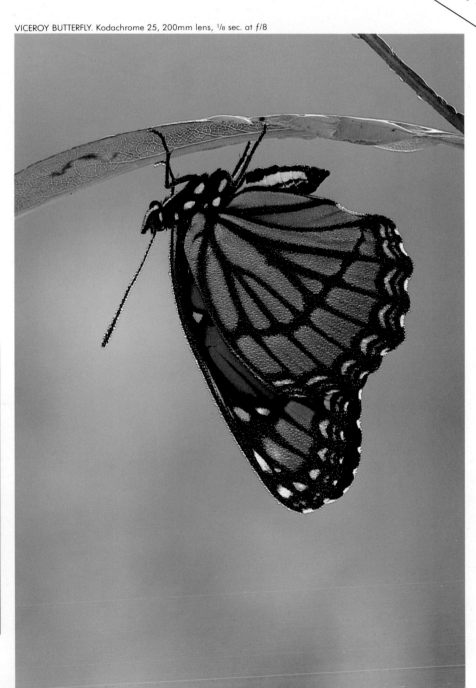

Using a 105mm lens (as I did for the photograph below), the angle of view could not help but include a narrow band of blank sky at the top of the frame. By switching to a 200mm lens, and moving back to retain the same image size, I was able to eliminate the sky and obtain the more successful image shown at right.

VICEROY BUTTERFLY.
Kodachrome 25, 105mm lens, ⅛ sec. at ƒ/8

A 300mm lens was needed here for two rea-. sons: the lizard would not tolerate a closer approach and the long focal length elimina-ted the surrounding tree limbs.

(Below) Lobelia grows in low, damp areas, areas usually filled with other assorted vege-tation. To isolate the lobelia, I used a 105mm lens. This focal length was long enough for background control, yet short enough so that I did not need a great amount of extension to attain the image size I desired.

CLARK'S SPINY LIZARD. Kodachrome 25, 300mm IF lens, 1/60 sec. at f/11

GREAT LOBELIA AND DEW. Kodachrome 25, 105mm lens, 1/2 sec. at f/16

MAKING SURE YOUR SUBJECT LOOKS SHARP

TIGER SWALLOWTAIL BUTTERFLY. Kodachrome 64, 200mm lens, 1/8 sec. at f/11

When shooting close-ups do you find that your picures don't seem to be in sharp focus across the frame? One part of the picture is in focus, but not the rest. Of course, you want all principal areas to be sharp.

There is no way that everything in a close-up photograph can be in focus. One of the laws of optics is that as magnification increases, depth of field decreases. And the drop-off is very dramatic. This seems to imply that you should always shoot at very small f-stops, but that is not an answer for a couple of good reasons. First, you should be able to pick a large f-stop if you want. Sometimes a wide-open, selective-focus photograph is exactly what is called for. Second, the long exposure times dictated by the smallest f-stop, compounded by light lost to extension, are not always practical in field work.

To keep the principal parts of a sub-ject in focus, you have to first identify the plane of the subject that is the most important and then very carefully line up the camera's film plane so that it is parallel to that subject plane. Depth of field is usually so limited that you do not have much leeway for error. Working at $1/4 \times$, photographing a subject roughly 4×6 inches you have a *total* depth of field of only about $1/2$ inch at f/11. Working the tripod into a position where the camera can be made parallel to the subject's principal plane is one of the most difficult, time consuming, and essential aspects of close-up photography. But being parallel to the subject means you can use wider apertures, and hence shorter exposure times. Once you think you're set up in the right spot, it sometimes helps to stand slightly to the side and look at the camera, checking that the back is parallel to the subject.

Using a longer than normal lens is

When I photographed this butterfly, I was looking down at a very slight angle. Even though it is shot at f/11, the depth of field at this image size is not sufficient to keep the top of the wings in focus. In order for them to have been in sharp focus, like the lower half of the butterfly, I should have photographed from about 6 inches lower, at which position the film plane would have been parallel to the subject.

(Opposite) You can expect to get fine quality if you take the time to position the tripod so that the film is parallel to the principle plane of the subject. This is precisely what I did when I photographed the sumac—and I'm very glad for the result.

also a help, since it gives you more working distance. This means that any error in lining up parallel to the subject will not be so critical. If you're 1 inch out of position, but 2 feet from the subject, that's one thing, but if you're 1 inch out of position and only 6 inches from the subject, you're in deep trouble.

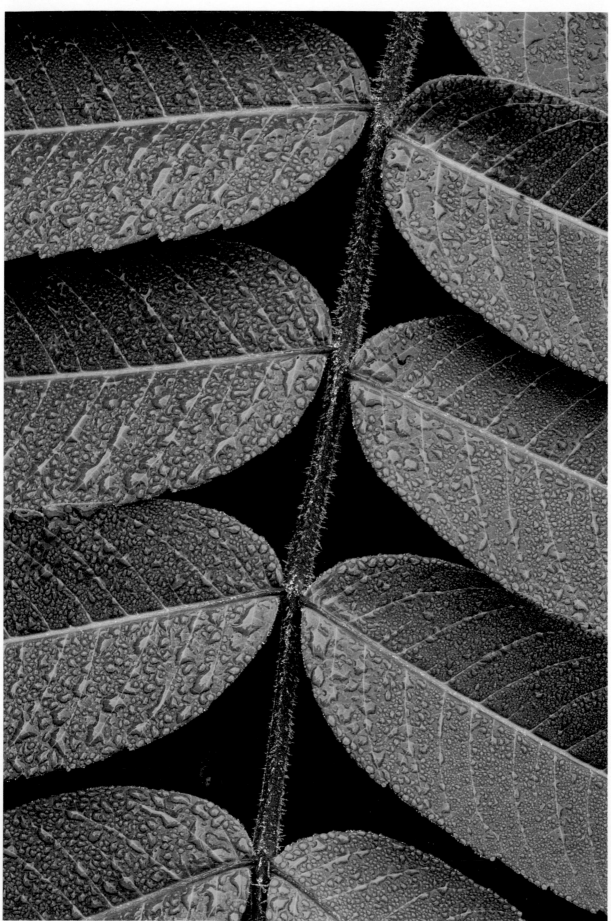

STAGHORN SUMAC AND DEW. Kodachrome 25, 105mm lens, ¼ sec. at f/8

DETERMINING CLOSE-UP EXPOSURES WITH A METER

Adding extension permits lenses to focus closer, but it also changes the exposure. You've probably heard the phrase, "extension costs you light." What this means is simply that as the front of the lens gets farther away from the film there is a corresponding decrease in the amount of light reaching the film. The tubing between the lens and the camera is just like a tunnel, and as you go deeper into a tunnel there is a rapid drop-off in the amount of light. Thus as you add extension you lose light.

One of the great advantages of your camera's through-the-lens meter, however, is that it compensates for all the extension. It reads the light actually passing through the lens and tubes, so you can just meter at the exact extension you need for your subject. Exposure is determined basically the same way for a close-up as it is for a distant scenic. You should first calibrate your camera's meter to give a correct exposure when you take a reading from a middle-toned subject (page 18). Then, with a middle-toned subject, just meter it with your camera and shoot at what the meter says. If your subject is not middletoned, first focus on the subject. Then swing aside and, without refocusing, meter a middle-toned area in the same light. I stress not refocusing, since every change in extension, including extension within the len's focusing mount, changes the proper exposure. If there is no middle-toned area, you can always read your palm and open up one stop (page 20).

BRACKEN FERN AND SNOW. Kodachrome 25, 200mm lens, ¹/₁₅ sec. at ƒ/5.6

(Top) *Exposure was critical to achieve this "graphic design." If I had shot at my through-the-lens meter reading, the snow would not have been as white as it is here. By comparing an incident hand meter reading with a TTL reading off my hand, I got my answer.*

(Right) *Once I had added enough extension to frame as I desired, I metered the middle-toned green background area. The lighting was very even early this summer morning.*

(Opposite page) *With nothing middle-toned in the frame or nearby to meter, I used an incident hand-meter reading. Then, as determined by indoor tests that I had conducted beforehand, I opened up the number of stops needed for this magnification.*

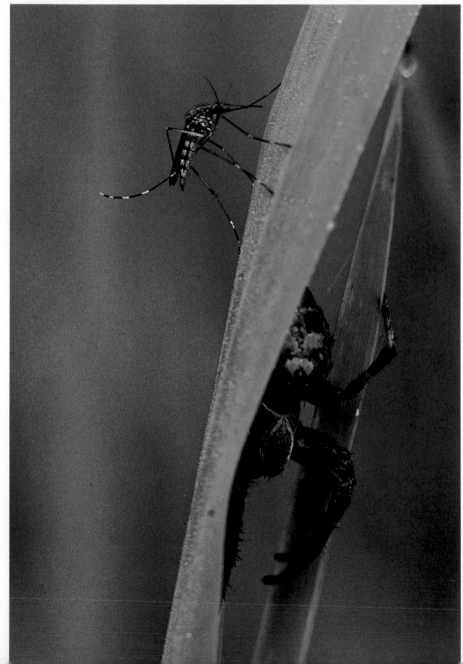

MOSQUITO AND SPIDER.
Kodachrome 25, 105mm lens, ¹/₂ sec. at ƒ/11

RACCOON TRACKS AND FROSTED OAK LEAF. Kodachrome 25, 105mm lens, ¼ sec. at f/16

DETERMINING CLOSE-UP EXPOSURES BY CALCULATION

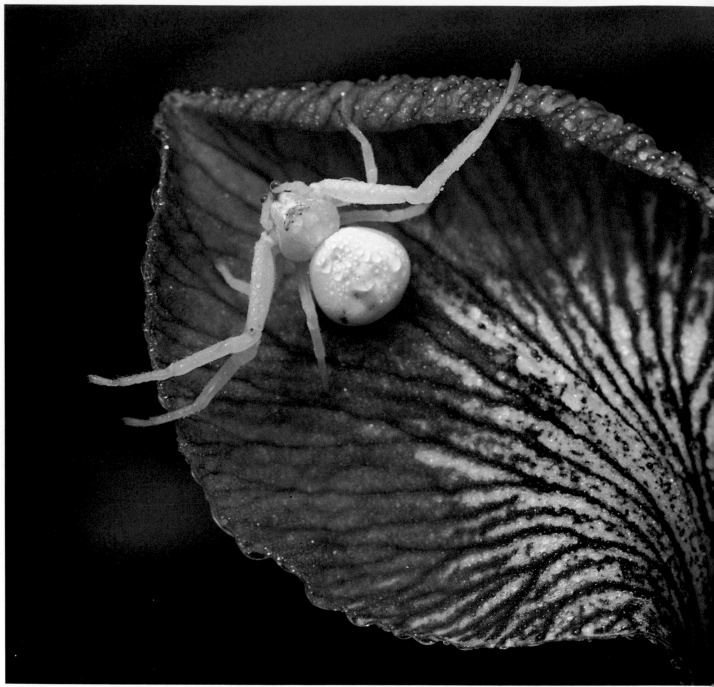

CRAB SPIDER AND WILD IRIS. Kodachrome 25, 105mm lens, 1 sec. at *f*/11

Another way of determining the exposure for close-ups that is helpful when you are using a hand-held light meter or the sunny *f*/16 rule is to work in extension factors. You will probably discover as you shoot close-ups that you do most of your work with only one or two lenses. It's fairly easy to figure out what various extensions cost you with these lenses in terms of stops. With your equipment on a tripod, meter an indoor wall in unchanging room light; the ISO speed set on the camera doesn't matter. Pick a shutter speed that gives you

a medium *f*-stop, such as *f*/8, with the lens set on infinity. Now add an extension tube and record the change in the exposure. How much do you have to open up to get back to proper exposure? That is the amount that you will need to open up from your hand meter reading or from your basic sunny *f*/16 exposure. Do this test with all of the extension tubes you plan to use. Then do the same test with the lens alone to see how much light the lens itself absorbs when it is extended to focus to its nearest distance. Add these factors to-

gether when you shoot close-ups.

For example, let's assume you're shooting in bright sun, using a 105mm lens on a 25mm extension tube. You know from your test that this tube, on this lens, costs you 1/2 stop of light. So, working from your base sunny *f*/16 exposure, just open up 1/2 stop and the exposure will be right. Now you want to photograph even tighter and you rack out the lens all the way until the focusing ring is on its nearest distance. From the test, you know that doing this costs you 1 stop. Add the 1 stop to the tube

MAPLE LEAF IN BRACKEN FERN. Kodachrome 25, 105mm lens, ¹/₆₀ sec. at f/5.6

I was very concerned that a slight breeze would rob me of a clear image of this delicate subject. The subject, a leaf caught on a fern, did not require much depth of field since it is basically a flat plane. This consideration allowed me to shoot with a 105mm lens almost wide open at the fastest shutter speed possible, but even so I waited until there was a lull before I shot. Over half of my other frames, though, were not sharp due to the nagging wind.

One of the best lessons a nature photographer can learn is to always be on the alert for the unexpected. The crab spider is known to camouflage itself among flower petals, hiding in wait for its prey. So I was very surprised to find this subject standing out so clearly against the wild iris early one morning. Having worked out my exposure values in advance, I was able to get this quick shot without any problems.

factor, since you're still using the tube, and you must open up a total of 1½ stops from sunny f/16.

If you own a hand meter and do a lot of close-ups, it's useful to make a little table of extension factors and carry it in your wallet. Mine shows the factors for my two most used lenses, my 105mm macro and my 200mm telephoto. The factors are listed for the lens extended alone, then for various tubes. I just take a hand meter reading—generally an incident reading—and then add the factors together and open up that amount.

WAYS TO CONTROL NATURAL LIGHT

Some of the most bothersome problems that you'll run into shooting close-ups are the result of bright contrasty sunlight. Harsh shadows around the subject or hot spots in the background destroy the delicate mood you want in your images. Shooting on overcast days is one way to control contrast, but you also need a way to control light on sunny days—a way to open shadows and tone down highlights.

The solution is to make a set, at least two each, of reflectors and diffusers. With these items you can manage the lighting of smaller subjects to an amazing degree.

The simplest reflectors you can make consist of pieces of corrugated cardboard covered with aluminum foil that has been crumpled and then mostly smoothed out. Glue the foil—rubber cement works—to the cardboard and then tape around the edges. The reflectors don't have to be large, just a convenient size to carry with you. For years I've used a pair made from 8 × 10-inch gray cards, covering the white side with foil while leaving the gray side available for use. Crumpling the foil gives a nice diffused highlight. If you need more reflected light, more of a spotlight effect, make one with plain uncrumpled foil.

To soften direct sunlight, make two 1 to 1½-inch wide picture frame—like rectangles of corrugated cardboard about 9 × 12 inches. Sandwich cheesecloth between the two frames, then glue or staple the two layers together. Use additional layers of cheesecloth for a more diffused effect.

To use either a reflector or a diffuser, prop it against twigs scrounged at the site. You can soften the light hitting the subject with the diffuser, then open the shadows with reflectors. In very bright sunlight try shading the subject with a solid cardboard reflector, then use another one to bounce some direct light back onto the subject.

To make a subject stand out against a background, or to eliminate annoying hot spots in a background, you can also use your solid reflectors to shade the background. Sometimes, as in the comparison shots of the dragonflies here, you may also need to use your jacket or some other handy item to throw the background into shadow.

Even on the most overcast day, it's amazing how much light can be controlled by using reflectors, diffusers, or other controls.

DEWY DRAGONFLY. Kodachrome 25, 105mm lens, 1/8 sec. at f/16

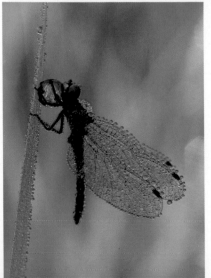

The small photograph at left was shot using normal exposure values. As you can see, adding foil-covered reflectors to bounce light onto the dragonfly improved the image in the photograph above dramatically. Not only is the dew more noticeable, but the dragonfly is well-separated from the background.

DEWY DRAGONFLY.
Kodachrome 25, 105mm lens, 1/15 sec. at f/16

SPHINX MOTH CATERPILLAR WITH WASP LARVAE CASES. Kodachrome 25, 105mm lens, ½ sec. at f/11

The only difference between these two photographs is, again, the use of foil-covered reflectors. Now the caterpillar really stands out as the subject, rather than blending in to the same tonality as the background.

X MOTH CATERPILLAR WITH WASP LARVAE CASES. Kodachrome 25, 105mm lens, ½ sec. at f/11

FLASH FOR FREEZING SMALL AGILE CREATURES

If you have ever tried photographing small animate creatures by natural light you know that it is a maddeningly impossible feat. The combination of using slow speed film for quality, extension for close focusing, and a small aperture for depth of field forces you to use slow shutter speeds and tripod support. Yet few small creatures stay still long enough for you to set up a tripod and take a shot of 1/8 sec. or longer. Many guides suggest catching small subjects and refrigerating them so they can't move. A good naturalist can tell photos of chilled subjects. After all, if you photographed a human who had been refrigerated until he could not move you could easily tell something was wrong in the pictures. The same is true of other subjects. Chilled subjects yield photos of chilled subjects.

Flash is the real answer. And for field work, you need a fast, mobile, handheld, easily used system. The first requirement is a *small* flash unit. Choose one with a manufacturer's guide number of about 30 or 40 at ISO 25. You can get one very inexpensively, but make sure

it can be taken off the camera's hot shoe. It must be a manual flash or an auto-flash that can be set on manual. You do not need a large flash for close-up work. In fact, a small flash will give you better lighting. A large, powerful flash must be placed far away from the subject. It becomes, in effect, a point source of light and gives harsh black shadows. A small, weaker flash can be placed close to the subject. The flash tube and its reflector are now large in relation to the subject and you end up with softer, more open light. Used close to the subject, a small flash acts like a light bounced from an unbrella. Avoid a ring light—a flash that encircles the lens. The flat, shadowless light that it produces just looks unnatural with field subjects.

For most close-up subjects, you also only need one flash. Directional lighting may not be flattering to people, but it's best with nature subjects. You want to delineate every scale on that butterfly's wing and every hair on that spider. Get all the sharpness you can from that lens you spent so much for by using only one

light and using it close. With a single light, you also avoid the problem of unnatural-looking multiple highlights; the flash produces a single highlight like the sun.

With flash, you should plan on using an extension-based close-up system; the quick, easy-to-use system for determining flash exposure described on the following page assumes that a certain amount of light will be lost to extension. That system also assumes that you will be using a short telephoto in the 85mm to 135mm range. I use a 105mm. If you use a zoom, set it at the focal length you pick, then use extension to make it focus closer. Don't use its macro mode if it has one since that also will not work with the exposure system. What I consider to be an ideal all-around field outfit is a 105mm macro lens that focuses to 1/2 life size all by itself, mounted on a 25mm tube. With no extension in the lens itself, only the tube, you're at 1/4 life size; rack out the lens to its nearest focusing distance and you are at 3/4 life size. Most subjects encountered are in this range. If you

EASTERN HOGNOSE SNAKE, Kodachrome 25, 105mm lens, 1/60 sec. at f/11

need more magnification, you just add another tube. Finally, use slow speed film—ISO 64 at the fastest. At the slow shutter speeds required to synchronize flash, you are too close to daylight exposure with higher speed film. You will end up with two images: one from the flash and a fainter ghost image from the daylight.

While feeding on the flower, this butterfly moved constantly from blossom to blossom. I needed to maneuver, thus a hand-held outfit was the only practical method of photography.

EDWARD'S HAIRSTREAK BUTTERFLY. Kodachrome 25, 105mm, ¹/₆₀ sec. at f/16

Flash was essential in order for me to photograph this snake because the natural light exposure was about 3 stops off bright sun. Without flash I could not have stopped the motion of the snake.

THE EASY WAY TO DETERMINE FLASH EXPOSURE

RUDDY DAGGERWING BUTTERFLY. Kodachrome 25, 105mm lens, 1/60 sec. at f/11

This large tropical butterfly enters the United States only at the southernmost points. For this large subject the base exposure was changed to open up 1/2 stop.

I've read about all sorts of methods for calculating exposure when you are using flash for close-ups. Some recommend holding a small ruler marked with exposure factors next to the subject. Others involve formulas. But none are practical for field work. Any living creature is going to leave when you poke a ruler at them. And while you are doing the calculations formulas require, the butterfly you wanted to photograph will have flown into the next county.

There is a fast, easy method for determining proper flash exposure for close-ups in the field. It is based on the idea that as magnification increases, that is, as you add extension, you need more light to make up for the light lost in extension. But as you add extension, you have to move physically closer to the subject in order to focus. If the flash is also moved closer to the subject you get more light. Therefore, if as you add extension and move closer to the subject you simultaneously move the flash closer, they will cancel each other out.

This will work as long as the flash and the lens are kept in the same relative positions and if they move back and forth in lock step. And it works only for magnifications of about 1/6× or greater. That covers an area of about 6 × 9 inches or smaller. Most insects, frogs, spiders, and other small creatures are in this range.

To figure out close-up flash exposure, find any middle-toned subject: green grass or an eraser on middle-toned carpeting. Set your equipment for any close-up size, 1/6× or closer. Pick a reference point at the front of the extension. I use the front edge of the lens since I can always find it. Position your flash three or four inches above this point and aim it at the subject. Now, without changing anything but the *f*-stop, run an exposure test, keeping careful notes. Shoot a frame at *f*/8, one between *f*/8 and *f*/11, *f*/11, between *f*/11 and *f*/16, *f*/16, between *f*/16 and *f*/22, and *f*/22. When you get your slides back, critique them as you nor-

TARANTULA. Kodachrome 25, 105mm lens, 1/60 sec. at f/11

mally do, whether on a light box or by projection. Pick the exposure that you consider correct. With most small flashes, a 105mm lens, and ISO 25 film, this will probably be somewhere between f/11 and f/16. Whatever your f-stop is, that is now your neutral subject exposure.

It doesn't matter if you change extension. As long as you always position the flash over the reference point and aim it at the subject, you will shoot at the same f-stop. You will change exposure only if the subject is not middle-toned (page 20).

You may object that this limits you to a set f-stop. Believe me, in the field it is hard enough to see the subject through the viewfinder, let alone worry about

f-stops. When you're standing chest deep in a pond at night trying to locate a singing frog, the difference between f/11 and f/16 is meaningless.

You might also ask why you should bother with all this flash testing when you could use an auto flash or through-the-lens auto flash metering. An auto flash does not take into account light loss due to extension. TTL flash metering does, but it operates on the same principle as an exposure meter: it wants to make everything neutral. It would work fine if the only subjects you photograph are middle-toned. But if you shoot the white tiger beetle, *Cicindela lepida,* on light-colored sand, its natural habitat, it will turn out a middle-toned beetle on middle-toned sand.

The law of optics says: as you gain magnification, you lose depth of field. That means focus is critical for close-ups. In portraits such as this, always be sure to focus on the eyes. If the eyes are out of focus, the whole picture will seem so. If you attempt to capture a highlight—from the light source—in the animal's eyes, the animal will look more dynamic.

111

MAKING A THIRD HAND TO HOLD THE FLASH

Now that you've run your close-up flash tests and are all set to go photograph in the field, how are you supposed to keep the flash over the reference point? You could just hold it there, shooting one handed, but that is very awkward.

There are several choices for a "third hand" to hold the flash. The most common are rings that screw into the lens like a filter and hold a flash to the side. But I would suggest not using these for two main reasons: I would rather not have the extra weight of a flash and support arm cantilevered out on the end of my expensive lenses, and, more importantly, the light is at a fixed distance off the lens axis. This means that the lighting is always going to be the same. This fixed distance is not very great, either, meaning that the light is going to be rather flat.

The best solution is to make your own bracket. The one that I use is shown in the accompanying photograph and diagram. I call it a "butterfly bracket," after the subject it is most often aimed at. The bracket consists of a basic L-shaped frame that mounts on the camera bottom and projects out at an angle in front of the camera. On top of this, there is an arm on a ball-and-socket joint. The arm holds the flash, and the flash can be positioned at any point along the length of the arm. This gives you the maximum flexibility in positioning the flash.

To make the bracket, all you need is a length of 1-inch wide, 1/8-inch thick aluminum strap and some fittings that you can get at a well-stocked photo supply store. A vise is useful for bending the metal. For the base piece cut a piece of aluminum strap about 1-foot long. At one end of the piece, drill a hole about 1 inch in from the end. This hole is for the tripod screw that will mount the piece to the camera. At the other end of the piece, drill a hole 1/2 inch in from the end. This hole is for mounting the ball-and-socket unit. All you need is a small ball-and-socket unit; it has a hole with standard tripod threading for mounting, and can be mounted with a 1/2-inch long bolt. To form a tab to support the ball-and-socket unit, bend the aluminum piece at a right angle about 1/2 inch in from the second hole. Now to form the main angle in the piece, first bend the other end of the piece at a right angle so that when you mount it on your camera's base it will rise straight up along the side of the camera about 1/2 inch out from the edge. Next bend the right angle you just formed so that instead of coming straight up vertically along side the camera, it will project forward at about a 45-degree angle.

Now to make the arm that holds the flash, cut another piece of aluminum strap about 7 inches long. Drill a hole about 1/2 inch in from one end, and about 1/2 inch in from that bend the piece at a right angle to form a tab. The threaded stud on the ball-and-socket unit will be secured to this tab with a nut and lock washer. Now all along the length of the arm drill holes at about 1-inch intervals. These holes are for attaching the flash, and the series of them allows you to position the flash at any point along the length of the arm. To mount the flash, you need a flash shoe, a simple bracket designed to hold a flash to a light stand by its hot-shoe base. The flash shoe is not a hot shoe; the flash must be connected to the camera by a cable. As an alternative to the series of holes, you can have a slot milled in the arm as on the bracket shown in the accompanying photograph.

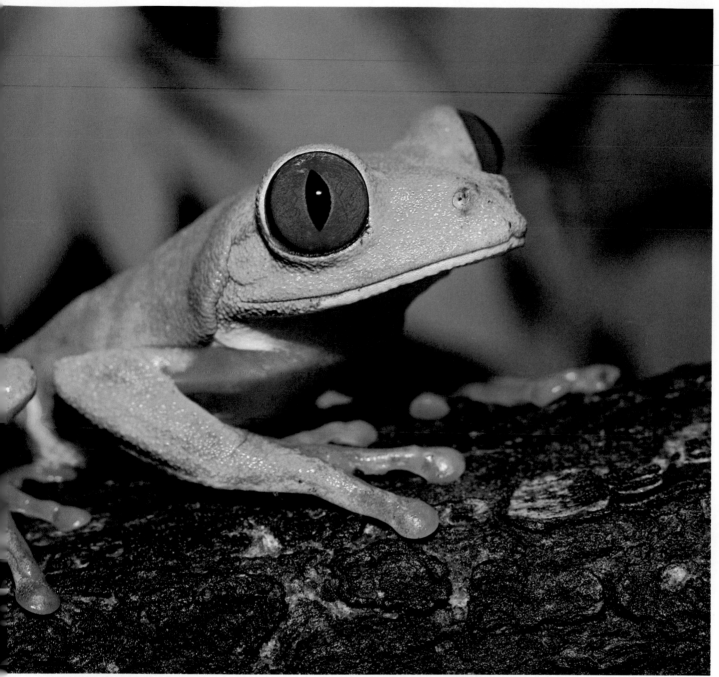

RED-EYED TREE FROG. Kodachrome 25, 105mm lens, 1/60 sec. at f/11

Shot at roughly 1/2X, I positioned the flash over the reference point and angled down at the frog. A middle-toned subject, the frog was photographed at my tested middle-toned exposure.

The butterfly bracket is shown at left with a small flash positioned over my reference point.

THE BUTTERFLY BRACKET

THE PRACTICAL WAY TO SET FLASH ANGLE

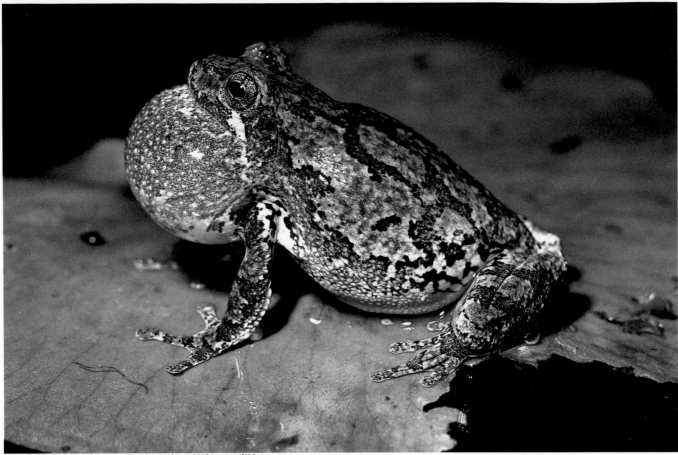

GRAY TREE FROG. Kodachrome 25, 105mm lens, 1/60 sec. at ƒ/11

When the male frog "sings" at night he's actually calling for the females in the spring ponds they populate. Wearing chest waders, I got into the pond with flashlight in hand, and looked for a singing frog. When I found him, I waded over ever so slowly. The night temperature has to be fairly warm in order for the frogs to continue singing and for you to feel comfortable in the water. At 45 degrees the frogs will stop singing; at 65 degrees you can photograph easily. For this photograph, and under the circumstances, I opened up one full stop from my base neutral exposure.

Determining the exact angle of the flash relative to the subject is best done through some experiments. Find a few small objects around your house of different shapes and textures, and take a series of photographs with the flash at different positions. Keep careful notes on what you're doing and evaluate the results critically. A good exercise in lighting is to mount your camera on a tripod, then use a small high-intensity desk lamp to illuminate any small object. Study the lighting through the viewfinder as you move the lamp around the subject.

Many guides insist that you should always light subjects from the head end. This is fine for indoor shots of non-moving subjects, but trying to keep the light on the head side of a constantly moving butterfly is hopeless. You will get the most flexibility if you instead use as a standard starting point what is often called "high basic lighting." Regardless of the camera's orientation, keep the flash on axis vertically a few inches above the lens, so that you are lighting the subject from about 30 degrees directly above the lens. This will give you good lighting no matter which way the subject turns. To take vertical shots with the butterfly bracket, you simply loosen the ball-and-socket joint, swing the arm 90 degrees to the side so that the flash is once again in its high basic position over the reference point, and then tighten the ball-and-socket. Be sure that you try it before you go out into the field.

Positioning the flash 30 degrees vertically off the camera-to-subject axis is just a starting point. Some subjects require adjustments. Working outside on a convoluted three-dimensional subject that does not have a lot of surface detail, a frog for example, you may want the flash a little lower than 30 degrees. This way the light is driven back into what would have been shadowed areas—more of the subject is frontlit.

Photographing rather flat subjects you will want the flash farther off axis, either by moving it higher vertically or by moving it horizontally to the side. For example, a butterfly with spread wings is not much of a three-dimensional subject. Photographing one totally spread is a lot like photographing a postage stamp. As the comparison shots here show, the only way you can get surface detail to show, in this case wing scale detail, is to skim the light more from the side, across the butterfly. Move the light farther off axis, but keeping it the same distance radially from the subject as your reference point. If your reference point is 12 inches from the butterfly, you can position your flash anywhere on an arc 12 inches from the insect and still keep the same f-stop. You may want to try up to 45 degrees off axis. If the butterfly is spread on sand, or some other solid background, you might try even more

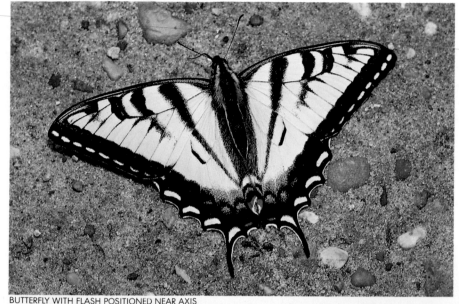

Occasionally, when photographing a subject with a relatively flat surface plane, you will want to move the flash slightly farther off axis. For example, with the two photographs of the butterfly shown here, I wanted to bring out the surface detail of the wings. In the first photograph (left) the flash was positioned near the axis, which resulted in a rather flat lighting. By moving the flash farther off axis, I was able to skim the light over the surface of the wings, revealing their texture.

BUTTERFLY WITH FLASH POSITIONED NEAR AXIS

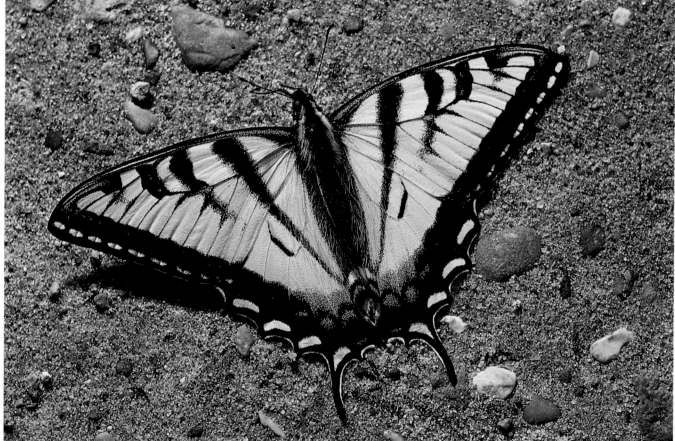

BUTTERFLY WITH FLASH POSITIONED OFF AXIS

off axis. Without a solid background immediately behind the insect, though, be careful that you don't end up lighting just the subject and not spilling some of the flash onto the background. After all, you don't normally see butterflies at night with a black background.

Don't add a second light from the camera position to fill in the background shadows. The sharp sidelighting of the first flash creates delineated detail. The second light will only destroy all the sharpness you just created, since it flattens the lighting on the subject. Re-

member lighting a butterfly with flash is not the same as lighting for human portraiture. With people you are generally trying to hide facial defects and blemishes, while with insects and other small subjects you're trying for all the sharpness possible.

115

MORE TIPS ON TAKING FLASH CLOSE-UPS

LONG-HORNED BEETLE ON WILD ROSE. Kodachrome 25, 105mm lens, 1/60 sec. at f/16

Once you have gotten your flash positioned and have determined the proper f-stop for correct exposure of middle-toned subjects, actually taking flash close-ups in the field is a fairly simple process. There are, however, some things you should keep in mind. When you approach a subject, come in slow and low. Preselect the magnification you want, and have the extension tube in place before you start to close in on the subject. You can fine tune the magnification once you have the subject in the viewfinder by turning the focusing ring to extend or pull in the lens itself. When you focus, however, you will find it much easier if, instead of turning the focusing ring, you physically move back and forth with the camera.

Be sure to brace yourself as much as possible when you take the shot. Depth of field is so limited when you are shooting small subjects that a slight accidental shift of the camera as you press the shutter can throw you off.

The camera can be off by a 1/4 inch, and the whole shot will be out of focus. Also, just as when you are shooting from a tripod, you must be careful to make the camera's film plane parallel to the visually most important plane in the subject. You must pay special attention to this because it is much more difficult to do when you are holding the camera in your hands. A shot that lacks this plane of sharpness will look unacceptably out of focus. Overall, the process of taking flash close-ups of small animate subjects is a very physical and involving form of photography.

In the field you will also have to be alert to adjusting your exposure when you encounter subjects that are not middle toned. From my experience, these are the primary times when you will have to change your f-stop:

Small, bright subjects such as a little bright butterfly, stop down 1/2 stop.

The use of a flash was essential for this photograph. The flash not only stopped the motion of the beetle, but allowed me enough depth of field to capture the flower in complete focus throughout.

White subjects, or subjects on light sand, stop down 3/4 stop.
Large objects, monarch-butterfly size, open 1/2 stop.
Large dark objects, monarch size but dark, open 1 full stop.

Base your initial exposures on these, but be sure to keep some notes for the first few rolls of flash close-ups you shoot. That way you will be able to determine exactly what exposure adjustments you like best, and soon you will know instantly what exposure to use when you shoot.

If a subject is highly reflective, like Sulphur butterflies, don't change the f-stop you regularly use with your flash, but do angle the flash so that the light hits the subject more from the side.

GUADELOUPE METALMARK BUTTERFLY. Kodachrome 25, 105mm lens, 1/60 sec. at f/16

When I photographed the metalmark, I had to skim the light a little more than the normal 30-degree angle to make sure the metalic bands of the butterfly wings would come through on film.

JUMPING SPIDER WITH PREY. Kodachrome 25, 105mm lens, 1/60 sec. at f/11

This photograph of a jumping spider may look tricky, but actually I used a straightforward, normal angle for the positioning of the flash.

A SPECIAL TECHNIQUE FOR SHOOTING TINY SUBJECTS

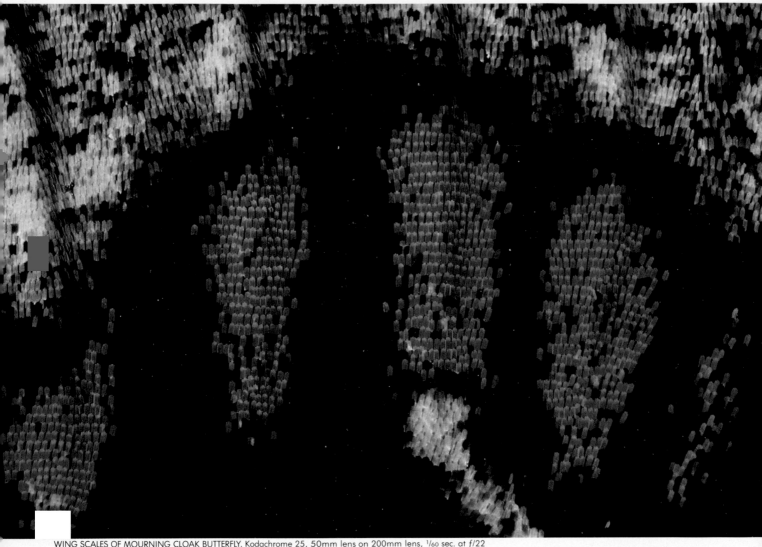

WING SCALES OF MOURNING CLOAK BUTTERFLY, Kodachrome 25, 50mm lens on 200mm lens, ¹⁄₆₀ sec. at f/22

The subject was fairly easy to come by—I plucked it out of the grill of my car! Then I stacked a 50mm lens on the front of my 200mm, and I was ready to close in.

For close-ups of very small subjects, requiring magnifications of roughly 2× to 4×, extension-based close-up techniques are no longer practical, since you need an unwieldly amount of extension. One solution is to reverse your standard lens. But this disconnects the lens's auto-diaphragm linkage, you must focus with the lens wide open and then manually stop down the lens for shooting. The real answer is instead to use what I call stacked lenses, a system based on added supplementary lenses. You're familiar with the filter-like, screw-in supplementaries, the plus diopter lenses. They yield low magnifications and are not of very good optical quality. But there are high-quality, multi-element, coated close-up lenses that you can use as supplementaries and, best of all, you already own them: they are regular lenses.

If you want to see how it works, mount a longer-than-normal lens on your camera. I'll call this the prime lens. Take your normal 50mm lens, leave it wide open, hold it reversed directly in front of your longer lens so that the two are touching, and look through the viewfinder. Working distance will be only a few inches, but you have instant high magnification. A rough formula for the magnifications obtained this way is:

$$\text{Magnification} = \frac{\text{Focal length of prime lens}}{\text{Focal length of reversed lens}}$$

For example, if you reverse mount a 50mm lens on a 100mm lens, you will get a magnification of about 2×.

You want to use two lenses together so that the reversed one is always wide

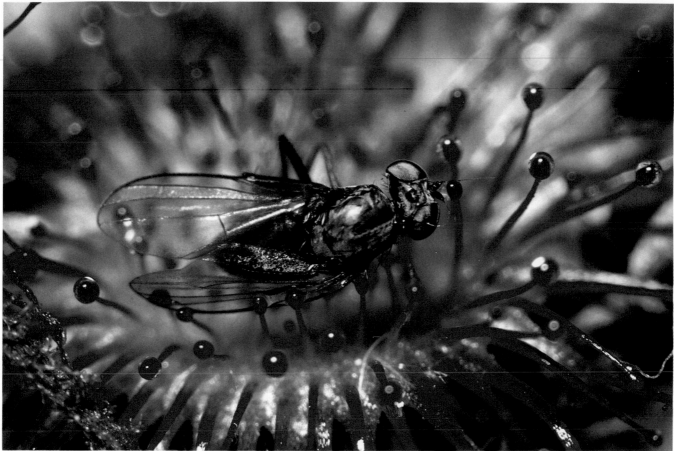

FLY TRAPPED IN SUNDEW. Kodachrome 25, 105mm lens on 200mm lens with 100mm extension, 1/60 sec. at f/22

MIDGE LARVAE ON SNOW. Kodachrome 25, 50mm lens on 200mm lens, 1/60 sec. at f/22

Sundew is an insectivorous plant that secretes small droplets on its leaf tentacles. When a small insect alights on the plant, it is trapped in the sticky liquid. Then, ever so slowly, the plant folds its leaf around the insect and digests it. Here, the magnification is about 3X, reached by using a 105mm short mount on a 200mm lens, with 100mm of extension between the 200mm lens and the camera.

On a warm day in midwinter, minute red specks on the snow led me to discover this midge larvae. The biggest problem at this magnification (4X) was finding the subject through the viewfinder!

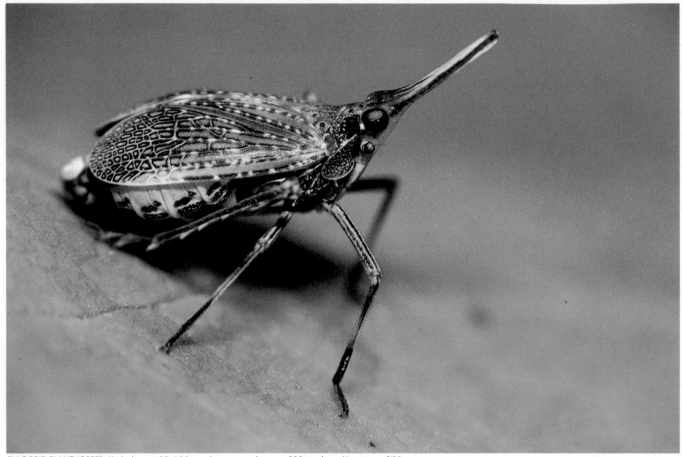

FULGORID PLANTHOPPER. Kodachrome 25, 105mm short-mount lens on 200mm lens, 1/60 sec. at ƒ/22

These insects are found in meadows of the northeastern United States. They tend to be very cooperative subjects—once you manage to locate them. Using stacked lenses enabled me to reach the magnification needed.

open. That way you can control exposure with the aperture of the prime lens just like you do normally. And you have the advantage of a functioning auto-diaphragm system as well.

If you're only going to shoot two or three high-magnification pictures a year, just tape the lenses together securely. Otherwise, search out a macro-coupling or male-to-male adapter ring; this is not a standard reversal ring, but rather has filter threads on both sides. Or you can take two regular filter adapter rings and glue them together with one of the super strength adhesives. The lenses do not have to be the same diameter but you should try to stay relatively close.

Which lenses work when stacking? First of all, resist the temptation for huge magnifications—2× is about all that is practical in the field and 4× is the absolute limit. However, 2× is a full-frame mosquito while 4× is a mosquito's face! The combination that I find ideal is a 200mm prime lens with a 105mm short-mount lens reverse mounted on it. (A short mount lens is a special lens without the usual lens mount that is designed to go on a bellows.) This combination gives a magnification of about 2×. For a 4× magnification, you can add a 50mm to the same 200mm. Or try a 50mm on a 135mm; that gives a magnification of about 2¾×. Some zooms will work as the prime lens if set at their longest focal length. As far as I know two zooms cannot be stacked. Wide angles do not work well as the reversed lens. Use a normal 50mm or longer for most of your work. As with extension-based close-up work, the longer the prime lens, the greater the working distance between the camera and the subject. With a 105mm short-mount lens reverse mounted on a 200mm lens, you should have about 3 or 4 inches. Given the magnification, that is a good working distance.

In finding two compatible lens, the main problem you face is vignetting of the corners. To see if you're getting it, hold your two lenses together and set the prime lens at its smallest ƒ-stop. Using your depth-of-field preview control, look at a light source. See if you're getting a full frame. Nearly all vignetting problems can be solved one of two ways: Add extension behind the prime lens, next to the camera body. Just keep adding extension and checking to see if the vignette is gone. (Most combinations will need some extension, and if your lens combination gives you 2× and you need 3×, this is how you get it—just add some tubes.) Or use a longer focal length as the reversed lens. Keep trying lenses until you find a pair that works. In my summer workshops I've had the opportunity to try all the major camera systems, and all have

SLIME MOLD SPORANGIA ON SPHAGNUM MOSS. Kodachrome 25, 105mm short-mount lens on 105mm lens, 1/60 sec. at f/22

combinations that work perfectly. As an absolute last resort—a desperation move as far as I'm concerned—leave the aperture of the prime lens wide open and control exposure with the reversed lens. Doing so takes away the auto-diaphragm. Before you venture into the field, you will want to protect the rear element and camera-connecting mechanisms on the reversed lens. With most cameras all you have to do is take one of the plastic caps that fit on the rear of the lens and cut out the center.*

*Canon bayonet-mount lens owners: When you remove a Canon bayonet-mount lens from the camera body, it remains at f/5.6 regardless of where the aperture ring is set. To get your reversed lens to open fully, you can buy a special Canon "macro hood." Or, you can adapt your regular rear lens cap. Look on the edge of the cap. One of the ridges also has a small extension that runs in the same direction as the lens. This little extension is about 1/16-inch long. Cut if off with a knife and the cap will now unlock your lenses, setting them wide open.

To meter with this system, just turn on your camera's meter and use it normally. Since there is not much extension used, there is lots of light for focusing and shooting. There are also no problems with diffraction—the distortion of light that you sometimes get when you use lots of extension.

Besides shooting natural light with this setup, you can add flash and the butterfly bracket. Again, you must run a flash test to get a neutral-toned exposure. Pick a reference point at the front of the system just as before and shoot by half stops. You will discover that, since there is not much light lost to extension, you'll have lots of light even with a very small flash. You may have to back the flash off somewhat, or diffuse it by putting a layer or two of material over the flash tube. With a 105mm lens reversed mounted on a 200mm lens, Kodachrome 25 film, and a flash with a GN of 28 to 40 at ISO 25, you will need to set the prime lens at f/22 or smaller for middle-toned subjects.

Stacked lenses

The photograph above shows my favorite combination of stacked lenses—a 105mm short mount threaded onto a 200mm. This system will come in handy when you are taking high-magnification photographs, especially if you don't find yourself doing this type of work very often.

(Top) Slime molds are a primitive plant with basic locomotion during one stage of their development. I found this particular slime mold growing on sphagnum moss under cedars in a quaking bog.

IN THE FIELD

LOUISIANA HERON IN CATTAIL MARSH. Kodachrome 64, 300mm IF lens, 1/60 sec. at f/8

Any lighting situation can add an exciting element to your photographs. Here, the late afternoon side lighting of the Florida Everglades gave prominence to the colors and textures of this water scene.

COPING WITH WEATHER

The odds are that unless you're a pro who specializes in Arctic or tropical photography you will not be spending weeks on end photographing in severe weather. Probably the extreme conditions you might face are a wintertime trip into Yellowstone or a mid-summer jaunt into the deserts. In warm weather you might also encounter high humidity. The most exhausting conditions I have ever worked in were 100-degree temperatures and 90-percent humidity while photographing an Iowa tall-grass prairie. Whatever the extremes of weather conditions, the problems you face are twofold: keeping your cameras working, and keeping yourself able to work the cameras.

Heat. Most of the precautions to be taken for hot weather work are nothing more than common sense. In general, if you can take the heat, so can your camera. Temperatures into the 90s are by themselves not particularly damaging to equipment. However, remember that a black camera body, or a black camera case, will absorb heat quickly and rise above the air temperature, so take steps to protect black gear from the direct sun. With cameras and lenses extreme heat can cause lubricants to run or optical cement to soften. Keep camera cases out of the sunlight as much as possible and keep them off the ground. Temperatures at ground level are far higher than just a few feet above the surface.

You've undoubtedly heard not to leave film or cameras in a car's glove compartment or on the back window shelf. The coolest part of a car's interior is generally the floor behind the front seat, but be sure you know the locations of the car's muffler and catalytic converter and don't set any equipment right on top of them. If the vehicle is air conditioned, don't be concerned about your gear, but do not drive all day with your camera case sitting in the direct sunlight. Once the car is stopped, however, it's better to take the equipment with you than leave it in the car for any extended period of time. Dark-colored cars, of course, absorb heat and light and get hotter inside than a light-colored car which reflects heat and light.

Keeping your film cool should be your main concern for normal hot-weather photography. From my experience with the Kodachromes, I find all that is generally necessary is keeping film out of the direct sun as much as possible and

watching for heat build-up within parked vehicles. I do carry my film in an insulated cooler, the normal ice chest camping variety, although I never use ice in the cooler. If I have access to a freezer overnight, I carry the refreezable packs available from camping supply stores and start anew each day. A good refreezable subsitute is canned grapefruit juice. Because it is acidic it freezes at a lower temperature than water. At the end of the day you've got a refreshing cold drink.

In all honesty I have rarely encountered situations where I have had to refrigerate film. I've discovered that when it is that hot I don't work well either, so instead I make short photography excursions at daybreak and at sundown when temperatures are cooler. Generally the light is better at those times anyway. If you must refrigerate film, keep it in the plastic film cans until it has warmed up. Allow at least one to one and one-half hours for this to happen. Unless the air is extremely dry, opening the film can and exposing the cold film is inviting moisture to condense on the film.

Keeping yourself comfortable is obvious. Sweatbands to keep perspiration from camera eyepieces, loose-fitting, light-colored clothes, a hat to protect you from the sun, and sunblock cream if you tend to sunburn all allow you to keep working.

Cold. Photography in cold weather is exactly the opposite of hot weather: now you want to keep your cameras warm. Cold weather is the problem you're most likely to face if you are interested in photographing the larger mammals in the United States, since they are in prime condition in late fall and early winter. On a fall trip into Yellowstone for elk during late September or the first part of October you will undoubtedly encounter cold and probably snow. Photographing bighorn sheep gathered on their winter range in Wyoming in December means working on exposed mountain ridges with high wind-chill factors.

Unless you're photographing in extreme Arctic conditions, a few simple precautions will keep you working in temperatures down to around 10 degrees. If you own one of the newer battery dependent cameras, keep the batteries warm. If you're not sure if your camera is battery dependent, pull the battery out and see if the camera

functions. Most modern cameras rely on batteries for metering and most also use them for controlling the exposure. At 20–30 degrees you should not have any problems at all in leaving your camera exposed to the cold, if you start off with a battery that is in good condition. However, I would advise always carrying a second set of batteries with you in an inside pocket where they will stay warm. If you do run out of batteries miles from any camera store, head for the nearest pharmacy and ask to see their hearing-aid batteries. Generally these are the same as the 1½ volt silver oxide button cells used in cameras.

Keep your camera inside your parka in very cold weather, taking it out only to photograph. If you must leave the camera exposed to the weather, you can buy an external battery pack that you wear under your jacket with a connecting cord that runs to your camera. Nikon makes one of these that replaces the standard camera batteries; it will fit a number of other camera brands also. With some cameras, changing power sources is as simple as adding a motor drive. With the Nikon F3 when you attach the motor drive the entire camera system is powered by the motor's eight AA batteries, rather than using the button cells in the camera body itself. I have used my F3 with a motor in extremely grim weather and have not experienced any problems.

If you use a metal tripod or monopod, tape any area of it you will touch. Even though you will be wearing gloves, the bare metal of a tripod is a heat sink and will chill you. In extremely cold weather avoid touching any metal with your bare flesh since you can freeze your skin to the metal. Still, things happen which you don't expect. Once, while I was photographing at −35 degrees, my breath condensed and froze my beard solidly against my Gitzo tripod. Luckily I was right next to my car, but I felt extremely silly getting into my car, holding a tripod next to my face, waiting for the whole mess to melt.

Carrying equipment in cold weather is a real hassle. I use a fisherman's vest with all its extra pockets. In weather down to about 25 degrees, I wear it as the outside layer for the convenience of access, but in colder temperatures it goes underneath my parka. In bitter weather remember that your extra film must be kept warm also, otherwise it can become brittle.

One problem you may encounter if

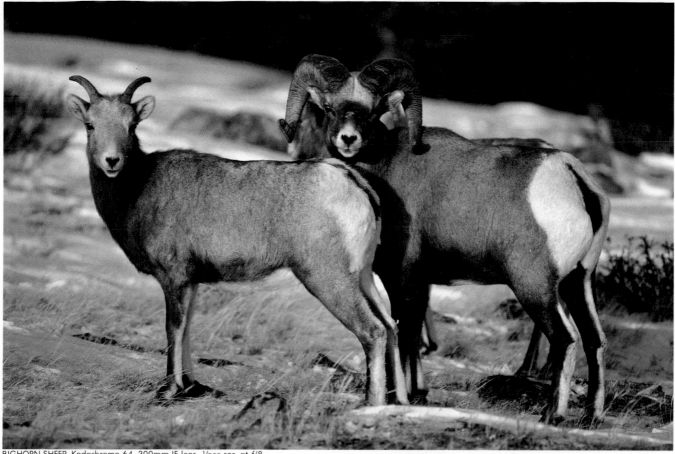

BIGHORN SHEEP. Kodachrome 64, 300mm IF lens, ¹/₂₅₀ sec. at ƒ/8

you exert yourself in the cold is that your body heat causes the camera's viewfinder to fog over. A handkerchief will solve that, but whatever you do, don't blow on the camera. If you do, you will only succeed in coating the equipment with your frozen breath.

I think the most exasperating part of cold weather photography is trying to re-load film in the middle of a driving snowstorm of big, wet flakes. I've heard of photographers who pull their arms through their parka sleeves and re-load with the camera inside their coats, but I cannot do this. With my luck I would stick my thumb through the shutter curtain. I end up hunched over my camera, my coat unzipped and hanging down to block the snow, trying to re-load right next to my chest.

Keeping yourself warm is imperative. Outdoor supply stores offer a variety of clothes, coats, and boots. The major problem is keeping your hands warm, yet not getting such bulky gloves that you cannot operate the camera controls. Ski gloves are good for moderately cold weather, while for colder times I use Polypropylene gloves inside

leather mittens. That way I can slip off the mittens to make a quick adjustment and still have my hands protected.

At the end of the day, before you go indoors, place your camera into a plastic bag, squeeze all the air out of it, and seal it. Moisture from the air will now condense on the bag and not on the camera or film. Leave the camera inside the bag for about 30 minutes, until the temperatures stabilize. However, if you're going indoors only for a few minutes it's easier to leave your camera outside. If there is any condensation on the camera and you go outdoors, the moisture can freeze and jam the camera.

Whether the weather is hot or cold, the best bit of advice I know for field photography is to own at least two camera bodies. If a lens breaks or jams up due to the weather you can always shoot with another focal length. Having only one camera body for field photography is an invitation to disaster. I once met a man who had traveled 2500 miles to photograph in the Everglades only to drop his one, and only, camera the first day there.

This photograph was taken high in the Wyoming mountains on the winter range of the bighorns. They seek exposed, windswept ridges because the ground there is relatively free of snow. Working the sheep at this location means that there will be plenty of cold and hard wind. Remember that when you're dressing and packing for the shoot.

125

LEARNING TO USE NATURAL LIGHT

Photography is light. In fact, the very word photography comes from two Greek words that mean *to write with light*. Far too many of us, though, are not aware of how the light itself changes from moment to moment. We know that the light varies in intensity and angle through the day, but that is where our knowledge, and all too often our concern, ends.

As photographers we must actually see the light. Many beginners, and many old hands for that matter, spend all their effort in finding subject matter or choosing the right equipment. They neglect the basic understanding of how light affects the image on the film; they do not differentiate between the light on the subject and the subject itself. Spend the day watching the light on a single subject to develop an understanding of how it affects your perception.

A tourist leaps out of his car, takes a snapshot of the Grand Canyon, then speeds away. From now on his picture is *the* Grand Canyon to him. He ignores totally the transitory nature of time and space. His picture really represents the Grand Canyon only on that particular day, at that particular time, from that particular spot. One glorious autumn, as I picked up my pack to walk to a waterfall, I overheard a man say, "I'm not going to walk the mile to that falls. I've already photographed this place two years ago." Two years! It won't be the same two hours from now or two days from now. We could spend a lifetime photographing the same location and never repeat the same picture if only we knew how to see.

Dragonflies move from favored perch to favored perch. Stalking them with a long lens in natural light demands that the lens be quick to focus and fast handling. The extreme side lighting of late afternoon changes rapidly, but as captured here, it adds a wonderful quality to the scene.

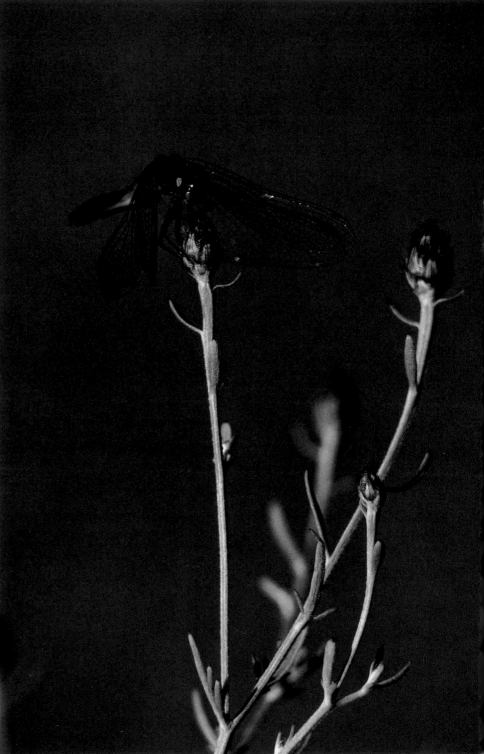

RED MEADOW DRAGONFLY ON STAR THISTLE. Kodachrome 64, 300mm IF lens, 1/15 sec. at f/4.5

BISON ON PRAIRIE. Kodachrome 64, 400mm IF lens, 1/250 sec. at *f*/8

These two photographs were taken only ten seconds apart, but in those ten seconds the lighting on the distant hillside behind the bison changed. In the first photo (left), the hill is lit by the sun, while in the second (below), it is in the shadow of a passing cloud. For both photographs the main lighting on the subject is exactly the same, and so is the exposure, but the emotional impact of each photograph is obviously quite different.

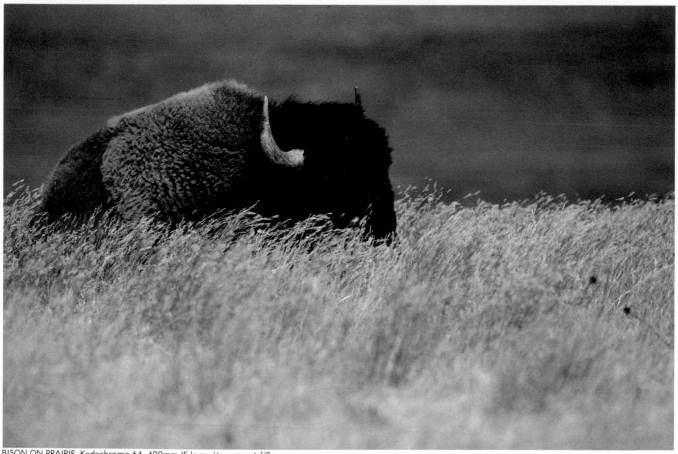

BISON ON PRAIRIE. Kodachrome 64, 400mm IF lens, 1/250 sec. at *f*/8

A SIMPLE, PORTABLE BLIND

The traditional blind is constructed of four uprights with a cloth covering, supported with guy ropes running from each corner. From my field experience I know this is not a good design for several reasons:

You need a design that allows you to shoot at infinitely variable heights. Working on a ground nesting bird demands a different shooting level than working in the middle of cattails where you must photograph over the vegetation. Ideally, one blind should cover the whole range.

The blind must be compact when folded, easily portable, and quick to erect at the site. Running guy ropes is not a fast job.

It must remain vertical even when erected on uneven terrain. This is one of the main failings of the designs for the blinds you see in most books. They must be set up on absolutely flat ground since they offer no provision for adjusting leg lengths. How can you work on the side of a hill?

The blind should be self-supporting. No matter how carefully you choose a location, with a guyed blind you usually end up about two feet in the wrong direction. With a self-supporting blind you just pick it up and move it wherever you want it.

The best blind frame that I know of can be purchased ready-made: it is a standard Welt Safe-Lock projection stand. It is self-supporting, with individually adjustable legs that screw into a flat top piece. Folded up, the legs attach to the top and there is even a handle to carry it all. When you add a covering the blind takes roughly three minutes to erect.

You need to add a leg section to make it go to stand-up height. Buy four 3-foot lengths of $7/8$-inch diameter tubing. Drill a $1/4$-inch hole through the tubing about 6 inches from either end. Now pull the crutch tips from the stand's legs and drill another $1/4$-inch hole 3 inches in from the end of each leg. Slip the tubing into the legs, line up the holes, and drop a $1/4$-inch bolt through the hole (or be fancy and buy a thumbscrew and wing-nut for 30 cents per leg). Use the lower hole and the tubing will be sticking out about 3 inches. Use the top hole and it will be out $2\frac{1}{2}$ feet. Of course you can still use each leg's locking collar to adjust the length. On my blind the legs go from a minimum length of 3 feet to a maximum of 7 feet.

For covering the blind buy any material that is strong, cheap, and dull colored so you won't be interrupted by a stream of curiosity-seekers. Measure your projection stand and sew a cover to fit. Make it just long enough for the regular legs, without the extensions you've added. Most of the time you won't be using the blind that tall and the extra material will be in the way. You can always add a skirt to the bottom, attaching it with Velcro strips.

For the lens, cut a hole and attach a sleeve about 12 inches in diameter and 12 inches long. This allows you to track from side to side without the lens pushing against the blind itself. Put a small peep hole in every side. Make a door by leaving a back seam open. To keep the door tightly closed run Velcro down its length (Velcro is much better than zippers or blanket pins since it cannot jam or get lost). Add a few pockets to the inside to hold odd items, or even rocks if you need to weight the cover down.

One overlooked item is what you sit on in a blind. Camp stools and folding chairs do not work well except on hard, level ground. Use a camp stool on soft or wet dirt and soon you're below the camera level. The best seats I've found are the five-gallon plastic pails used to package joint compound or institutional foods. You can usually find one among a restaurant's refuse.

If you're working in a very windy area, set a big rock on the top platform to stabilize the blind. Once inside, you can move your location if you have to. Pick up the tripod with one hand, the blind with the other, and tip-toe into position. I know it sounds rather silly, but it works.

The two photographs at right show the projection stand blind frame, and then the frame covered for a blind. In the photograph of the frame, you will notice the leg extensions have been added. In the second photograph, you can see how the large hole allows the camera lens free movement to track from side to side.

PROJECTION STAND BLIND FRAME

PROJECTION STAND COVERED FOR BLIND

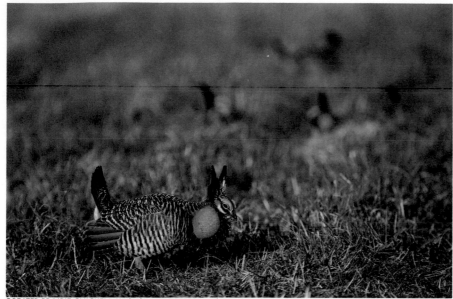

GREATER PRAIRIE CHICKEN. Kodachrome 64, 500mm lens, 1/250 sec. at f/5.6

One day at a booming ground in Missouri, I set up my blind before dawn and then waited for the birds to come in at first light. A male in the foreground made a particularly colorful subject.

This photo was made near a winter bird feeding station. Shooting with natural light, I focused from my projection stand blind whenever the birds landed at the feeder, which was placed at the bottom of a tree.

CARDINAL.
Kodachrome 64, 500mm lens, 1/250 sec. at f/5.6

129

SHOOTING FROM THE CAR

When you're photographing a well-traveled area such as the National Park and National Wildlife Refuge systems, one good blind to use is your car. Birds and mammals are used to cars, and, since they have learned that cars pose no threat, can be approached quite closely in these areas. Have your equipment ready before your final approach: exposure set, shutter cocked, window down. Drive slowly into position, turning off the engine just before you're ready to shoot.

You will have to use a 300mm or longer lens for most car work, and supporting such a lens is difficult. Bean bags work fine (actually I use rice in mine) with faster shutter speeds, but they are not that useful for slow speeds or for panning. With some vehicles you can jam a tripod between the car seat and the door. The best aid, though, is a window mount and my favorite is the Bushnell spotting-scope mount (product number 78-4405). It is very compact (small enough to live under my driver's seat), inexpensive, and clamps on the window glass. It's very sturdy and solid. One control handle locks all movement. Since it is made to be used with a spotting scope there is no provision for changing vertical and horizontal format orientation, so you have to use a lens with a rotating tripod collar.

(Top) *Birds are smaller than we think they are, so if you're going to photograph them from your car, you will need a longer lens. Even though I used a 500mm on my Bushnell window mount, I had to get within 25 feet of this western kingbird in order to get his photograph. For most bird photography, 500mm is about right for car work.*

(Right) *It pays to drive the back roads. Going through Iowa, I intentionally took local roads because I knew I'd more likely than not come across something that I would like to photograph. I noticed this sandpiper in a mud puddle—the only wet area for some distance—along the edge of a dirt road. As I eased my car into place, the bird flew a short distance away, returned, flew away again, and returned. The window mount and my 500mm lens eventually got him.*

WESTERN KINGBIRD. Kodachrome 64, 500mm lens, 1/500 sec. at f/5.6

PECTORAL SANDPIPER.
Kodachrome 64, 500mm lens, 1/500 sec. at f/5.6

WHITETAIL DEER. Kodachrome 64, 400mm IF lens, 1/30 sec. at f/3.5

I usually leave the mount attached to the lens and rest the whole works on the car seat beside me when I'm driving through a good area. To photograph, drop the mount over the edge of the window glass and screw it down tight, then lower the window to jam the mount against the window frame. Pressing outward against the glass when shooting also helps. I've shot with lenses from 300mm to 600mm off the Bushnell mount with good success. While I always use the fastest shutter speed I can, I'm not afraid to work in low light where my top shutter speed might be only 1/60 sec. or so.

The light was so low early one summer morning that I had no choice but to shoot 1/30 at f/3.5 if I were going to photograph this deer properly. Again, the Bushnell window mount helped the situation enormously.

SUCCESSFULLY STALKING A SUBJECT

There are two schools of thought about the proper way to stalk animals. One is the "sneak-up-on-them-unseen" group. These photographers wear camouflage clothing and hide behind trees. In my experience this approach does not generally work well, since animals have far keener senses than we have and are rarely totally unaware of our presence.

The other method of stalking is the "ambling-along-without-a-care" approach. Pretend you're going for a casual stroll and are interested in anything except the animal. If you can, work in from the downwind side. Don't take a direct path toward your subject, but zigzag back and forth. Take your time. The biggest mistake most photographers make is hurrying too much. Move slowly and keep low to the ground. If the animal starts showing signs of nervousness, sit down and wait for 10 minutes. Just sit still and do nothing. When the animal has calmed down, you can resume your approach. Try not to look directly at your subject since animals are very aware of eyes. Don't do anything fast, since this would suggest the sudden movement of an attacking predator.

Don't burden yourself down with all of your equipment. Normally I carry whatever long lens I need on a camera body equipped with a motor drive, my tripod or a monopod, and at most one shorter lens. Always take at least twice as much film as you think you'll need. I have a small belt bag which holds 15 rolls of film and it is always kept filled. At the end of any stalk I remove all shot film and immediately replace it with unexposed rolls. One of the most disappointing photographic experiences is to be finally into position with your animal and then realize you only have the half a roll of film in the camera.

(Top) *We tend to think of stalking in terms of large mammals, but many small creatures must also be stalked. For instance, I stalked this horned lizard with the flash bracket outfit. When you're photographing lizards, it is most important to approach the final 10 feet or so very slowly and very low to the ground.*

I couldn't get any closer than 20 feet from this pronghorn antelope, but with my 400mm lens, I had no problem in capturing his profile.

MOUNTAIN SHORT-HORNED LIZARD. Kodachrome 25, 105mm lens, ¹⁄₆₀ sec. at ƒ/11

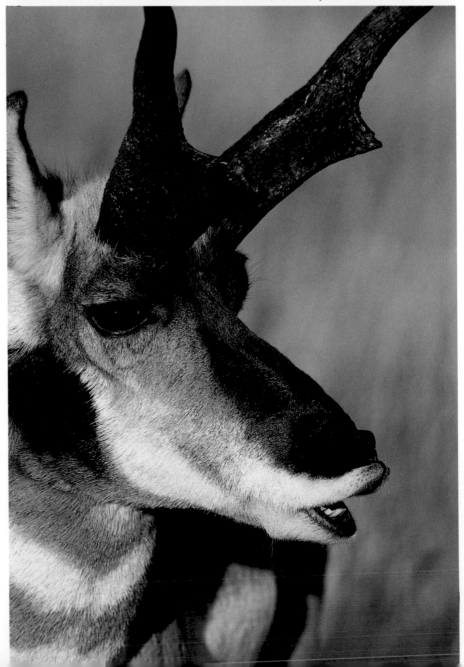

PRONGHORN ANTELOPE.
Kodachrome 64, 400mm IF lens, ¹⁄₂₅₀ sec. at ƒ/8

It is almost impossible to stalk birds because their vision is very good. Find one that is preoccupied with preening or feeding so that your approach won't be noticed.

BLUE-WINGED TEAL. Kodachrome 64, 300mm IF lens, $^1/_{125}$ sec. at $f/8$

FINAL NOTES

CLOUDS AT TWILIGHT. Kodachrome 64, 55mm lens, 1/15 sec. at f/11

Some of the most spectacular photographs will come about when you least expect them. There's probably nothing worse for a photographer than coming across a view like this and not having a camera. The answer, of course, is to keep your eyes open and always be ready—the photographs are there, just waiting for you to take them.

WORKING WITH FLASH

I no longer use flash very often for a simple reason: there is far too much sameness to flashed photos. For example, I have seen hundreds of flashed flower pictures during summer workshops and at camera club displays, and all look as if they were taken in someone's basement the same day. Part of the ambiance of any subject is the light itself. The natural light falling on a subject is part of the subject—you cannot separate the two. The light illuminating a flower on a foggy, overcast day is not the same as the high-noon light of a summer day. And noon light on the plains of Wyoming is not the same as noon light dappling through a Michigan woodlot. Why make all your pictures look the same?

There are times, though, when using flash is the only answer. I would urge you to learn to manage flash rather than relying on automatic or dedicated units. Again, it is a question of control. The problem with all auto systems is that they make whatever surface the sensor reads into a middle-toned value. Most auto units read a fairly large area. What happens when your subject is small in the frame? Will the flash expose for the subject or for the background?

Working with flash is a lot easier when you can determine exposure in stop values. With flash you're concerned with the flash-to-subject distance, not the camera-to-subject distance (of course, with a flash in the camera's hot shoe these distances are the same). We've all seem some guy sitting in the third tier at a huge stadium firing off a flashcube, expecting it to light up the entire stadium before him. This is impossible since the flash-to-subject distance is too great for such a little light. However, if he could run that flashcube down to the stadium floor with some sort of wire, so it was up close to his subject, it would work. That is exactly what you must do, you've got to get your flash off-camera with a long cord.

The usual method of determining exposure is with a formula:

$$\text{Guide Number} =$$
$$\text{Aperture} \times \text{Flash-subject distance}$$

The Guide Number (GN) is supplied by the manufacturer and is different for different film speeds. Since most flashes are used indoors, GNs are for averaged-sized rooms; go outdoors where there are fewer reflective surfaces and the given GN will be too high.

To determine an outdoor GN, set your flash up at a measured distance from a middle-toned subject and run an exposure test. Let's say your flash has a GN of 28 with ISO 25 film. Set your flash 5 feet from the subject. If the GN is right then $28 \div 5$ or $f/5.6$ should be the right exposure. Shoot an exposure series, bracketing by half stops from $f/4$ to $f/8$, and pick the correct exposure when you get your slides back. Let's assume that $f/4$ turns out to be correct. You now know that the real ISO 25 GN for your flash outside is $5 \times 4 = $ GN 20. GN calculations, by the way, do not take into account any light loss to extension, which is why I recommend a different method of using close-up flash.

You can figure out flash GNs for other films very easily if you work in stops. You could determine the new GN mathematically by multiplying the old GN times the square root of the new ISO number divided by the old ISO number, but who can do that without a calculator? Working in stops it becomes very simple. Just use the f-stop series of numbers. You may have to shift a decimal over a place or two but that is no problem. For example, a manufacturer says that his small flash has an output of GN 160 for ISO 400 film. Many manufacturers are doing just this, giving GN ratings for the high speed films, since it makes their flash seem very powerful. But what is the GN for Kodachrome 25? There is a four-stop difference between ISO 25 and ISO 400. Drop the zero temporarily from the given GN of 160 and you have the number 16 from the f-stop series. Four stops open from $f/16$ (since we're going to a slower film) is $f/4$. Add the zero we dropped earlier to get a GN of 40 at ISO 25. In actual practice, just look at a lens and count over the number of stops on the aperture ring and you're there. You can fudge between numbers and it is plenty accurate. After all, the difference between GN 80 and GN 110 for the same film is only one stop.

After you have a base exposure it's often easier to work in stop flash distances. Working from your known flash position you control exposure by moving the flash closer to or farther from the subject. If you pretend the f-stop series of numbers is a distance scale and move the flash in these increments, you will be working in stop values. If you have a flash at 11 feet (or any unit of measurement so long as you are consistant) and want to weaken it one stop,

move it away from the subject to the next f-stop number, 16 feet. Or perhaps you would rather make it stronger; then move it closer to the nearer stop, 8 feet. Either way is a one-stop change in whatever exposure you were shooting at the initial 11-foot distance.

Let's try an example. You're shooting $f/11$ with Kodachrome 25 and a flash at 4 feet from the subject. You want to shoot at $f/8$. Where do you put the flash? You have to move it away from subject, to weaken it so you can open up one stop to 5.6 feet. What if you wanted to shoot at $f/16$? $F/16$ is two stops more light than $f/8$, so move the light in two stops from 5.6 feet to 2.8 feet.

Let's assume that while you had the flash at 4 feet and were shooting Kodachrome 25 at $f/11$ you wanted to knock off a few frames on Kodachrome 64. You didn't want to move the light. What is the correct exposure for Kodachrome 64 here? Just change the f-stop you're shooting by the $1\frac{1}{3}$ stop difference in film speeds to $f/16+$. After taking a few shots this way you decide that $f/11$ is really the stop you want to shoot at. To use $f/11$ with Kodachrome 64 you put the flash $1\frac{1}{3}$ stops farther away. Move it from 4 feet to a little past 5.6 feet, maybe 6 feet or so. This flash distance measurement is not that critical. If you're off a few inches it does not matter. After all, the difference between 8 feet and 8 feet 6 inches is not very much when you consider that you have to go all the way to 11 feet for the next stop.

Working in stops greatly helps when you start to use two lights. If you intend on doing multiple flash I would suggest identical units, or at least units of the same output, so that any calculations are the same for all the units. A typical use for two lights is one on the subject and one on the background. If you want both to be lit to the same intensity, put the background light the same distance from the background as the subject light is from the subject. If the main light is 4 feet from the subject and you want the background lit to the same intensity, put the second light 4 feet from the background. Suppose you want the background one stop darker than the subject. Put the light one stop farther away from the background, or 5.6 feet. Two stops darker than the subject would be 8 feet, and so on. I'm assuming here that the subject and background are of the same reflectance. If they are not, just work in stops with them also.

GRAY TREE FROG. Kodachrome 25, 105mm lens, 1/60 sec. at ƒ/11

If you're using two lights from the front, a typical set-up is a main light higher than and to the side of the subject (45 degrees over, 45 degrees up is a basic starting point). A fill light is then added on the camera-subject axis. I would suggest about a two-stop difference between the two lights. From whatever your main light distance is, back the fill light off two more stops. If the main light is at 2 feet, the fill would be at 4 feet for a two-stop difference. A one-stop difference would be 2.8 feet , a two-stop difference would be 4 feet, for three stops, 5.6 feet, for four stops, 8 feet, and so on.

If you plan on shooting small nesting birds, the easiest way to figure out your initial main light exposure is to run a test. Pick the lens and extension that you're going to use in the field. (By the way, you will discover that you will do most of your flashed nest work with one lens.) Focus on a middle-toned subject the size of an average nest. Put your flash at a measured distance from the subject and run an exposure bracket. This will take into account all your variables, such as the lens extension, your film, and the flash output. Standardize on the film, lens, and flash distance in your field work. I no longer do much flashed nest work at all, but I used to use a main light at a distance of 2 feet from the nest. Remember that a weaker flash placed up close to the subject will yield softer lighting than a powerful flash placed farther away from the subject, since the small, closer flash acts less like a point source of light.

Similar to the singing frog illustrated on page 114, here's another crooner for which I opened up one full stop from my base neutral exposure.

CATALOGING AND STORING SLIDES

A cardboard slide page, a stamp with your name (and address or telephone number, as you desire), individual acetate slide holders, and a loupe—the basics.

After you have gone to all the trouble to purchase top quality equipment and to find good subjects, you should also take as much care of the resulting slides. I'm always amazed how some photographers will buy the best optics and travel the world for the exact subject, then store their slides in the most cavalier manner, loose in drawers or bags. The office end of photography is not my favorite part, but it is a necessary part.

Cataloging slids is a job that should not be put off. If you have 100 slides, finding a certain one is not hard. It takes a little longer to sort through 1000 slides, but it is still a very manageable number. However, when you have 10,000 or more slides, you better have a workable system for filing and re-trieval.

The first job is to edit your slides. A lightbox of some sort should be in your office. There are many varieties on the market. Inexpensive plastic panels with a 60-watt bulb behind them are primitive but functional. They yield very uneven illumination, though, being far brighter in the center than on the edges. If you're shooting a lot of film

and doing a lot of editing, buy a good lightbox, or a tracing box from an art supply firm, or make your own. Mine is homemade. It is built like a table, with a 2 × 3-foot light section, which allows me enough room to spread out several rolls of film. The light source, 5000K fluorescent tubes (color corrected daylight tubes available through any electrical supply store), is located a few inches below a 1/4-inch thick frosted Lucite panel.

Use a loupe to edit your slides and edit ruthlessly. I like the Nikon 7× loupe (product number 1350). You may want to save some flawed slides for personal reasons, but otherwise get rid of them. I keep a large wastebasket next to my lightbox and many a time it has been filled with throwaways.

Cataloging your slides into a file and developing a storage system go hand in hand. Most photographers I know store their slides in one of three ways. Some use metal slide file boxes, available at most camera stores. These boxes are about 15-inches wide, 7-inches deep, and 2-inches high, and are available with different inserts, either for holding

slides in groups or in individual slots. The group-storage model permits each box to hold roughly 700 slides. This is a good method to store a smaller collection, but once your total number of slides grows you will be shuffling boxes around a lot.

You can also purchase slide storage systems from audio-visual supply firms: basically these are larger versions of the metal slide boxes. I've used a Knox Acculight four-drawer module cabinet system (product number 6242) for years and am very pleased with it. Each unit is 24-inches wide, 18-inches deep, and 12-inches high, and holds about 11,000 slides. Each drawer is divided into 70 group compartments. Modules stack one on top of another.

A third method of slide storage is to use plastic, 20-slide pages in a standard office file cabinet. You can either just stand the pages in the drawers, interspersing them every so often with a cardboard sheet for support, or use a hanging file system. If you decide to use the latter method, and want to suspend several slide pages from each hanger bar, there is only one system that I know of that will support the weight of the slides and pages, the Pendaflex #109 Report Spines. Most hangers do not have enough torsional rigidity. Pull one out of the file, and everything else bends and falls off the file frame. Each Pendaflex #109 hanger will hold five plastic slide pages, and 50 hangers will fit in a standard 26-inch file drawer.

You've still got to catalog your slides. It doesn't matter how you do it, so long as you or whoever is going to use the system can find the right slides. Most photographers file by subject matter, and that can be broken down as far as you want to go. You could have Birds, *Passerformes, Fringillidae,* Sparrows, or Chipping Sparrows, depending on how much sorting you want to do.

Here's how I catalog slides. This is certainly not the only method, nor the best. It is a system that grew out of chaos many years ago and seems to work for me most of the time.

I catalog by subject matter, my subject headings being rather broad: birds, mammals, insects, flowering plants, non-flowering plants, herbs, and so on. Every slide in my file receives an identification code, a letter-number-letter system. For example, birds are coded B with a number. B1 is the first slide in my bird file, then B2, B3, and so on. If I have duplicate frames I add a lower-case letter: B1a, B1b, B1c. If I were starting over, I would definitely use an all-number coding, since letters—especially lower-case letters—are too easily misread as numbers.

I keep a master notebook of file numbers that grows as I add more slides. The numbers in each category just get larger and larger. Then I also have a card catalog by specific subjects. For example, I have a chipping sparrow card and on it is written all the numbers of chipping sparrow slides: B1, B19a, B19b, B249, B388, B842, and so on. I try to cross index subjects also. A chipping sparrow nest photo is listed under several headings: chipping sparrow, nests, eggs. Of course, if you own a personal computer, there is undoubtedly some software available that would allow you to store all this information on a disc.

The slides themselves are physically stored in numerical order sorted by broad category. All my bird shots are together, all the mammals, all the insects. Each slide is labeled with my identification number in the upper right corner, and my name is rubber stamped on the slide mount. Then I print a short, identifying caption on the slide mount. Something along the lines of "chipping sparrow at nest" or "autumn color, deciduous forest." When I send slides to clients, I keep a list of all the slide numbers, so I can tell exactly what I sent them, what they return or hold, and what they buy. This seems like a lot of work but I think it is worth the trouble. I've had editors ask for a specific photograph they saw published three years ago, and I've been able to supply the exact shot.

If you decide to store your slides in plastic sheets, a numbering system based on the pages is an easier method. Let's say B is still your bird file notation. The first plastic page in the file is "1", and each slide on that page is numbered 1 through 20 depending on its location left to right, top to bottom. B-4-16 indicates the fourth sheet, 16th slide in the bird file.

A word of warning: if you're planning to submit slides to a stock agency, do not caption or number those slides until you've checked with the agency. Every stock house I know of has its own distinct way it wants slides identified and labeled.

MY PERSONAL FIELD GEAR

A lot of people ask what equipment I use. The following lists may not hold true for long; I am notorious for switching my gear around. This is not an endorsement per se of any of this equipment, although I have shuffled through all sorts of lenses, cameras, and bags to come up with what I think is a very workable outfit that allows me to cover almost any subject.

Equipment, though, is just a tool. How often I have heard someone say, "Gee, you must have a good lens." Yes, as a professional photographer I do own some good optics, but not once has one of them gone out and produced a photograph all by itself. Good equipment makes it easier to work in the field, but it is certainly no guarantee of a good photograph.

My basic around-home "let's take a walk" outfit. This is the outfit I would carry to go out for dew-covered subjects in the morning, or for general photography. I use a Focus Travel Camera Case (available from Focus, Box 641, Bigfork, MT 59911), permanently fixed in a backpack configuration. This is a soft nylon case with foam inserts you cut to fit your equipment. In it I carry:

 24mm f/2.8
 55mm f/3.5 macro
 105mm f/4 macro
 200mm f/4
 camera body
 27.5mm and 52.5mm extension
 tubes
 small cigarette-pack-size flash
 homemade flash bracket
 81B warming filter
 polarizing filter and hood
 cable release
 film, 4 or 5 rolls
 foil-covered reflectors (2)
 Swiss army knife

I also take my tripod, a hand meter, and if I'm planning to shoot any tight close-ups, a rack-and-pinion focusing rail.

If I'm out scouting an area or looking for non-close-up subjects, I eliminate the flash equipment and the large extension tube. I change foam inserts in the Focus case and add:

 300mm f/4.5 internal focus
 motor drive
 1.4× teleconverter

My basic field-trip equipment. When I'm traveling by car on a major trip I pack most of my gear into a Lowepro Mag-

YOUNG OPPOSSUM. Kodachrome 25, 105mm lens, 1/60 sec. at f/11

Lucky for me, I had been in the right place at the right time with the right equipment— otherwise I would have missed this little expressive creature. Be prepared! You know the motto, so don't find yourself in the unfortunate position of having to say: "If only I had my camera . . ."

num case (available from Lowepro, P.O. Box 280, Lafayette, CO 80026). I take the Focus pack with me for field work, but the Lowepro case holds more and is easier to work out of when I'm shooting from the car. The Lowepro case holds:

24mm $f/2.8$
55mm $f/3.5$ macro
105mm $f/4$ macro
200mm $f/4$
300mm $f/4.5$ internal focus
camera body with motor drive attached
14mm and 27.5mm extension tubes
81B warming filter
polarizing filter and hood
cable release (2)
Swiss army knife
81B warming filter for 300mm
lens tissue and blower brush
jeweler's screwdriver set
hand meter
as much film as will fit

In a separate padded case goes a 400mm $f/3.5$ with a motor-drive body attached. I carry this all set to shoot, in case I have the opportunity for a grab shot from the car. Additional film is in a picnic cooler. Scattered around the car (always in the same locations so that I know where they are without hunting) are tripod, lighter weight backpacking tripod, monopod, shoulder stock, window mount, binoculars, and notebook. I also pack a fishing vest to use in the field if I need extra pockets.

When I travel by air, I hand carry the Lowepro case, the case with the 400mm lens and motor-drive body, the tripod in a shoulder case, and as much film as possible. When going through airport security I ask for a hand inspection of everything. Any additional equipment, such as the backpack, gets loaded into my luggage. I firmly believe you should carry on the airplane what you need in order to photograph. You can always purchase another pair of jeans or a toothbrush if you luggage is sent to the wrong place, but what could you do about a tripod?

Don't duplicate my camera equipment. Develop your own outfit tailored to your needs and subjects. But be warned: most photographers tend to be equipment fanatics, believing they need at least one of everything and preferably two of most of them. It is just as easy to have too much equipment as it is to have too little.

Having scouted the area and chosen the spot from which I wanted to photograph, I returned one day at sunrise to capture this lovely scene on film. Sunrise is a time of day that imparts a magical quality to most any place.

WABASH RIVER, ILLINOIS. Kodachrome 25, 24mm lens, $1/15$ sec. at $f/8$

RESOURCE BOOKS AND SHOOTING SITES

Two areas that people always ask about are where to go for certain photographs, and how to identify subject matter if you are not a trained biologist.

Most of the professional photographers I know are not professionally trained in the biological sciences. (In fact, most have generally had no formal training in photography either.) But they have spent hours, days, or years in the field carefully observing the subjects in which they are interested. If you don't have this time, there are many reference books that will help. I believe it pays to read everything you possibly can about nature. The more you know ahead of time about your subjects, the more you can anticipate behavior or know when and where to look for certain subjects.

Field guides are a good place to begin. Onc of the most popular series is the *Peterson Field Guide Series,* published by Houghton Mifflin Company. There are over 20 titles in this series of books, covering everything from birds and mammals to sea shells. Equally popular, although with fewer titles, are the *Golden Field Guides,* by Golden Press. Golden also publishes small nature and science guides, which for some subjects (spiders, for example) are the easiest to obtain and most thorough popular books on the subject. A third series is the *Audubon Society Field Guide Series* from Alfred A. Knopf, which uses photographs rather than drawing for the plates. You should pick and choose among these different books. You'll probably end up owning some titles from each series. For odd subjects you are better off to try your state university or local academy of science.

As to where to go, the best location for field photography is somewhere very close to where you live. You want to find a spot that you can get to quickly when the light is exactly right. This will also be an area that you can learn thoroughly. You will get to know the terrain, the locations of certain plants, where nesting birds are likely to be found, and where to find any unusual subjects.

If you plan to travel, my first choice for photography would be the National Parks. The parks are ideal for photogra-phers; roads lead to spectacular vistas, and birds and mammals are far more used to people than elsewhere. The National Wildlife Refuges are good places to see creatures, but they were created first for the animals, not for human visitation or for photography.

In all seriousness, it is not so important *where* you are to photograph, as *when* you are there. Everyplace in the world is magical at the right time, but it is up to you to be there at that time. I would suggest you keep a natural history log book. Wherever I travel I keep a record of the date, what was in bloom, the progression of the season, weather, condition of animals, and the exact location of any unusual subject or of good shooting areas. If I plan on returning to an area, I can check my notes and determine the prime time to go for whatever subject matter I want.

Yellowstone National Park is crawling with creatures large and small, all wonderful subjects for your camera. This bison was hardly difficult to miss or to identify, but if in doubt as to the identity of some of your subjects, shoot while you have the opportunity and find out particulars later.

BISON AT FIRST LIGHT. Kodachrome 64, 300mm IF lens, 1/60 sec. at f/4.5

INDEX

Edited by Don Earnest and Marisa Bulzone
Designed by Jay Anning
Production Manager: Hector Campbell